THE VELDERET

Also by Cecilia Tan

Telepaths Don't Need Safewords
Black Feathers

► THE VELDERET ◄

▼

Cecilia Tan

Circlet Press

THE VELDERET

Printed in Canada
ISBN 1-885865-27-9

First Edition June 2001

Circlet Press is distributed in the USA and Canada by the LPC Group. Circlet Press is distributed in the UK and Europe by Turnaround Ltd. Circlet Press is distributed in Australia by Bulldog Books.

For a catalog, information about our other imprints, review copies, and other information, please write to:

Circlet Press, Inc.
1770 Massachusetts Avenue #278
Cambridge, MA 02140
circlet-info@circlet.com
http://www.circlet.com

Production by Windhaven Press., Auburn, NH (www.windhaven.com)

Acknowledgements

This book wouldn't be what it is without the help of my fellow SWOF (Sick Women of Fiction) members, Lauren P. Burka and Mary Malmros, who read many early drafts. My thanks to Deena Moore of Taste of Latex magazine, who provided the deadlines that got the ball rolling, and to Mavis for shepherding the text there. I should thank Robert Dante even though he doesn't know why. Thanks also to Richard Kasak, Richard—sorry it didn't work out.

Big thanks also to those whose, um, creative input provided inspiration, Ian, corwin, Joe, most especially Clyde/Teresa for taking care of writers block in a rather unique way, and of course Those Who Cannot Be Named In Print—love you guys, anyway.

▶ Chapter One ▼

"I WANT TO BE A SLAVE," KOBI SAID, from where he lay on the living room floor with his long black hair spread out like a carpet. "The erotic plaything of a powerful, indomitable owner." His eyes twinkled with an "aren't I crazy?" light, or maybe that was the image of the fireplace flickering on the media wall. He sat up enough to take another swig of the wine and passed the bottle back to Merin where she sat on the couch, and lay back again, watching her reaction.

Merin sat still with shock; her fingers barely felt the wine bottle in her hand. She and Kobi had been sharing the apartment for several months, ever since the last housing lottery assigned them into this standard, two-occupant place. It was nice but not fancy, and she and Kobi got along better than well, sometimes sharing beds as well as friendship; but this was the first time they'd ever gotten drunk and bared their secrets to one another. "Say that again," she said, almost a whisper.

"I want to be a slave!" Kobi's voice rang off the ceiling.

A thrill ran through Merin's blood when he said it—the taboo spoken aloud, at last, and the words stirred something in her. "Me too," she said.

Kobi sat up, the wine forgotten. "What?"

"I said 'me too.'"

1

Kobi was as shocked to hear her admission as she had been to hear his. "Really?" She was nodding to him—slow, serious nods. He took her hand as though he needed assurance that she was real. "I thought—I thought I was the only one."

Merin held tight to his fingers and took a deep breath. Her mind, which minutes ago had been fuzzy and sleepy with wine, now buzzed with giddy possibilities and long-repressed memories coming to the surface. "Do you remember the stories they told us as children, about the cruelty of our ancestors towards the Gerrish, how they subjugated them and forced them to work . . ."

Kobi nodded, his eyes fever-bright. "Yes, yes, and how the mistreatment led to the destruction of the Gerrish race." He sounded like he was quoting some long-ago educator. "That's why we have the Age of Equality now."

Merin curled her legs under her on the couch and went on. "Even when I was a little girl, I used to wonder what it had been like for the Gerrish, to be bought and sold, to be used . . ."

Kobi shivered. Every Bellonian child had been taught in school that the enslavement of the Gerrish was the greatest crime committed in history, and it was only in the aftermath of the Gerrish extinction by a genetic plague that Bellonians began to build the peaceful, free society that currently existed. It took hundreds of years to eliminate warring tendencies and inequality in their society. *And here I am,* Kobi thought, *going against it.* "I used to daydream about the Gerrish, too." he said. "I used to imagine I was the servant of an ailing lord, who needed to be comforted in his final days."

"Comforted?"

Kobi blushed at the memory and let her hand go. "In my fantasy he was dying of a rare sexual disease that required him to have sex almost constantly during all his waking hours, so he had a whole bunch of slaves who served him to ease his affliction." He laughed out loud. "I always had a vivid imagination."

"I guess so!" Merin let herself laugh a little, too, but she was still thinking about the ethics of their admission to one another. "But the Gerrish enslavement *was* a great crime," she said.

Kobi's eyebrows came down, as did his voice, in serious thought. "Yes. But think about it. It's wrong to subjugate someone. But there's no crime in wanting to be subjugated, is there?"

She pursed her lips. "There's no law against killing yourself, either, I suppose."

Kobi frowned. "That's a distasteful comparison, don't you think? Or do you think we're self-destructive for thinking this?"

Merin touched him on the cheek. "I don't know. Do you think the Kylar are going to destroy us the way we destroyed the Gerrish?" Since the establishment of the Kylaran embassy last year, rumors were flying thick through the streets and through the legislature where Merin worked. Contact with the Kylar and their culture had been limited thus far, so the speculation about their social practices was endless.

Kobi shook his head. "We don't even know if the Kylar are going to colonize here or just trade with us." Kobi felt his cheeks getting warm. "If they did colonize, though . . . you know what they say about the Kylar."

Merin nodded her head and smiled. "So that's what's got you thinking about becoming a—" she rolled her tongue over the words "—love slave."

"They say their overlords keep a dozen or more slaves to satisfy their libido! Imagine it, Merin! It could be my dream come true!"

Merin slid down to the floor to look Kobi in the eye. "If the Kylar do colonize here, it won't be for several years. If they do, they'll probably bring their own slaves with them. And if they wanted to take on Bellonian slaves, they won't find anyone suitable, because we've been conditioned out of thinking that way."

Kobi smiled and stroked her short curls. "Merin, don't you see? That's why we have a chance. You and me, we're not like the others. We want this. When the Kylar come, we'll be ready!"

"What do you mean, ready?"

"We'll have to have practice. We can practice with each other!"

She laughed out loud. "Doing what?"

Kobi was shaking his hands in excitement. "Just like when we

were kids, did you play at being parents, educators, legislators? Let's pretend. Like this." He cleared his throat and growled, "Slave! Are you ready for me? I need some service!" And he pressed her back into the floor, pinning her by the shoulders and kissing her neck.

Merin had slept with Kobi plenty of times since they had been assigned to share this apartment. They often had sex to blow off steam or relieve boredom. She'd expected they probably were going to end up in bed tonight since neither of them had plans. But she hadn't expected anything like this. Kobi had never been so intense before, she'd never felt his yearning need like this. His long black hair fell loose like a curtain, intensifying the moment, isolating them from the cluttered media room they shared. She squirmed under him and enjoyed the buzz of sexual tension building between her legs. She said, in falsetto, like a long-ago educational depiction of a helpless Gerrish maidservant she vaguely remembered seeing, "Oh master, anything to please you. Take me!"

Kobi let her go for a moment as he began to slip out of his clothes. "Um, strip!" he commanded. He had trouble getting his waistband over his erection.

She was wet when he slipped into her, there on the floor, pressing her down with his body. But in his mind, their roles had reversed, as he fantasized again of being a slave, serving his master's needs. Or, in this case, mistress. Then they were both lost in the mindless lust of heat and sex. It felt good.

Merin spoke first after they were done. She wasn't sure what to say, so she settled for stating the obvious. "That was intense."

"Yes." He rolled onto his side and propped his head up with his elbow, his hair flowing around him.

This could be fun, she thought. "Next time, do you want me to be the one in command?"

"Yes! Sure!" He held her hand. "We can take turns."

They lay like that for a while, among their scattered clothes at the foot of the couch. Merin's mind was busy as she relaxed. *We can't be the only ones, either,* she thought. *How could we find more?* "Hey, Kobi?"

"Hm?"

"When is your next session at the Velderet?"

"I'm bartending there tomorrow."

"No, I mean, when is your next sexual encounter due?"

He blushed. "I already used one this month. So, ten days at least. What are you thinking?"

"Nothing," she said. But she knew she'd tell him her idea as soon as she convinced herself it could work.

The following week passed with Merin spending her days at the legislature, where she was doing her mandatory three years of duty as a consensus lawmaker, and Kobi spending the nights tending bar at the Velderet. They hardly saw each other, so there was no opportunity to play "let's pretend." But Merin's mind kept returning to her ideas about Kobi and the Velderet.

The Velderet was a sex house, an Age of Equality institution begun on the theory that all citizens should have equal access to some basic sexual freedoms. Any Bellonian could walk into the Velderet, or one of the many other places like it, once a month and request sexual satisfaction, or save up currency and transfer it there for extra time or sessions. Merin looked up the legislation ruling sex houses and transferred it to her home system to peruse later. Was there such a thing as fraudulent use? She'd find out. While she was poking through the databanks she also found some graphics of the latest in "sensual fashions." Could be interesting, she decided, and transferred them, also.

Kobi, in the meantime, made a friend at the Velderet: a customer named Mica, who had started coming in recently and usually hung around to talk and have a drink. One night Mica began griping that he wasn't getting his usual satisfaction anymore. "Maybe I just don't know what to ask for," he said as he rested in the lounge after one of his sessions. The whole room was decorated in a spiral motif, with customers entering at the lip of the cone and working their way down to the bar at the bottom. Mica leaned his arm on the bar, staring at the swirling patterns in the smooth surface. "Or maybe I'm in here too often, getting jaded."

Kobi had noticed that Mica tended to come in once a week or more. "Could be," Kobi said, as he poured Mica some iced water. "Have you been seeing the same people again and again? You could try cybersex instead. Then you could have the pick of partners from all over."

"No, it's not that. I try to come on different days. But they all seem the same. Maybe as I get older my tastes are changing."

Something in Mica's voice made Kobi listen more closely. "Like how?" he asked, pretending to busy himself behind the bar.

"Like . . . I want it more quick? I had one woman last month who was great, really physical, rough almost. That . . . got me going." Mica stared into his glass, his dark eyebrows casting his face in shadow. "It's probably just a phase I'm going through."

Kobi looked around. The lounge levels above him were mostly empty. "I know what you mean," he said.

Mica's eyes flickered up for a moment before he looked pointedly away.

"I do," Kobi insisted, and pressed his hand to his chest.

Mica also took a look around to confirm they were mostly alone and unobserved. He wrote something down on a throwaway and passed it to Kobi as he stood up. "I'll see you around." And then he left.

Kobi read what was printed on the damp piece of paper. It was an access code for a retrievable data file. He slipped the paper into his pocket.

Merin had fallen asleep in front of the media wall that night. When Kobi came home, he found her curled up on the couch with a video of some fashion show looping on the screen. He sat down next to her and touched her shoulder. "Merin, wake up."

She woke with a yawn. "Did I fall asleep? What time is it?"

He took the control board out of her lap and entered the code Mica had given him. "Someone told me something interesting today, I think."

Merin yawned again. "What?"

"We'll see what it is." The screen went dark while the system

retrieved whatever it was. And then, on the screen, appeared the words:

The Kylaran Desire

They both watched, rapt, as the letters dissolved into the image of a naked, kneeling woman, her hands bound behind her back. She wore a suit of something black and stretchy that oddly covered all of her torso except for her breasts. A voice speaking Bellonian intoned the evils of the decadent Kylaran empire . . . while the image changed. The animated graphic figure now was tortured by faceless figures with whips; then, limbs spread beyond the view of the screen, she was entered from behind by a man. The soundtrack in the background featured a woman's cries and screams as the voice listed the kinds of service that were commonly expected of *caitan,* the elite Kylaran sex slaves.

Merin laughed. "This is obviously a piece of propaganda. But is it condemning the Kylar? Or promoting their way of life?"

Kobi mouthed the word *ky-tahn.* "Those sound like cries of ecstasy to me. Look." He pointed out her face, enhancing the image with the control board and enlarging it. "Is she grimacing in pain or smiling?"

Merin squinted. "The resolution of the data's not good enough. I can't tell."

The clip ended with the image again of the woman kneeling, rotating slowly to show her reddened buttocks, her full breasts, the metallic cuffs at her wrists and the collar around her neck. The screen went dark.

"Where did you get this from?" Merin looked at the throwaway with the code written on it.

"A guy at the Velderet wrote it down for me." Kobi shrugged. "Do you think it's contraband?"

Merin considered that. "Maybe not. If it purports to be a piece of propaganda against the Kylar . . . the legislators really haven't dealt with this issue before." It was illegal to create or distribute dramas depicting "inequality" except for certain educational programs about the Gerrish. But no one had *wanted* to create

such things before, either. And no one had actually come forth in the legislature to condemn the Kylar or claim it was wrong to have contact with them. She was deep in thought when Kobi touched her on the arm.

She felt the dampness of his fingers and smiled. "You horny bastard."

"Please, Merin, I . . ."

She held up a hand. "Are caitan allowed to beg for favors?"

He got down on the floor and bowed his head.

"You had better beg well."

"Please, mistress, I'm so hungry, I could die."

"Hmph, well, we can't have you dying now, can we? I paid good money for you." Merin struggled to keep a straight face. So it wasn't the most eloquent improvising she'd ever done.

"Please, mistress," Kobi said again. "I am so full of need."

Oh, Kobi, you always are, she thought. But Merin was hot, too, she realized, between watching the propaganda and now seeing Kobi's face flushing with desire. But that's no reason to rush, she thought. "Then touch yourself."

Kobi flashed a look at her and she raised an eyebrow. He slipped back into character and slid his pants off. He wet his hand with his tongue and began stroking. Merin had never watched a man touch himself before. She was fascinated by the way he curved his fingers to catch the lip of head. She wriggled out of her own clothes while he pulled and stroked. His hand was beginning to shake.

"Don't you dare come unless I say," she said, pulling his hand away from his cock as he gave a little whimper. She motioned for him to lie down and then straddled him, stroking herself and teasing him with the sight and scent of her cunt. Then she settled onto his erection. She'd been on top before, but she'd never ridden a man like this. He jerked and shuddered under her, trying hard not to come, but in the end he couldn't stop himself. But then again, neither could she.

"Oh mistress, let me take care of that mess," he said quickly, and they switched places. He put his head between her legs and lapped up his own seedless come as it leaked from her, then kept lapping

until Merin clapped her thighs so tight around his ears he could hardly hear how loud her screams and moans of orgasm were.

A little bit later, he asked, "So, do you think it's true?"

"About the Kylar in the propaganda?" She shrugged. "Who cares? What matters now is who is putting this data out and why. And if others like us are seeing it, how it is affecting them. . . ." She put a hand on his shoulder. The time had come to tell him about her idea. "I'm sure now we're not the only ones. About the Velderet . . ."

Under Merin's instruction, Kobi made an appointment to utilize his monthly quota of sexual satisfaction in one of the Velderet's cyber suites. "Pick a time when there will be lots of other people connected," Merin had said. "Your chances will be better."

According to the data, most of the citizens in the population centers connected after dinner. So he waited until evening and then let himself in to one of the plain, gray rooms that held the network connections. Each room had a bed, a small cabinet of supplies for real world encounters, and a terminal. The main suites in the Velderet were much more richly decorated, but for a smooth cyber connection, a plain background was easier on the brain, with less distracting visual data if your eyes were open. He took a seat at the console and began the registration procedure.

"Hello, Kobi," the programmed computer voice said to him as the words appeared on the screen. It asked him whether he wanted his previous preference file loaded or if he'd like to choose a new set.

"New set," he said, and the registry questionnaire came up in front of him.

The first questions were very basic. Age? Gender? Body type? and so on, as the system tried to determine his ideal partner. He specified a slightly older individual with physical strength rated high, no gender selected. Then it became more specific about sexual tastes, asking him to rate the desirability of certain acts, both performing them and receiving them: massage?

ear licking? cunnilingus? fellatio? anal penetration? Hundreds of sexual and sensual activities. He tried hard to draw an erotic map that showed his underlying motive—to be the erotic play-thing of a domineering partner—something the computer wouldn't sense, but perhaps the human being it matched him up with would.

Merin's idea had been to try to work the system to match Kobi up with a partner who might have the same ideas as he did. "We know we're not the only ones, now," she insisted. "What better way to find the others?" One couldn't request of the system any encounter that had any element of dominance in it. But perhaps the person it matched him with, perhaps he could say to him or her, "Let's reenact the Kylaran Desire . . ."

He marked high preferability for all the acts that required him to be penetrated in some way and designated himself "passive." Then it came down to the personality and mood selections. *Romantic* did not seem the right choice, although being swept away to a distant, exotic world by a tall, dark Kylar was about as romantic as he could imagine. He also rejected the categories of *Nurturing* and *Inexperienced,* among others, and settled for *Passionate.* He checked *Complex* rather than *Straightforward,* but specified *Anonymous.* All that setting really meant was that he wasn't interested in meeting a Relationship partner through this encounter, so names did not have to be exchanged.

Lastly, he selected *Link Only.* By meeting his potential part-ner through cybersex and not in person, he could not only choose from anyone linked up at sex houses all over the world, he would risk no physical damage if he found what he was look-ing for.

"How would you like to appear?" the computerized voice prompted him.

"Oh." He had almost forgotten Merin's facsimile. Since he would be projected into the computer's mind, he could change his appearance if he wished. "Please use my usual nude body," he said, knowing it was on file. His naked figure appeared on the screen. "But clothe it in this." He fed the paper into a scan slot. The computer filled in a dark outfit that fit snugly over his

shoulders and around his waist. Merin had designed a male equivalent to what they had seen the caitan wear in the propaganda clip. "Hair in a topknot," he added, remembering the way the woman in the clip had hers piled atop her head.

"Material of clothing?" the computer reminded him.

"Something stretchy," Kobi said, realizing he did not know what to say.

"Choose from the following." A list of fabrics and materials both natural and synthetic scrolled down the screen. He had never used this option for anything before. The cybersex he'd experienced had just been in the nude. His eyes stopped on the word "leather."

"That material will limit mobility and make sexual activities difficult or uncomfortable," the system advised him. "Please choose something with greater elasticity."

"List from least elastic to most."

The list flickered as the words rearranged themselves. He scanned to the bottom. There was something he hadn't seen before: "Ultra-stretch rubber."

The Kobi on the screen was suddenly clad in something shiny and tight. The computer showed the figure doing jumping jacks and the material stretching accordingly. "Within acceptable limits," the computer said. "Please lie down and await connection."

Kobi stripped out of his clothes and lay down on the bed in the suite. He had to ask the computer for further instructions on how to attach the tiny leads to his skin at various points on his head and neck. Cybersex wasn't something Kobi had done very often. In fact, the only times he had done it were once when he had a broken arm and shoulder and could barely move, and once when he had been sick with a bad flu that he didn't want anyone else to catch. It hadn't been as satisfying as meeting a real person flesh to flesh, he had told himself then, but maybe being sick or injured had dampened his response. Cybersex had originally been designed for those with physical disabilities for whom ordinary sex was difficult or impossible, but there was no reason any person couldn't use it. Many people these days seemed to prefer it. In fact, with enough excess currency, one

Cecilia Tan

could even buy the right connectors and hook in to the cybersex network from home.

Kobi lay back in the warm room and waited for a connection to come through. *I hope this works,* he thought.

Merin scanned over the many bright-colored facsimiles spread across the living room floor. "Sensual fashions" were particularly disappointing this season. Mostly androgynous, baggy things, very soft on the skin, of course, and easy to remove, but very little looked particularly enticing. She doodled with some more ideas similar to the thing she had come up with for Kobi. It was good to stay in practice with design. Once her three-year tenure in the legislature was up, she could go back to attire design. Most of what she had done was not fashion but utilitarian, designing better clothes for certain types of laborers, hospital workers, construction . . . She tried to imagine that if this was how a slave was dressed, how would a master be attired? What would the needs of a master's clothes be? The clip hadn't shown anything useful. Her pen ranged over the control board as she searched for something else that might inspire her. She passed out of the fashion sector and into a branch on historical costume and checked the heading "Ancient Military Uniforms."

To Kobi it seemed that the light in the room changed, but as he looked down and saw himself clad in the black, Ultra-stretch suit, he knew that he was seeing the room in the virtual network. He could feel the Ultra-stretch now, too, tight and slick, not like cloth at all. He wiggled a bit and loved the feel of it on his skin. What would it feel like without body hair?

A chime sounded and the room warped a bit as a naked, male figure opened the "door" and came in. He had short, sandy hair and looked to be about five years older than Kobi, probably breeding age, if he had a taste for women. "Hi," he said.

"Hi." Kobi resisted the urge to get down and kneel. There was no way to know what this guy's reaction might be to that. Kobi stayed on the bed as the man approached and looked at him, like a doctor looking over a patient. Kobi tried to imagine he was

a prospective slave buyer, examining the merchandise before try-ing it out himself. *I better try to feel out this guy's true prefer-ences,* Kobi thought. "I have a very talented mouth and ass," he said, watching for a reaction. No change. Time to initiate some-thing. "And I'm ready for you whenever you are." There, that was almost like something a slave would say.

The man ran his hand over the Ultra-stretch and Kobi shiv-ered, back in his mental game of slave for sale. He turned over onto his stomach and waved his ass in the air.

"Well, here," the guy said. "If you suck me off some, I'll be hard enough to fuck you, okay?"

Kobi pretended that was an order and went at the flaccid pe-nis with gusto. *What will happen to me if he doesn't get hard?* Kobi thought. He imagined being punished for failing to do his duty, but he couldn't really imagine what the punishment would be, only that there would be some. He moaned around the cock in his mouth. The guy was getting hard. He didn't wait long be-fore pulling away from Kobi's mouth and positioning himself at the end of the bed. Kobi rocked back on all fours. *Oh, perfect,* Kobi thought, *just like in the clip when the caitan gets fucked . . .*

"You ready?" the guy said, spreading Kobi's asscheeks apart with one hand and guiding his cock with the other. Maybe cybersex had some advantages, Kobi thought. No lube necessary.

Kobi nodded, pretending that he really had no choice. His master was just toying with him, asking like that. As he was when he later asked, "This okay?" when he changed to a faster rhythm and, "You getting close?" a bit later on. Kobi didn't answer either time—it would have broken the dream too much.

But the truth was, he was getting close, and he wasn't able to hold it. Not like a good slave would have. The guy didn't seem to care much, either, as he slicked himself in and out of Kobi as fast as he could, straining toward his own orgasm.

That's it, Kobi thought suddenly, *he's using me for his own pleasure! Oh yes. By the red moon . . .* And he moaned a little as he thought about that.

"Are you okay? Am I hurting you?" the guy asked. "Do you want me to stop?"

Some people are just too nice, Kobi thought. *It's like he's forgotten we're cybersexing and he can't really hurt me.* He shook his head as he clenched his butt tight and sent the guy over the edge into orgasm.

Later, Kobi sat in the dimly lit lounge, playing over the encounter in his mind. If the guy had kept his mouth shut, Kobi thought, would it have worked better? The truth was, that night's partner just wasn't into it the same way. *Then again,* Kobi thought, *I never did ask him specifically or give any direct hints. Maybe Merin will come up with a more direct way to get the message across. . . .*

His eyes stopped their roaming as he spotted Mica coming into the lounge. Mica made his way through the softly sculpted tiers and scattered pillows to where Kobi sat. Kobi indicated a soft pillow next to him but Mica did not sit.

"Here," he said, and handed Kobi a scrap of paper. Then he walked back out the way he had come.

It was another code. Another propaganda clip? Kobi folded the paper in half and stood up. It was time to go home and find out.

► Chapter Two ▼

KOBI TRIED NOT TO HURRY. He was vain, he knew it, and he knew how silly he looked when he tried to walk too fast, but the scrap of paper in his pocket felt like a white hot star; surely everyone could see it. In reality, it was Kobi's curiosity that was burning. He gave up trying to look graceful and broke into a jog.

The street was nearly deserted at this hour, anyway. The red moon had set and the white moon was rising behind him. He had spent a long time at the Velderet after his cybersex session, thinking and drinking. Most of the windows were dark in the clean, white domiciles he passed; even the buildings seemed like they were asleep. For Kobi, it only reinforced the feeling that he was no longer a part of the Bellonian mainstream. By his own admission he was different, a kind of sexual outlaw. He had desires and dreams and fantasies that were inadmissible to others; he was now an outsider. He decided he liked this feeling.

Besides, he wasn't alone. He wondered if Merin would be asleep when he came home, or if she would be waiting up with eager questions about his cybersex experiment. He almost jogged past their building. The door recognized him and opened onto the dimmed hallway. Lights flickered up to show him the way to his door, but he ran ahead of them and burst in.

"Merin?" He saw her jacket hanging by the door, and her shoes, but there was no answer.

She was asleep in front of the media wall, a stylus still in her hand. Kobi looked at the figure rotating slowly on the screen. It was of indeterminate gender and was wearing some kind of well-fitted clothing, something tailored to sit close to the body, angular and severe. "What's this?"

Merin lifted her head and blinked at him. "Something I was working on. Does it remind you of something?"

He pursed his lips. "Yes, but I can't decide what. It sure doesn't look like anything you can get off the rack at the Garment Center." He shook the lapels of the loose, robelike jacket he was wearing, and then froze. His hand slipped into the pocket and he brought out the scrap Mica had given him.

Merin looked disappointed. "It doesn't remind you of anything?"

Kobi sat down next to her on the couch and handed her the piece of paper. "Maybe I'm too tired . . ."

Her fingers flew over the control pad. On the screen a second figure appeared, kneeling in front of the first one.

"Oh," Kobi said. "Of course." Now that he looked at it again, the outfit was very suggestive of some kind of archaic military uniform, without being too obvious. These days, ever since the Age of Equality was declared, there was no military hierarchy, and no law enforcement other than the consensus crews and the Evaluators. Uniforms were something they only saw in history class. "Very subtle."

"Not too subtle, I hope," she said. But her fingers were already entering the code from the paper. There was a pause while their home system accessed whatever data it was. Merin's mannequin figures disappeared as a new clip began, with bold letters fading into view on the media wall.

THE GREAT CRIME
The Story of the Gerrish
Part Three

"It's an educational drama," Kobi whispered. "I remember seeing this when I was a kid."

Merin shushed him. She had seen it, too. They were starting in the middle, though, skipping over the dry, historical parts about how the Gerrish were enslaved and what important figures in the government had done which thing. It began right from the segment depicting how terrible life was for a Gerrish slave.

All the Gerrish in the clip were sleeping in a ramshackle hut with no windows when an overseer of some kind came to wake them for the work day. He wore a uniform that looked a little like what Merin had sketched and Kobi pointed in excitement. The slaves who were slow to move from their sleeping pallets were slapped or prodded with a long, thin rod the overseer carried. The camera followed them as they scattered to different tasks.

Merin whispered. "There's something weird about this."

Kobi kept his eyes on the screen, where a Gerrish woman who had made an error in her weaving was being beaten. Of course, what the screen showed was the rod being lifted high, then the empty air, while a sound effect of it swishing through the air and a woman screaming in pain came from off-camera. This was, after all, meant to be watched by young people in school. "What?"

"I'll tell you after it's done."

The scene had already jumped to another example of how mistreated the Gerrish were. It was a catalog of the horrors visited upon them, with a lot of beatings and confinements for misbehavior. The clip ended before the chapter about how the gene plague that killed off the remaining Gerrish might have been prevented.

Kobi was ashiver, thinking about that rod whistling through the air.

Merin touched him on the shoulder. "The weird thing about this is, we've seen this before."

He nodded. "But?"

"But when you're a kid you don't realize things like, for example, all this film footage wasn't actual real footage. The

camera hadn't been invented yet during the Gerrish enslave-
ment. It was a dramatization made with modern actors." She
tapped the control pad. "These people played out these roles,
just like we do, only they did it as part of their job."

"I never thought of that before."

"Do you think any of them were really eager to play the
parts?"

"Are you saying you want to become a *dramat*?"

Merin sighed. "No. But it makes me wonder if maybe there
aren't plenty of Bellonians who are . . . like us, but who just find
other ways, allowable ways, to get what they want." She twisted
one of her curls around a finger. "Think about this. It was sup-
posed to be a documentary aimed at convincing kids that what
we did to the Gerrish was the most awful, horrible thing, right?
Is that why they harp on the beatings and bondage so much? Or
was somebody in charge of this production really having a good
time with it?"

Kobi rubbed his eyes. "This is too deep for me. And now I'm
all horny again, after I used up my sexual satisfaction quota at
the Velderet, already, too."

Merin poked him in the ribs. "You really would happily have
sex all day every day, wouldn't you."

"Of course! That's why I'm perfect for the job of Kylaran love
slave." Kobi was already slipping out of his clothes.

"Of course you are." Merin pushed a button on the control
pad and the time appeared on the screen. "You know, I have to
be at the legislature in four hours."

Kobi thought about the ways he could handle this. He could get
on his knees and beg like the slave he wanted to be. But then she
could always pretend to order him to wait until the morning or
something. He could try telling her how unsatisfying the trip to
the Velderet had actually been. But Merin wasn't the kind who
would fuck just because she felt sorry for him. *She's probably
horny, too,* he thought. *After seeing that drama, she probably
wants to do it, it's just she's thinking about her responsibilities.*

Merin started to get up.

"Stay where you are."

She turned away from him, toward her bedroom. "I have to get up in the morning."

"No, you don't," he said, trying to put a bark into his voice like the overseer in the drama. "Your only responsibility is to serve me." He held her fast by the arm and pulled her back toward him.

She struggled just a little, like the woman trying to escape her punishment had done.

"You are a slave," he said as he forced her to her knees. "What you want is of no concern to me. I am the overseer and my word is law."

"Yes, sir," she said in a throaty whisper as he laid her down onto the floor and spread her legs with his own.

He watched in a moment's fascination as some milky fluid began to drip from her cunt. He lowered his pelvis until the hot tip of his penis felt the wetness. He rocked it back and forth until he was sliding up against her, coating his cock with her juices and making her moan and writhe. She thrust her hips at him and he slid deep into her. Her own fingers went to her clit as he pumped in and out of her, and when she began to come, he held himself back, pulling out of her so he could wait. But she wrapped her legs around him and pulled him back in, slamming up against him and making him come, too.

He looked at the screen, which was still blinking the time. "See, that didn't take very long at all."

Merin went to work rather sleepy, but she hurried through some of the paperwork so she could do some more digging in the legislative database. Part of the whole basis of the Age of Equality was the fact that there were no penalties for breaking the Anti-inequality laws. Someone exhibiting dominant behavior was supposed to be counseled first, reconditioned second, and hospitalized as a last resort only. The last case of hospitalization Merin could find in the public record was before she had even been born: a government official.

The incident had been the final straw for the legislature, which had been in civic rotation ever since. Citizens chosen

at random served three years at a time in the Legislative Conclave to prevent anyone from becoming too accustomed to the position. Final legislative changes were always passed by public vote, anyway. Out of the entire population, there were four or five cases per year sent for reconditioning, always people who had exhibited dominant tendencies. After two hours of searching, she could find no cases where someone exhibiting submissive or subservient tendencies had been counseled or retrained. "We All Serve Each Other," she murmured to herself, quoting an Age of Equality motto.

That night Kobi filled her in on how his session at the Velderet had gone, how he'd filled out the profile questionnaire hoping to match up with someone who shared his proclivity. "I was afraid to say anything too obvious," he said, "because I was afraid the guy would freak out. So I just lay there, hoping he'd be kind of demanding. And he kept saying things like—'Oh, oh, are you okay? Oh, I'm sorry.' "

Merin laughed. "Well, no one said finding others through cybersex would work on the first try." They were sitting on the couch again, and Merin had put up a landscape on the media wall for atmosphere, a gray-and-blue mountain range with white clouds slowly forming at the top. She wished they had one of the full wall-size screens—the standard issue system they had didn't extend to the corners and ruined the effect that they were actually looking out over the hills. "Maybe it's just luck."

Kobi tucked his feet under him on the couch. "What are you going to do? It's your turn next."

Merin tapped her fingers against her chin. "I guess I'll try the same way you did, and maybe I'll have better luck," she said. "Maybe tweak the settings slightly differently. Ultimately it's not the computer profile that will do it, it is finding the right person on the other side."

"So when are you going to try it? Will you choose a night that I'm working?"

She smiled at him. "I was thinking at the end of this legislative session. It'll be four more days on, then I get three days off."

Kobi could hardly contain his anticipation. "And what are you going to do until then?"

Merin squeezed his hand. "I'll have to be satisfied with you until then."

On the designated night, Merin closed up the files in her office, said good-bye to Nazir and the other legislators in her working group, and went home an hour early so she could have a long bath. Since she'd been sleeping with Kobi, she hadn't been to the Velderet seeking sex, and this felt like a special occasion. She scented her skin even though her partner, whoever he or she might be, wouldn't be able to smell it through the cybersex connection. She brushed out her curly damp locks and they framed her face. Her hair wasn't long enough to be able to pile up like the slave in the Kylaran propaganda clip, so she hoped that the outfit she had designed based on the clip would be enough of a hint to whoever she would connect with. It hadn't worked for Kobi, but then again, the slave in the clip had been a woman, and the first one in the educational drama had been a woman, too. As she walked from the domicile to the sex house, she wondered if that would make any difference. They said that before the Age of Equality men used to dominate women more often than the other way around, and she thought about the female caitan in the clip being penetrated from behind. Was that all because of anatomical differences? The thought amazed her. They had really been like animals back then. The evening was warm and the white moon rose like a big eye in the sky, watching to see what would happen.

When she arrived at the Velderet, she went first to the lounge where Kobi was tending the bar. She stood at the top of the large oval of a room and saw Kobi down at the circular bar in its center. Around the top wall were dim alcoves, and the sloping sides of the room were dotted with soft cushions and sitting pits, the perfect place to lounge after fulfillment of quota or while hoping to meet someone. She went down the stairs to the bar and slid into a seat at Kobi's elbow. He poured her some of the sweet wine he knew she liked.

"Ready?" He put the glass on a throwaway.

"I suppose," she said, and took a sip. "Ah."

"It's too bad you didn't come in a little bit earlier. I could have introduced you to Mica."

When she looked blank, he made a motion toward the paper under her glass. She gave a little nod—the fellow who had been giving them the access codes for the clips and dramas.

"He just left," Kobi said. "Already done for the night, I think."

Merin pondered that. "I wonder how he does it?" Meets someone, she meant.

Kobi understood, but shrugged. "He doesn't seem to. He seems pretty dissatisfied with what he gets. And he doesn't usually cybersex."

Merin swirled the wine in her mouth. "Maybe if we get this to work, you can tell him about it, and we can return him the favor of the dramas."

Kobi nodded. "Good plan. Except that it hasn't worked yet."

Merin stood up. "Well, maybe it will."

Merin checked in to the cyber suite and adjusted the temperature. She preferred it warm for sex. With cybersex one could feel any temperature desired, but she liked the real feeling of damp sweat on naked skin. There wasn't anything else to do but put her clothes into the bin provided and sit down at the console. Just as Kobi had done, she entered her preferences into the system's questionnaire, trying to second-guess what someone who would be willing to play along with an inequality game would want so that the computer could unwittingly match them up. She wavered on whether to prefer a tall or short partner. Anatomical differences? Someone tall might seem appropriate, she thought, as the slave types in the dramas had always been cowering low, but growing up in Bellonian society, someone who was too tall might have been socialized to be timid to compensate for it. No Inequality in the Age of Equality. In the end she left that entry "no preference" and moved on to various sexual activities. Like Kobi she decided that being penetrated was more slavelike than being the penetrator, and she set preferences for

male partners and concentrated on various other aspects. In the hierarchy of menus she also found a sub-category that Kobi hadn't, about prior and post-coital activities. She entered that she liked to give sensual massage but not receive it. That seemed like a possible proper slave activity, to get the knots out of one's master's back. As a final step, she fed the sketch of the Kylaran slave woman into the scanner and the computer clothed her cyber figure in it.

She put on the leads and sat on the bed to wait for a connection. Now she could feel the black stretch fabric pulling tight around her breasts but leaving them open to the air or the touch of eager hands.

A naked man materialized next to her, no computer pretense of the door opening, which she thought odd. Cybersex was supposed to simulate the real thing as much as possible, but maybe he was in his suite in this position already. It didn't really matter. She looked up at him.

He was thin, with dark hair that was neither very long nor very short, and had a scraggly sort of beard that would not grow in fully. "Hello," he said as he looked at her, his eyes following the curve of the tight outfit she wore with intense interest.

She inclined her head in greeting.

He hooked a finger under the edge of the garment and met her eyes. Merin felt a thrill run through her—*he likes it*, she thought. His finger continued along the edge of the fabric until he slid it across the smoothness of her skin, that one finger tracing a path across her exposed breasts, over one nipple and then the other. She held still, but a tiny sound of pleasure came out of her throat.

"The costume suits you," he breathed, his mouth close by her ear. He was pressing her back into the bed, inch by inch, until she lay under him.

But does he know what it is? she wondered. "I designed it from something I saw . . ."

He nodded. "I've seen it, too." And he put a finger to her lips as if they mustn't say any more about it. He reared up on his knees instead and traced the edges of her nipples with both

hands. Around and around his fingers circled as Merin began to moan, then thrust her chest upward as he kept at it with the lightest of touches, never making firm contact on the nipples. Merin twisted under him a little as her skin craved a more direct touch, but he could easily pull his fingers back. He played with her that way for a long time, until she began to really thrash.

He held her by the chin to still her and make her look at him, then he shook his head. "Lie still," he whispered, "or I'll stop altogether."

Merin blinked. Had he just given her an order? Having never been ordered to do anything in her life, Merin wanted to be sure. Well, it wasn't an order, exactly, it was a choice, and she could choose to go along with it. Still, it fit with the game they were playing, didn't it? And yet it didn't feel like what they always *said* oppression would feel like . . . she lay as still as she could and the dark, thin, man lowered his tongue to her nipples. She moaned, awash in the delayed pleasure. *I did what he said and now he's rewarding me,* she thought. "Ooooh."

"I like you," he said, as he turned her until she was on all fours and his hands stroked her back and her buttocks. She had redesigned the bottom half of the costume so that her bottom was bare but some material still gripped her legs as a short skirt.

One hand slid over the bare curve of her ass and down to where the outer lips of her cunt were pressed between her legs. His fingers brushed lightly at the hot, loose flesh there.

Ah, Merin thought, *he's going to tease me again.*

He stroked her a few more times, then instructed the computer to remove the clothing from the scenario. The instant Merin was naked, he pushed her legs apart and forced her down flat on the bed, his one hand searching her cunt roughly now, pushing aside folds of labia and seeking the correct angle and position to plunge two fingers inside of her.

She gasped, the shock of the rough treatment making her go rigid. His fingers sank deep and began pumping. In her mind's eye she conjured the image of one of the Gerrish slave girls from the edu-drama. She thought of the fantasy Kobi had shared with

her, about the master who had a strange sexual affliction that required him to have continuous sex. *He's going to fuck me next whether I'm ready or not,* she told herself. Of course, she was ready, more than ready. If she hadn't been, she could always disconnect from the program, anyway.

He pulled his fingers out of her and slicked his penis with the wetness. "Good to know you're ready to take what I'm going to give," he said.

Merin didn't want it to end. She wanted to stay in the fantasy as long as possible. "I am eager to please you in any fashion that you wish," she said, hoping that he would draw this out a bit more and not go for the quick finish.

"Very good," he whispered. "But there is only one thing I require of you, now." He pressed his wet penis between her buttocks and slid it there for a few moments before letting it slip downward toward her waiting hole. Ever since his fingers had left it, she had felt empty, and wanted to be filled.

He spoke another few words to the computer and the room reoriented so that the bed platform was a bit higher off the floor. He pulled her by her thighs to the edge and stepped off. Holding her thighs, he hoisted her hips up until she was in an easily accessible position. He slipped into her.

"Ah," she whispered, as he began stroking in and out of her. With each thrust in, his flesh met hers with a slapping sound. He began to speed up, pulling her toward him faster while his hips worked, then slowing down again, leaving her thrusting herself backwards, trying to get him to go deeper.

"What would happen," he said in a soft voice, "if I stopped now? What would you do?"

Merin thought for a moment. "I'm not sure."

"Why not?"

"Because . . ." She was distracted for a moment while the stroking got faster again, but then regained her train of thought. "Because I'm not really sure what would be appropriate for this . . ."

"Role?" he offered.

"Yes—" She grunted as he began fucking her harder than

before. "I mean, what, uh . . ." Her thought was lost again as his fingers slid around her waist and sought out her clit. After the long fucking, she began to come almost instantly, her back rippling with each wave of pleasure, throwing her head back and gasping as the orgasm passed through her.

After it subsided, he continued to saw at her clit, making her twitch and thrash. Her hands pushed weakly at his, but he refused to let up the pressure.

"Don't you like it when I touch you there?" he whispered.

"Not, not after . . ."

"Have you ever tried it?"

"It hurts . . ." she said, but even as she did, she was thinking about it. It wasn't pain, exactly, just uncomfortable. She'd always told her lovers to stop and they, of course, always had. But this was a new set of rules.

His fingers were massaging her clit and her whole cunt while his cock still slid in and out of her.

"I'll stop," he said "after you come again."

She nodded. "I'll try."

"Good."

She could already feel the second orgasm building, under the strange discomfort of having her clit touched when it was so sensitive. Eventually the pleasure grew greater than any other sensation and exploded through her again.

His fingers withdrew. And still he was fucking her. "Do you think you've had enough?"

Merin thought about Kobi's partner, the guy who'd kept asking, "Are you okay?" who hadn't caught on to the little game at all. But somehow when this man asked her if she'd had enough, it didn't sound out of place. *It's a cue,* she thought, *another chance for me to play my role, whatever that is.* "I'll only be finished when you've had your pleasure," she said.

He laughed. "You're good."

"So are you."

He was still chuckling a bit as he sped up again, then forced himself deep inside with four strong thrusts and grunted. "Ah," he said with satisfaction.

He slipped out and helped her to turn over, then lay down on the bed next to her. "You . . . seem like you've done this before."

Merin smirked a little. "I was going to say the same thing about you."

"Well—" he shrugged "—here or there. I wasn't sure what to say when I saw you wearing the . . . whatever that was. From the . . ." He skirted around mentioning the propaganda clip about the Kylaran love slave. "You know."

Merin pressed on. "But do you know others who . . . play roles like this?"

He shook his head. "I don't know how to contact them. I mean, it's always by chance."

"What if we could increase the chances?"

Curiosity and caution flickered across his face as he looked at her. "How?"

"Say we always connect to cybersex on the same day, same hours. Anyone else we meet who might . . . you know . . . we encourage them to do the same."

He lay perfectly still. "I suppose it could help. And what night should we choose?"

She thought about her walk over to the Velderet, about the white moon rising. "What about every time the two moons are in juxtaposition?"

"Hmm, that'd be about every twenty-two days? It just might work."

Merin rolled over and rested her head on his chest. "Besides," she said "that way there's some chance that you and I will be paired up again."

"I'd like that very much," he said, as he stroked her hair. And he mouthed a word silently, the Kylaran word for slave: *caitan*.

► Chapter Three ▼

MERIN PLAYED THE CYBERSEX SESSION over and over in her mind. The way he had touched her, spoken to her, how he "forced" her to come, it was her best fantasies come to life. She could hardly wait to tell Kobi every lascivious detail. He had still been tending bar when she had emerged from the session, but she didn't dare tell him there in public that an anonymous man in the network had dominated her. Instead, she planned to wait up for him at the domicile after his work shift. But once she'd slipped into bed, and the images of the man kept returning, she masturbated herself into an exhausted sleep.

The next day in the legislature went by in a haze as her mind drifted from one daydream to another. She shivered and sighed thinking about his slim cock sliding in and out of her while she lay still at his command. But there were duties to be performed and she tried to concentrate on processing the petitions scrolling by on her screen. In the middle of the afternoon, a legislator from another pod came striding in, his face red from exertion.

"You might want to get ready," he panted. "Some of the Kylarans are coming over for a look."

"What do you mean?" Herra, the woman who worked at the next desk over, asked. "What for? I thought they shunned

any contact with governmental issues and just wanted to trade."

He shrugged. "I guess they changed their minds. It's only a junior ambassador and his entourage. But I think we might do well to give a good impression." When no one else spoke, he made the ritual call to consensus. "Do you agree?"

"I agree," Herra said, and Merin and some of the others chimed in. Consensus reached, they began to straighten the odds and ends on their desks and comb their hair.

When the Kylarans did come through, she almost didn't notice. She was staring at her screen, but daydreaming about last night again. They were quiet, observing everything, saying nothing. The same legislator who had made the announcement earlier was leading the party of two men and three women through the offices, talking in a quiet voice. Merin caught sight of them as they were leaving the wing, going toward the housing services department. They walked two by two, but nothing in their mannerisms revealed if they had any kind of dominance relationship to one another. There was nothing obvious, no slave shackles, no one cowered in submission. Well, of course not, she thought, probably only dominants are allowed to hold positions of authority. She took note of the fact the Kylar style of dress was more form-fitted to the body than baggy Bellonian togs. Kylarans as a whole seemed to be on the tall side, or perhaps they only seemed that way since they were all quite thin, a fact accentuated by the tightness of their clothes. She thought about the tightness of the costume she'd worn in her cybersex session, and that got her daydreaming all over again.

She told Kobi all about her session as they sat in their kitchen that evening after dinner. Watching his reaction was almost as much fun as the sex itself had been: his eyes went wide, his breathing sped up, and by the end he was moaning with desire.

"By the red moon, you must have luck on your side," Kobi said, massaging his thighs and breathing deeply.

"And so do you," she said.

"Me?"

"Yes, because you live with a kind and generous housemate like me." She walked into the living room and twitched a finger for him to follow. "Take your clothes off and lie down." Initiating these little games was getting easier.

Kobi shivered as he disrobed, not from cold but from excitement. Merin was giving him orders and he obeyed eagerly. He lay down on the thick rug in front of the couch, his cock standing up hard and ready for whatever came next.

Merin slipped off her soft baggy pants and straddled him, her pubic hair just brushing the tip of his erection. She reached down and spread her lower lips with the fingers of one hand. With her other hand, she fingered her clit. "Can you reach me?"

"I don't know . . ."

"Say 'I don't know, Mistress.' "

He convulsed a little with pleasure as he said "I don't know, Mistress. But I'd like to try."

"Impudent pup." Merin held her hand palm up and raised it a fraction of an inch. His hips rose accordingly, nestling the head of his cock between her spread fingers. She let the hand droop and he settled back down. "Very good." She raised her hand again, a bit higher, and this time he went high enough to feel her strong walls resisting him.

She played him that way, up and down, up and down, touching herself with one hand and controlling him with the other until she was conducting him like an orchestra and he sang a frenzied chorus of need. She came once, twice, watching as he held himself back. When he couldn't withstand it anymore, he remembered to ask:

"Oh, Mistress, may I come?"

She gave him one nod of her head and sank down onto him, burying him deep inside her. She could feel his cock twitch as he came. Unlike some males, who didn't take well to the mandatory sperm suppression treatments, Kobi had copious amounts of infertile come and hormones to spare.

She climbed off him. "Time for another shower."

Kobi hopped up. "I'll race you to it!"

Merin narrowed her eyes. "Is that any way to treat your Mistress?"

He froze in his tracks, thought about it for a moment. How far was she willing to push this game? He wouldn't be the one to back down. "No, ma'am."

"Come keep me company." Merin felt a little thrill as he acquiesced.

The shower stall was too small for two people, so Kobi sat on the sink while Merin stepped inside. Jets of mist began to spray from all directions as soon as she latched the door. The door came up to the height of her chin, and a small curtain kept the spray from escaping.

"So, what do you think of my plan?" she said as the soap mixture began to flow into the spray.

"Which plan?" Kobi stood next to the stall to hear her better.

"The plan to try to get anyone else we find who is interested in this kind of sex to connect to the cybersex network at the same time." She lifted her arms. "Do you think you'd be able to spread the word from the bar at the Velderet?"

"Quite possibly. But how do we tell who's interested? And what do we call it?"

Merin kept her mouth closed as the head soap sprayed down from above and she worked it through her short curls with her fingers. By the time the rinse began, she almost had an answer. "Well, one of the selections I made in the cybersex options designated the session as 'vigorous.'"

Kobi thought about that. "And Mica, when he talked to me, he called it 'rough.'"

"Well, do you think if we call it 'rough and vigorous,' those people who are interested will understand what we mean?"

"I can't think of anything else."

"Then Rough and Vigorous it is."

Kobi went to work that evening with a renewed sense of purpose. It wasn't a very busy night, but there were always customers who came into the Velderet to socialize in the lounge, not just to sample any sex, whether cyber or real world. Kobi made

a special effort to talk to everyone who sat in the soft, hanging chairs at his bar.

Toward the end of his shift, two people came and sat down, a man and a woman who sat near to one another but not together. Kobi took their orders and served up their drinks while he tried to decide which one to approach first. The woman, he thought.

It was impolite to inquire about the session a person had just had, so he tried a different line of questioning. Putting on a blasé tone, he began by asking her if she ever cybersexed or if she preferred real world interaction.

She laughed and flipped her long blond hair over her shoulder. "I like cybersex when I have my period."

"Cause it's less of a mess?"

"Yes, but also because I tend to be really horny then. Sex relieves cramps, too."

"Really? So, that's when you use your monthly quota?"

She nodded. Her smile made him forget to be nervous.

Kobi wiped down the bar in front of him even though it didn't need it. "I'm starting to cybersex more, myself, but I'm having trouble finding what I want in all the menus."

She sipped her drink. "When I have cramps I definitely want it to be a certain way. I usually just give a description in the Open Spec."

"The which?"

She smiled. "Open Specifications. When you first connect to the sex house net, it gives you a couple of choices. If you don't select any of them, you get what's called 'open specifications.' You can put anything you want in there."

Kobi clutched at his heart and feigned being wounded. "Why doesn't anyone tell me these things?"

She finished her drink. "It doesn't work very well. The questionnaire is much more likely to give you a compatible partner since it specifies a wide range of parameters and isn't looking for a hundred percent exact match. But what goes into Open Spec is in your own words, and to find you a partner that seems like a match, you'd have to be using more or less the exact words that they did."

Like "Rough and Vigorous," he thought. "Wow. But then, how do you get any use out of it?"

She was still smiling. "I keep it simple. Also, there's a review feature. The net will match you up with someone by your default options, and then let them review what your Open Spec says. If they agree, off you go."

Kobi leaned both elbows on the bar as he stared at her. "So, how do you know all this?"

She put a card onto the bar. "You could read the manual, you know. It's online." But her card had the real explanation. It listed her job title as "network technician." She shook his hand. "Nayda. Nice to meet you."

"Kobi."

She slipped out of her chair. "This is my work district now. You'll see me when your cyber suites need maintenance."

"Will that be soon?" he asked, leaning toward her slightly. She was cute, a little shorter than he was, her hair blond and a little curly, cut to just above her ear.

She gave half a shrug. "I usually go to a club in the East district when I'm off duty," she said.

"But surely the Velderet has much to offer?"

Nayda gave him half a wink, but she bit her lip nervously. "Perhaps it does." And then she went up the tiers of pillowed reclining space and was gone.

"Hey," said the guy at the other end of the bar. "I thought sex house employees weren't supposed to socialize with customers."

"Only if we take advantage of them," Kobi replied automatically. It looked like the fellow's glass had been empty for some time.

"Well, now that you're done with your social hour, could I please have some more of this?" It was not an order, the man was too well-socialized to make it sound like a demand, and yet Kobi could hear his annoyance just the same.

Kobi snapped his full attention to the man. The guy'd been drinking the new concoction called Fire. "I'm sorry." As he poured a fresh glass of the spicy liquor for the man, he thought about power. *I'm serving him this drink,* he thought, *making me*

*the one on the low end, but then again, he has to wait for me
and ask me for things, making me the higher one. So which one
of us in in control? Maybe it's all in the way you look at it.*

He brought the drink over and set it on the bar with care.
"So," he said as he took the empty glass away, "when you con-
nect, do you prefer cybersex or real world . . . ?"

By the end of the week, Kobi had told a few dozen people
about Rough and Vigorous night. If someone thought he was
promoting some kind of crime involving dominance, he would
likely lose his job and have to endure counseling, maybe even
reconditioning, so he had to couch his language. Even with his
ambiguous wording though, he felt sure that some of them had
known exactly what he was talking about. *Merin's right*, he
thought, *we're not the only ones.* There was only one problem
with the night as scheduled, which was that he had to work.

"It's going to be weeks before my schedule rotates," he com-
plained to Merin one evening while they were watching the
news. "You get all the fun."

She placed a hand on his cheek and said, "I'll make it up to
you. Now, hush." She wanted to pay attention to the story cur-
rently showing on the media wall, about the new proposals to-
ward trade and government to come from the Kylaran embassy.
An angry Bellonian spoke to the reporter.

"Can't you see?" he said, waving a hand in the air danger-
ously close to the reporter's face. "They don't want to cooper-
ate with us, they want to *dominate* us."

The reporter looked shocked at the man's strong language.
"But everything the legislature has negotiated has been to our
mutual benefit—"

"A lie! The Kylar revere strength! Enslavement is their way of
life! They'll make slaves of us all or—" The rant was cut off.
Apparently some people out there were believing the propa-
ganda.

The focus changed to a third reporter sitting alone. "We
believe that many of the reports of Kylaran lifestyles are highly
exaggerated and most are nothing more than rumors. The

legislature is seeking to substantiate any claims, but urges the Bellonian populace not to jump to conclusions about our new partners in trade."

The next story was about expanding agricultural development in the northwest. Merin muted the sound and turned back to Kobi. "Now what were you saying?"

He had to think back. "Ah, I think you were promising to make it up to me . . ."

Merin smiled. "You're right. I have a surprise for you."

"What?"

"Stay here." Merin slid off the couch and went into her bedroom. The uniform patterns she had been playing with in her spare time made for some interesting designs. She donned one she'd had constituted to her own size. It looked partly like the taskmaster's uniform from the Gerrish educational drama and partly like the skin-tight clothes of the Kylar.

"Should I close my eyes?" Kobi called from the other room. "What's taking so long?"

"Just another minute," she called. The outfit was not easy to put on, not like the loose, flowing clothes she was used to. She had to tug at it and adjust it to look right in the mirror. She put her hands on her hips and tried to put a stern look on her face. What was missing? In her mind's eye she pictured the guard in the edu-drama. They always carried a baton of some kind. She looked around the bedroom. What could she use for such an accessory? She didn't have a walking cane or measuring stick . . . her eyes lit upon the window. There was a long, thin handle used to open the top sash during the hot season. She climbed onto the bed to see if it would come loose. It unclasped easily and she swished it in the air. The sash opener was about as long as her arm and as thick as her little finger. The smooth synthetic material felt cool in her fingers as she flexed it in front of the mirror.

She found Kobi naked and on his knees by the couch waiting for her, his eyes on the floor. He was already peeking, but she put the tip of the stick under his chin and raised his face toward her.

"Wow! You look—!" he began, but then remembered his role and closed his mouth. His eyes darted back and forth between the stick and Merin's sexy figure while he tried to guess how she would react to his outburst.

She gave him the stern look she'd practiced. "Apologize!"

"I'm sorry, Mistress! I forgot!" *Hey, I almost sound sincere,* thought Kobi.

"Very well. You'll have to make it up somehow. Come over here." Merin seated herself on the couch and opened the seal of the tight crotch in the stretch-fabric outfit.

He walked on his knees to position himself between her legs. "Shall I lick you, Mistress?"

"No. You did that last time. Use your hands. You don't deserve to have your tongue touch me, you lowly—" Merin was at a loss for what to call him "—leaf."

"Leaf?" He looked at her, puzzled.

"Leaf, you know, it falls on the ground? To be trod upon?"

"Leaf?" he asked again, starting to giggle.

"Get serious!" Merin raised her voice and brought the stick down on the couch. They both jumped at the loudness of the sound it made, like wood cracking. Sobered, he clapped his mouth closed and she stared at the rod in her hand. A powerful prop, indeed.

She began to direct him what to do, how to use the tips of his fingers to coax her labia open, to use his thumbs to tug gently on her vaginal opening to encourage her natural lubrication to flow, to coat his fingers in it and stroke her clitoris with light upward touches. After a time she directed him to begin probing into her with one finger while he continued to touch her clit. He discovered that if he turned his hand palm up and hooked the finger inside her toward him he could make her clit throb.

Under her instruction, he flicked her clit with his fingernail in rhythm with the throbbing until she began to moan. Her head rolled back and she seemed to lose herself in the sensation.

Kobi inhaled the scent of her and the juices coating his fingers. He wanted nothing more than to coat his cock with them,

too, and plunge into her. But the stick was still in her hand and she was still giving the orders. "Mistress?"

She looked up at him and touched his ribs with the stick, prodding him closer to her. He rocked up on his knees and she slid the stick between his legs. The pressure on his balls brought his crotch close to hers. "Come inside," she said.

Kobi sank up to his balls in her and sighed in relief. As he pumped into her, though, he felt the stick sliding along his back, his ass, and he shivered. The sound it had made against the couch still rang in his memory and he worried that Merin might overdo it. If he got hurt, how would they explain it to the doctors? Merin could get into a lot of trouble if they suspected she had inflicted a wound on him.

But somehow even the worry that she might hurt him made him even hotter. His breath became ragged and he found himself on the brink of orgasm. *Oh no, not again,* he thought. *There must be a way to stop it! Stop!*

But sheer willpower was not enough the stop him from coming. He tried to pretend he wasn't coming—if Merin was hot enough or wet enough she might not feel his seedless semen jetting into her—but when he went flaccid a few moments later there was no hiding it. He slipped out, shrunken and empty.

Merin looked him in the eye. "I wasn't done with that yet."

"I know. I'm sorry! I couldn't stop it."

Merin considered. "Then you had better put your fingers in where it was, and you better do it well."

He slid his fingers in the way they had been before, and slicked them in and out of her while tweaking her clit.

"I suppose you'll have to be punished for it, too," Merin continued, once he settled in to a rhythm. *I wonder if this could actually work?* she wondered. It was certainly annoying when Kobi came too soon, even if they weren't having rough and vigorous sex. Could it be possible to actually train him to last longer? Merin considered the stick in her hand. The taskmasters must have had a reason they treated the Gerrish the way they did. Could people be trained into better behavior?

Kobi said nothing, but kept his eyes on the stick. He realized

that he had been waiting for her to use it ever since he first saw it in her hand. He shuddered and gave a little whimper, thinking again about the loud whack she had given the couch earlier.

Merin twirled the stick slowly as she thought about the possibility of hurting him accidentally. *Obviously I can't hit him on the head,* she thought. *Or anywhere bony that could break or bruise. And not near the vital organs in the stomach.* That left the meaty parts of his thighs and his buttocks. She thought back to the Kylaran Desire propaganda they had seen. The woman slave the footage had depicted had been whipped on her back, her buttocks, and thighs. Perhaps there was some logic in all these things. Merin reached out with the stick and tapped Kobi on the ass.

He stiffened and she cleared her throat, urging him to keep his hands busy in her cunt. She curved her spine to one side; she could see and reach his buttock on that side easily.

She gave him another tap. This time, since he was expecting it, he did not move. It didn't seem to hurt him, either. *If this is going to be part of training him,* she thought, *it ought to hurt a little, at least.* She tapped again, trying to make the blow harder, but she couldn't really bring herself to swing it. Instead, she began tapping again and again in the same spot, faster and faster. After a few moments his skin went pink, then red, and his face flushed as well.

Kobi craned his own neck back to look. "Ow, that's starting to hurt."

"I better do the other side, too," Merin said, and shifted her position. "Keep working."

She tapped rapidly on his other cheek until it had a matching mark. There was something vaguely unsatisfying about that method. It was like taking tiny nibbles of a treat when she wanted to swallow it whole. She put down the stick then and pulled him up onto her. His hands came free of her and she grabbed his buttocks, ground her crotch into one of his legs, and began to swat him with her open hands.

Kobi yelped as the first double smack landed square on his

ass. Now those little red spots hurt much more. Each time she smacked him, she forced his leg to rub her crotch.

Kobi had done a good job with his hands and she was close to coming. After a while her hands began to smart from smacking him, and she switched to holding him by the butt and grinding him up and down until at last, she came.

When she recovered her senses, she let Kobi roll off her. "Look at your ass!" The redness was already fading. Nothing visible would remain in evidence and she told him so.

Kobi rushed to the mirror to see what was left of the redness. "Wow, that really smarts!" he said, rubbing his hands over the sensitive skin. "That was incredible!"

Merin joined him at the mirror and ran her hand over his ass, too. "Do you mean you liked it?"

Kobi thought for a second. "Well, it was hard to like while it was going on, but now, it feels great."

"Well, maybe," she said, giving him one last playful swat, "next time you'll have to keep from coming in order to get it."

"Yes, Mistress," he said, his eyes still on his reflection's red skin.

For several days Kobi found himself preoccupied with the dilemma of how to keep from coming too soon. He had a few more failed attempts both with Merin and by himself, while masturbating and trying to keep himself under control. *Either my willpower is too weak,* he thought, *or willpower isn't enough.* It wasn't as if he could go to a doctor or a counselor and explain his problem to them.

One night Nayda came into the bar near the end of his shift. *She's smart,* he thought. *Maybe she'll have a suggestion.* Besides, he had been hoping to have a conversation with her of a personal nature.

"Hi, Kobi!" she said. "Could I have lemon water, please?"

"Sure! Did something break?" He prepared her a chilled glass.

"Pardon?"

"You said you'd be back if something broke in the system."

She smiled. "I did, didn't I? Well, nothing's broken. I was just in the neighborhood and thought I'd say hello to you."

He supressed the urge to say "Really!" He put her drink onto a throwaway in front of her with a flourish. "I was just thinking about you."

"Oh? Why?"

"I want to ask your advice about something." *Okay, Kobi,* he thought to himself, *how are you going to say this?* He wanted to ask her if there was a way he could use the cybersex system to give himself more stamina. But there were two things he did not want her to think. One, that he didn't have much stamina, and two, that he was only telling her this to give her a hint that he already had a girlfriend. "There's this guy who comes in here a lot and you know how bartenders always hear everyone's troubles . . . he asked me my advice about something and I had no idea what to tell him. In fact, I get a lot of guys asking me the exact same thing and I don't know what to say to any of them."

"Well, what's the problem?" Nayda took a sip of her drink without taking her eyes off of Kobi.

"They all tell me that their partners wish they would . . . um . . . last longer." Kobi hoped he wasn't blushing. He tried to look nonchalant by rearranging the clean glasses behind the bar.

"Oh." Nayda seemed to think about it for a bit. "And you think there's something in the software that can help?"

"Well, I was hoping there would be, and you seem like the person to ask."

Nayda brushed her hair back from her round face. "There are all kinds of diagnostic programs in cybersex, you know. You can measure the intensity of your sexual response, length of your orgasms, heart rate, blood flow, all kinds of stuff. I'm sure if someone wanted to goof around with different stimulation patterns, they could find out how they could last the longest." She named off a couple of subdirectories where he could search to find the right programs.

"Could you write that down? I mean, so I won't forget by the time I see these guys again."

"Sure." She wrote the names down on a dry throwaway. "The

best one, which is the least tiring diagnostic, is one called Second Self that creates a cyber double of you, mapped to all your responses and stimulus points. You can try things out on it to see how you would respond yourself. If you keep using the same Self, it will grow and change its conditioning just like you would so you can see if that would achieve the desired effect."

"Wow, that's amazing."

"Not really, just a little pseudo-intelligence and good psycho-scanning." She shrugged. "It's mostly used by doctors trying to cure impotence, though. Not, um, overeagerness."

Kobi smiled. "It may be just the thing."

After that she stayed until the close of the shift, and Kobi wondered if he should invite her out for something to eat, or if they should go to another sex house where he wouldn't be an employee. But then she excused herself and said she had an early call somewhere else and couldn't stay up. She left, Kobi handed off the bar to the late-shift tender, and excused himself to one of the cyber suites.

He put on the leads and called up Second Self. The computer instructed him to do several things: yawn, breathe, touch himself briefly, clench his teeth. To get a baseline response it induced an orgasm in him by stimulating the correct centers of the brain. Kobi watched in amazement as his cock stood up like a divining rod and began to pulse of its own accord.

He spent a few hours twiddling with the Second Self settings until he felt he had established a complete mapping of his sexual responses. Kobi2 now walked, talked, and presumably fucked, just like Kobi. In the cybersex "room," Kobi decided maybe he should take his double for a test run. He certainly wasn't sleepy.

He settled himself onto the bed the way Merin had leaned back on the couch last night, and ordered his double to come and suck him off. Kobi2 nibbled at the head, then thrust his wet tongue along the underside of Kobi's shaft and Kobi gasped. It was perfect. So perfect that he couldn't take it for very long. He remembered what Merin had said to him. He put on a gruff

voice. "That's enough. You don't deserve to have my cock in your mouth. Use your hands."

Kobi2 pouted a little and then licked his hand. His slick fingers tugged at the still-wet penis and Kobi shivered as the knuckle of his double's index finger slipped past the cleft of his cock. It was like touching himself, only better, more exciting; somehow not being able to feel the hand itself heightened the sensation. But Kobi couldn't take very much of that either.

"Come inside," he said, and Kobi2 complied, slicking his own cock to full hardness and then slipping into Kobi's ass.

"You must try not to come until I say you can," Kobi said earnestly. His double nodded and pumped in a steady rhthym.

Kobi slid his hands over his double's ass and gave an experimental smack.

"Yow! That smarts!" said Kobi2.

Kobi grinned and smacked again, the impact of his hand thrusting the cock inside of him even deeper. Being in charge was kind of fun. "Say, 'That smarts, Master.'"

"That smarts, Master!" Kobi2 complied.

Kobi was having so much fun landing handprints on his double's ass that he almost didn't notice how red in the face Kobi2 was getting, how his arms were beginning to shake and his breathing was turning choppy.

"Master . . ." Kobi2 began.

"Don't come yet!" Kobi said. "Not until I come."

But even as he said it, he felt the explosion building in his groin. Kobi2 was fucking him deeply and there seemed to be no way to hold out any longer. Kobi let out an inarticulate cry as his cock spewed onto his stomach and Kobi2 let loose into his gut. In reality, of course, Kobi2 was only a piece of software who couldn't make an actual mess. He saved the encounter as a part of Kobi2's conditioning and disconnected from the net. *That was fun,* Kobi thought, *even though it may not have done anything to increase my stamina.* There was real come on his stomach and he set about cleaning it up before heading home in the early morning sunrise.

▶ Chapter Four ▼

MERIN BRUSHED HER HAIR in the bathroom mirror, drawing out her slight curls with each stroke and trying not to think too much about tonight. But even in this simple act of brushing her hair, she felt she was preparing herself for Him, the mystery man who had met her through cybersex and who might, just might, connect with her again tonight. Thinking of him brought a rush through her system and she sighed. It had been three weeks since that first rendezvous and the memories of it were still vivid in her mind: how he'd played the forbidden role of dominant with words and gestures, coaxing her to lie still as if bound in place, and controlling her pleasure seemingly for his own satisfaction. *Let him be there tonight,* she thought, *please.*

She ran the brush through one last time before gathering the hair together into a hair loop on the top of her head. She had watched the weird propaganda clip again that evening and was once again left wondering whether its depiction of the Kylaran way of life, with its institutionalized slavery and punishment, was accurate or merely hearsay. She'd wanted to see if there were any hints in it for how she should behave with Him, since he'd hinted that he had seen it, too, and he'd even used the

43

Kylaran word for slave: caitan. She already had the tight-fitting, breast-baring outfit of a caitan programmed in for her cyber self, but not the hair-do. She frowned into the mirror. Her hair wasn't long enough to stay up in the top knot and pieces of it curled their way out of the loop to dangle around her face. *Well, I can let it grow,* she thought. *It'll never be as long as Kobi's, but so what.*

Kobi was already at the Velderet working his bar shift that night. He was still jealous that Merin could connect up on "Rough and Vigorous" night while he had to work, but Merin was doing her best to make it up to him. The two of them had played at roles several times the past few weeks. Merin was getting better at wielding the rod, which hung over her bed during the day in its original function of window-sash opener, but she couldn't quite bring herself to really hit him hard with it. Kobi, meanwhile, when he took on the dominant role, wouldn't hit her at all, not even with the flat of his hand, and had trouble keeping serious about it. Which was all the more reason why Merin hoped that Mr. Dark and Mysterious would connect with her again tonight.

She arrived at the club to find all seats at the bar taken and Kobi working up a sweat trying to keep up with all the orders. She waved to him and went directly to a cyber suite. This time she connected smoothly and easily, using the same preference profile as last time, hoping that the cybersex system would connect her with Him as it had once before. She settled onto the couch and touched the electrodes to her head.

The sensory input of her cyber self replaced her real vision and sensation. Now she could feel the sensuous fabric of the caitan's outfit against her skin, and see it if she looked down at herself. She ran her hand down the satiny covering over her stomach and shivered. She resisted the urge to let her hand keep traveling down, into the curls of her pubis, to the nub of flesh that was beginning to throb as she thought about how he'd touched her, his voice gently insisting . . . *Don't you dare touch yourself,* she imagined him saying. *Not without my permission.*

She composed herself on her knees on the bed. If someone

else connected in, it would not look incriminating, she decided. It would not look that different from some of the meditative postures some people used to relax. It wasn't as if she were groveling on the floor, after all.

But still there was no chime, no connection. There must be others connected tonight, she thought, others who were interested in this kind of thing. Kobi said he'd dropped the hint about "Rough and Vigorous" night to a few people each day. He said Mica had met a few more, too. It was difficult to say how many since they had to be very vague—any obvious outward sign that they were practicing dominance role-playing would get them sent for counseling. But still, if there were others connected tonight for R&V, maybe her dream partner was already hooked up with someone else?

The thought made her burn, her skin hot and flushed. *Don't think that way,* she told herself. What would a slave, a caitan, think? A slave couldn't presume to dictate when her master does anything, right? He could keep dozens of slaves, and choose to ignore some. Merin shifted her position to put her knees further apart. Another good thing about cybersex: her cyber self would never suffer from a foot going to sleep or a cramp. She could not decide whether or not to be upset that he didn't meet her. Regardless of what caitan-type protocol she could dream up to justify it, there was still the fact that they'd agreed to meet again, hadn't they? What kind of obligations did two anonymous strangers have to one another, anyway? Maybe none. *Maybe I should just not . . .*

The chime sounded and a tall, dark figure stepped into the room. She met his eyes for one moment and then dropped her head. It was Him. His face was hidden by a dark flowing robe and hood, but she had no doubt who it was. He ordered the computer to erase the clothing and she knew him by his voice, too.

He spoke a few more words of command to the computer and the bed platform reshaped itself to be a low, firm pad. With her head bowed, she could only see his feet when he approached. He took a step closer and she could feel the heat of

him on her forehead. With one finger he tipped her chin up and her lips brushed the head of his erect cock. He edged his hips forward slightly and her lips parted to admit the smooth head.

"I've missed you," he said, looking down at her.

Merin sucked at his cock and smiled around it. She couldn't answer with words, so she tried to show how happy she was to see him by sucking more enthusiastically, her tongue and lips working together to draw him in as deep as possible. She wanted to ask him questions, too, about whether he had met anyone else in "R&V," if he'd seen any new propaganda or media clips, so many things. But there would probably be time to chat later and now that he had made it clear what he wanted, she would have to break role to do anything other than suck him.

She continued working him in her mouth for a long time, long enough that she thought of another question to ask him, perhaps: how did he get that kind of stamina? Could he teach it to Kobi? He remained quiet and mostly still, allowing her to devour him at her own pace, her head and neck working forward and back as she did her best to please him. In the back of her mind she thought about that. He didn't "order her" to do anything, he didn't say "do this" or threaten her, and yet there was no doubt in her mind that he wanted her to do this and she was doing so because she wanted to do what he wanted. From the outside, she thought, it might not even look like domination.

And then he said "Enough," and raised her head still further until she was looking him in the eye. "Very good. Have you missed me?"

"Oh, yes . . ." She trailed off, unsure what to call him. They had not exchanged names, and he hadn't insisted on a forbidden title like "master." She gave a little bob of her head in place of saying anything else.

He smiled and nodded in acknowledgment. "I feel the absence, too," he said, and she was sure he meant the absence of a title or name, even though he went on to say, "Three weeks is a long time."

"I . . . hoped I might see you sooner," she ventured.

"Work first, my dear," he said with a rueful smirk. "Besides, the allowance is for only once a month, no?"

"True," she said. "But we've been spreading the word about R&V for tonight."

He cocked his head. "Arrinvee?"

" 'Rough And Vigorous' I mean . . ."

"Ah, now I see. As we'd talked about last time. You hadn't given it that designation yet."

Merin explained how she and Kobi came up with "R&V" and what Kobi told her about entering those as code words into the Open Specifications in the system.

"Wonderful! You must tell me more. But in a moment. We're not quite finished here, you know," he said, his expression turning stern. Merin felt suddenly as if she'd been talking too much to suit the role and bowed her head again. "You may have to work a bit harder to please me."

She nodded.

He lay down on the pad. "Do you remember how I made you come?"

"Oh, yes."

His smile was neither warm nor cold. "Tonight you have a different challenge. Tonight you must make me come, without coming yourself in the process."

Merin nodded her head, thinking that this could be interesting. *Exactly the opposite of what I get with Kobi . . .* who was no challenge to get off, and also the opposite of her last encounter with this man, when she had been told not to move.

He stretched himself out with a sigh and she pressed her hands against his chest, kneading the taut muscles there. Her hands walked down his torso to his crotch and stroked his testicles until he was fully hard again. She took him in her mouth, plunging him deep into her throat. But as it was before, he seemed to be able to hold up to that activity forever. She decided there was no point in waiting and straddled him, nestling the head of his cock in her pubic hair. He stayed relaxed as she lowered herself onto him, smiling as he watched her shudder with pleasure at the deep penetration.

Merin rode him slowly at first, rocking forward and then set-
tling all the way back down. Gradually she increased the tempo
and shortened the stroke. He sighed but kept his eyes on her.
He's examining me, testing me, she thought, and clenched him
tightly with her inner walls. He made a little sound at that and
she took to rhythmically squeezing near the end of each stroke.

She was pleased to see sweat break out on his forehead and
she continued to work. She placed her hands on his shoulders
to give her more leverage to thrust and felt how rigidly he lay.
He was getting close, she was sure of that.

But a few minutes later, he was plateaued. She let herself sink
down again, to see if changing tactics would arouse him more.
But it was arousing her more, she found; she wanted it deep and
hard and she knew the kind of rippling bottom-of-the-belly or-
gasm she could have if she kept up this way. *But he told me not
to come,* she reminded herself. *And I can't just give up.*

She could use her hands, but that always felt clumsy to her,
like it might irritate him more than arouse him. She thought
about how he'd gotten closer and closer every time she tight-
ened her vaginal muscles. *If he needs it tight . . .* she felt the
blush of heat all over her as she thought about the one orifice
she hadn't used yet. She'd had lovers who teased her anus with
their fingers or their tongues or their cocks, but she'd never let
them fuck her there. She bobbed up and down as she consid-
ered it. There was something more violable there, somehow.
When she had filled out the preferences file she had indicated
she was willing to be penetrated anally, but she had imagined
if He was going to do so, he would have pretended to force her
to take him. Somehow that would have been easier. His cock
was slick with her own juices and her anus twitched in antici-
pation. She paused.

He was watching her carefully, as if he could see her think.
He raised one eyebrow slightly at the interruption.

She lifted herself free of his cock then, and with one hand
guiding it, settled it against her ass. Her own breathing came out
shaky and rough. She could not quite bring herself to sit back
the rest of the way. The head of his cock felt huge against the

tiny hole; there was no way it would fit. And yet she knew Kobi liked cock up his ass, and he had no problems with it. *Cock felt huge in your cunt the first time,* too, she told herself. She tried to lean back, but again it felt like some gigantic thing pressing against her, unable to enter the given opening.

She was afraid to look into his probing eyes. *I can do this,* she thought, *I just have to try.* She reached her other hand back and slipped the tip of one saliva-wetted finger into her anus. She gasped, surprised at the pleasure in it. She moved the head of his cock into place again.

It probably won't even hurt, she thought. *This is cybersex, after all, where lubes don't really matter, do they?*

In the next moment she sat down hard and cried out as the head pushed through her sphincter. It did hurt, and she began to tremble, unable to push down the rest of the way, but not wanting to pull herself free, either. She held that position for a few moments, shaking and trying to steel herself for more.

She felt his hand on her hair. "Good, good," he was saying. "Remember that it pleases me when you feel pleasure, and it pleases me when you feel pain." His cock twitched inside her and she forced herself to relax. "Don't be afraid of the pain," he said.

Another inch. Now she could feel herself opening up for him, bit by bit. Finally she sat all the way down, feeling like he was filling her more than he ever had before. She made a tentative move forward and found the pain lessened with the motion of fucking. It wasn't as slick or easy as it was with her cunt, but it got easier as it went along. And, she noted with some satisfaction, now he was gritting his teeth. Her insides were being rearranged, and the pain was dull now, not sharp, but it might be worth it if he came before she did. *It's not very likely that I'll come from this anyway,* she thought.

But then his hands left their resting place on the bed and found their way to her crotch. His fingers played across her clit and one middle finger worked its way between her lips and slipped inside of her as she bobbed up and down. Waves of liquid pleasure replaced the pain as each penetration doubled the sensation of the other. She gritted her teeth, too.

Now it was a race, as she tried to force herself down on him faster and faster without triggering her own orgasm. His face was twisted in a grin as he held himself back.

"Are you ready to come?" he asked her.

"Just . . . about . . ." she replied.

"Well, then." With his free hand he pulled her down close to him. "Hold still, then, and come."

With his cock and his fingers deep inside her and her clit pressed against his wrist, she did. She did not quite hold still, as she jerked and spasmed, but he held her against him and stroked her skin when she was done.

After a few moments, he rolled her gently to the side and pulled free of her. She looked down at his still-hard cock and dropped her head. "I'm sorry."

He laughed. "You have no reason to be. I've played a little trick on you, I think."

"What do you mean?"

"I don't ejaculate unless I want to. I've come several times, though."

"You mean . . ."

"Yes, you did as I asked." He shushed her with a finger to her lips. "And you did very well." He nestled her in close to his arm and they cuddled that way.

Funny, she thought, *there's never any cuddling in those edu-dramas or propaganda clips.* And yet something about the way he held her made her feel as if the playing at dominance had not ended, as if this, too, were a part of it. She felt protected, cherished, and rewarded for her service.

"I take it that was your first time?" he asked.

"For anal sex? Yes."

"Was it only the pain that worried you?"

"I guess so. The newness of it, too."

"Pain isn't something to fear in and of itself. Why something hurts, or why someone would hurt you, that should be the fear, not the sensation itself." He held her tighter. "Don't you think?"

"I'm not as afraid of feeling the pain as I am of inflicting it," she said then, thinking about how she couldn't really bring

herself to whack Kobi with the window-sash opener. "That's harder."

His eyebrows went up in surprise, almost coyly, she thought. He asked, "Then you've played the other side, too?"

"With my . . ." She stopped herself, remembering her anonymity and Kobi's. "Yes, once in a while. But somehow I can't . . . I'm afraid my partner will really get hurt, I guess, and it'd be reported."

He fixed his eyes on her. "But in cybersex, there's no physical damage," he said slowly, his words implying that he knew she had slipped up in revealing she did this in the real world, but that he was pretending to ignore it.

"Oh, yes, of course, that's right," she said, too quickly. "But I still have trouble."

He pursed his lips. "Hmm. Do you think you'd be more comfortable inflicting it on . . . your partner if you knew what it felt like?"

"My partner can't quite do it either."

He sat up and ran his hand down the valley of her breasts. "What about me?" One hand drifted to her nipple and he squeezed it between his forefinger and thumb. She gasped at the pain, which seemed to travel right to her crotch as pleasure. "I am not averse to . . . a little experimentation."

Merin clutched at him. "I think . . . I think I need to rest." She felt shaky and light-headed after the ass-fucking and wasn't sure how much more she could take. "But what I really want to feel is a kind of stick." She described the sash-opener to him. "And cybersex doesn't allow for any such prop in the program."

"Then you need to find someone in the real world who is willing to . . ." He nodded slowly. "A difficult trick."

"Yes." She wondered what he was implying.

He sat up all the way and scratched his chin. "You don't have to tell me where you are, but if I knew, I might be able to introduce you to someone. A woman I've been in contact with. She's also been . . . experimenting."

A woman, how nice! Merin thought. It had been a while since she had slept with a woman. She tended to think of women as

good for serious, committed relationships, and since she'd been in the legislature, she hadn't had time for anyone full time. Except Kobi, but he had come more out of convenience as a housemate than as an expected partner. "Experimenting?" she echoed.

"Likes to reenact those Gerrish edu-dramas," he said, and Merin could already picture the rod whistling through the air as it did in the taskmaster's hands in all the media files. "Depending on if you are geographically close."

"I'm in Marianna," she said, before she could hesitate.

"The capital? Perfect. So is she." And he gave her the net ID of the woman in question and made her repeat it back to him. "Now I'm afraid I must go," he said.

She nodded her head.

"You made me proud of you," he told her. "I'd like to go further next time."

She nodded again.

"But there's no guarantee we'll be matched every time. So until the next time we do meet, there is one thing you can do when you cybersex."

"What is that?" she asked.

"Say nothing, pretend you cannot speak, and keep your eyes closed. If your cyber partner is male, allow him to do whatever he likes to you and imagine that it is me. If he speaks to you, imagine that I sent him there, that I am lending you to him. Don't open your eyes unless I tell you to, and then you'll know it is me by my voice."

She nodded one final time and said, "I understand." It was, she realized, the perfect way to keep the game going, even if they weren't together.

"Very good." He caressed her cheek again. "But I'll expect you, now, to be connecting on these 'R&V' nights, so if I do want you, you'll be there for me." Then he winked out.

Merin opened her eyes on the cyber suite in the Velderet and stretched herself out. *Wait a moment,* she thought, *that last bit was an order, wasn't it?* Was that just a way of saying he'd like to see her again, but staying within role? Did he really expect her to connect and look for him every time? What would he do

if she didn't? Well, there was no way he could be sure, anyway, she realized. If she was matched with someone else, he might miss her entirely, and he couldn't look her up since he didn't know her ID.

She repeated the net ID of the woman he'd given her to herself. She'd send a note tomorrow, something leading without being too obvious—she'd have to be careful. Every new person who became involved increased the risk of reporting it, she realized. *Someone will eventually take it upon themselves to recondition us all if we're not very careful.*

Kobi set the glass down in front of a customer and hoped no one else needed anything. It had been a hectic night at the Velderet, people coming and going and everyone needing a drink, a refresher, something for their friends up at the back table. He wished he could take Kobi2, his cybersex double, out of the computer system and put him to work in the real world. He wished Nayda would stop by to say hello so he could thank her for introducing him to the software that made it possible. He wished Merin would come out of her cyber suite and tell him something wonderful. A man on the other side of the bar signaled to him and he went to fill the order.

Then he got his third wish. Merin came down through the pillowed embankments to slip into a chair at the bar.

"Did you . . . ?" he asked, eyeing the people seated around her.

"Yes," she said. "If you give me something sweet to drink, I'll tell you about it when I'm done."

Kobi poured her a frothing Winter Fruit Liqueur and then went to collect the empty glasses from where two patrons had left. Things were finally slowing down. He glanced at the time and was amazed to see how close to the end of his shift it was, less than an hour to go. Merin had been in there a long time. He fidgeted with napkins and stirrers, one eye on the clock, one eye on how much froth was left in Merin's glass. He knew better than to ask her for details in front of people, of course; she'd tell him once they got home where it was safe.

"Where's your friend?" she asked after the man next to her said his goodnight and left.

"Who?"

"Mica. I still haven't met him."

Kobi looked around. "I haven't seen him tonight. His schedule's erratic and he's almost never here this late. Must have an early morning kind of job."

"Like me," she said with a yawn. "When do you finish up here?"

"As soon as Zill gets here," Kobi said, glancing at the time again. "She usually comes in around now."

As it turned out, Zill was late, and Kobi had to wait an additional fifteen minutes before he could leave, then there was the ten-minute walk back to their apartment, during which Merin kept getting that faraway look that meant she was thinking about Him. Kobi thought he would burst.

But then they were home, snuggled in bed, and while he masturbated hungrily, Merin recounted for him everything that had happened to her that night. She told him about the woman she was going to contact, after he had come.

"Oh, wow," Kobi breathed. "Do you think she'll meet you? In person?"

"I hope so. Now the trick is to leave her a message that she'll understand but that won't be too blatant."

Kobi thought about it for a moment. "What about 'a mutual friend recommended your work to me.'"

"But what if she's a garbage collector or something? Won't that seem weird?"

"Weird, maybe, but not enough to arouse suspicion, I don't think. There's no reason to expect that some counselor is going to be monitoring messages for something nonsensical."

Merin shrugged. "And then what if she's a photographer or a carpenter? She'll think I'm serious, that I want to hire her." She sat up in bed and rested her head on her knees. "Maybe something like 'Mutual friend suggested we have similar taste . . .'"

Kobi chimed in. "'So come on over for a taste test!'"

"I don't think so."

"Why not?"

"Well, what if she's a gourmet chef or something? Or likes spicy Southern Continental food? Besides, we don't know if she'd be willing to come here, or if we'd even want her to."

Kobi snorted. "You sound like you don't really want to meet her."

"It's not that." Merin thought for a moment before answering. "It's just that we have to be careful. If someone gets second thoughts . . . we wouldn't make it through counseling, you know that."

"I've never been counseled."

"Well, neither have I, but I had a housemate who was, once. They can tell when you're lying, and when you're hiding things from yourself. And if you can't face up to them and fix them . . ."

"Reconditioning."

"Yes. You're forced to move to a place where no one knows you, start a new job, sever your old connections so that you can resocialize anew. We'd be split up for sure." Merin didn't like that thought, and yet even with her worry the possibility seemed distant. "We don't know how well my mystery date knows her. She might be more freaked out than he knows."

"But you trust him."

I do, Merin realized. She trusted him implicitly and she wasn't sure why. Perhaps it was the shared secret, or perhaps it was something about allowing him to use her the way he did. It was the strength and suddenness of that very trust that made her want to just do as he suggested and contact this woman right away. But it was her surprise at the strength of feeling that made her take cautious steps. "Yes, I trust him," she said. "But that's no reason not to be careful. Maybe we should meet with this woman, under the pretense of dinner, and see if we like her."

"We?"

"I'd feel better if you were there, too."

Kobi shivered with excitement and burrowed down into the bed. "We could meet for drinks at the Velderet. She wouldn't have to know our net IDs or anything. Just give her our description."

"All right. I'll send her an anonymous message in the morning and tell her if she's interested she should meet us in the bar—on your next night off."

"But that's tomorrow," Kobi pointed out.

"All right, tomorrow," Merin said. "We'll hope she doesn't have other plans."

"Oooh! Goody goody." Kobi snuggled up next to her happily and went to sleep.

That night Kobi dreamed of a tall, willowy, dark woman, with shadows for eyes. She towered above where he knelt so that if he reached up with his hands he could barely brush the tips of her curly black pubic hair. He strained upwards, trying to reach higher, when a crack of lightning came down from the sky and struck him across the back.

"You dare . . . ?" came her voice, the thunder.

He cowered down around his erection, and reached for it instead. And again he felt the fire crackle across his back.

When he tried to scream, he woke up. It was late morning, the sun striping the bed with light where the window shade had come loose. At the top of the window hung the sash rod Merin had tried to punish him with. How would it feel to really be hit hard with it? He shivered, thinking about thunder and lightning and wishing Merin was home. Well, if she had sent the message like she'd said she would, tonight he might find out what it was like. He put his hand onto his cock and winced a little as if the lightning might strike him again, but all he felt was a tug of desire and he started stroking. Until tonight, there was plenty to do. . . .

► Chapter Five ▼

THE DOOR TO THE VELDERET SWUNG open automatically as Kobi and Merin rushed toward it off the rainy street. Warmth and voices drifted out as they shook off their rain cloaks and hung them in the vestibule among many others. Kobi gave Merin an excited look and squeezed her hand. "Do you think she's here, yet?"

Merin shook her head. "Her message said she'd meet us here at six thirty and it's only six now."

"Did she say what she looked like?"

"Nope. She knows to look for us, though." Merin led him into the lounge where Zill was working the bar. They took floating seats near the top of the round room, where they could see everyone and be seen easily.

Kobi bounced in his lighter-than-air chair. "Do you think she'll be pretty? Do you think she'll be tall?" He thought about the woman in his dream last night, who had been as tall as a mountain and had used lightning for a whip. He remembered the feeling of fire burning across his back and wondered if it would feel anything like that to be whipped or hit. "Do you think she'll really . . . you know . . ."

"I don't know," Merin said with a sigh. "Remember, we still don't know if she'll agree to it." Merin was trying to imagine

how to phrase such a request: "Hello, ma'am, would you beat me and my friend here so we can see what it's like?" "Hi there, you don't know me, but I hear you wouldn't mind hurting me . . ." Doubt nagged at her. She'd tried to be clear without being incriminating in her note, and yet there was no way to be sure.

Kobi interrupted her thoughts. "There's a woman over there staring at us."

"Where?"

"Near the door. She's been there since we came in."

Merin looked. In another floating chair was a short woman with tight, light brown curls on her head. The woman met their eyes with a steady gaze. After a moment, she slipped out of her chair and began to cross the room.

"Do you think that's her?" Kobi said, his heart pounding.

"If it's not, we better get rid of her," Merin said.

The woman put her hand down flat on the small table between Merin and Kobi. "Are you two the ones looking to audition?"

"Excuse me?" Merin turned an ear toward the woman.

"For the edu-drama I'm doing." The woman raised her eyebrows a bit on the word "edu-drama." "Our mutual friend tells me we share an appreciation of history."

"We sure do," Kobi said, and offered his hand. "Would you like to go somewhere for dinner?"

The woman did not shake his hand, but took hers from the table. "I think the studio's the best place to discuss this kind of business." Her eyes slid to the next table over where two women were deep in conversation. "Besides, then you can take a look at my work."

Merin looked at Kobi. She wanted to be sure. "We weren't expecting you until six thirty."

"I know." And with that she turned toward the door.

Kobi and Merin followed her without hesitation.

The woman led them several blocks from the club to a series of industrial buildings. She never once looked back to see if they

followed or slowed her pace through the rain. Merin wondered how a woman with such short legs could walk so fast. Her head came barely up to Merin's chin. She opened the door to one building with her handprint and held the door open for them.

Inside, a white hallway glowed softly with black, windowless doorways spaced at intervals along it. "Welcome to World's Eye Studios," the woman said.

World's Eye. Merin knew the name from some legislative work she had done, securing funds for certain kinds of educational programs produced by this company. When her cybersex contact had mentioned this woman might be interested in reenacting Gerrish slavery edu-dramas, though, she had never dreamed it might be a person who actually produced such dramas for view. Now the comment about the audition made sense.

The woman opened one of the black doors and they stepped through into a room from another time. A fire flickered from a stone hearth, wooden tables and chairs cast dark shadows against rough hewn walls, and the view through the glassless window showed nighttime fields lit with moonlight. The door sealed behind them and blended into the background of the ancient house. Merin's eyes froze upon the object on the table: a taskmaster's rod, just like the ones that they had seen used on Gerrish slaves in the histories.

"Realistic, isn't it?" the woman said. "Lights, up two." The room brightened from some unseen, indirect light source. "As you know, I am looking for a few more dramats to play the parts of Gerrish slaves. I prefer to audition people in period setting, to encourage a fuller exploration of the role. I also prefer to improvise and allow a dramat to see what he or she can discover in the role outside of the written script. Don't worry about lapses in your performance. This will not be recorded and is for my personal evaluation only. The studio is, of course, soundproof and has no windows. Do you understand?"

"I . . . I think so," Merin said, her mind trying out all the possible hidden meanings of those statements.

"These kind of historical scenes require a great deal of body acting," the woman said. "There will be physical contact of

various kinds. I'll need to see how well you can play at being sick, hungry, perhaps injured. If at any time, however, you feel you really are sick or injured, simply say 'break' and we'll take one. Do you understand?"

Kobi and Merin both nodded.

"For the length of the scene, you should address me as 'Tasker Illana,' or 'Tasker.' Illana is my character's name, and Tasker was the official title by which the slave supervisors were known." She picked up the rod and tapped it in her hand. "You two will play the part of newly captured Gerrish. This is very early in the enslavement, when there were still a few rural Gerrish not under rule. If you would really like to get into the part, I would suggest you strip down to nothing. The scene will begin with the two of you asleep on that pallet there. You are brother and sister . . . no, wait, you are lovers. The scene officially starts when I enter the room. I'll give you a minute or two to get ready." She stepped out through another invisible door.

Kobi began stripping out of his clothes immediately. "Wow, this is amazing, isn't it? What a setup. I hope I get to meet your friend someday to thank him for introducing us to this woman!"

Merin took her clothes off and folded them into a pile. They seemed out of place in the flickering, rustic light. She put them and Kobi's inside a wooden box by the fireplace, their rain cloaks on top. "I'll reserve my thanks until after we see how this comes out. Let's get in place."

They climbed onto the low pallet that was covered in matted grass. Kobi put his arms around her. "We're supposed to be lovers, right?"

"Right." She swatted his erect cock. "Hard role for you to imagine, eh?"

A little bell ringing quieted them, and Tasker Illana stepped into the room. Her uniform was crisp and fitted, with leather reinforcements at the knees, elbows and shoulders, Merin noticed. Kobi gasped.

"All right, you two, let's see what you're good for." The Tasker's boots rang heavy on the wooden floor as she approached the pallet. "Get up."

Merin moved to get up but Kobi cringed away.

"I said, move!" The rod came whistling down on the pallet itself with a loud crack. Merin jumped away from it and stood off to the side. Kobi crept cautiously out, his hands over his head. As he straightened up next to Merin, his hands went to cover his crotch instead.

"Stop that." The rod whistled again and caught him on the knuckle.

"Ow!" he cried and thrust his hands behind his back. But it hadn't really hurt, he was only acting like it did. Was the rod not going to hurt because this was play acting? He frowned in disappointment.

"Looks like you two are going to need some training before you're presentable."

"Where are we?" Merin asked, looking around her as if she'd never seen the place before. "What are you going to do to us?"

"You were caught on Mayor-Lord Hollen's land, so by rights you belong to him. But Hollen's got no need for any more servants or laborers. I'm to see what you're good for."

"You can't do that," Merin said. "We're free people."

The Tasker laughed. "Look at you! Naked and filthy, living in trees; you're not people, you're animals." She stood in front of Kobi. "Let me get a good look at you." She tapped him with the rod, spreading his legs wider and making him bend over. He felt her leather-gloved hands on his back, then spreading the cheeks of his ass, fondling his testicles. "You look clean enough. But scrawny. Not good for heavy work. Maybe a bed slave, though . . ."

A bed slave! Kobi thought. Was that what he thought it was?

"Maybe if you're tame enough."

She inspected Merin the same way, pulling her cunt lips apart and running her hands over her ass. Merin squirmed under her touch and was shocked by the impact of a blow on her behind.

"Hold still!" the Tasker barked and pulled Merin into her lap on the pallet. The Tasker's fingers returned to probing her cunt while Merin wondered what the Tasker had just hit her with. Her hand? The spot on her ass cheek where it had fallen tingled

now, but the pain had been so momentary she couldn't be sure if it had really hurt. She squirmed again, trying to get out of the Tasker's grip, but lying on her stomach as she was she could not get up.

The Tasker held her by the hair then, and again came the blow on her ass. "I told you to hold still!" Three more times she struck on her ass with a loud clap. Merin gritted her teeth—that definitely had to be a hand hitting her. Each spank felt like a momentary shock and then the skin smarted. *It isn't so bad,* she thought, but she could feel her legs trembling and her clit twitching. She felt the Tasker's body tense as she raised her arm for another blow.

"Stop! Don't hit her!" Kobi grabbed the Tasker by the arm.

Merin tumbled to the floor as the Tasker struggled with Kobi. When she looked up, Kobi's arms were locked behind his back. The Tasker bound them with some shackles she carried on her belt. With one booted foot she pushed him to the floor and attached one of his ankles to another shackle set in the post of the pallet. "This'll teach you to touch a Tasker without permission," she said, and raised the rod in her hand.

Merin held her breath. This was the moment they had been waiting for. *But shouldn't I try to stop her, too?* she thought. *Well, I'll let her hit him once before I try it . . .*

The rod landed squarely on the fleshy part of Kobi's ass and Kobi screamed. Goosebumps spread across Merin's skin. She'd never heard a cry like that before and wasn't sure she was ready to hear another. She lunged for the Tasker.

Illana was ready for her, stepping aside and flinging Merin onto the pallet. With a knee in her back she held Merin still until she could be shackled in place. *Interesting,* Merin thought as the shackles closed on her wrists and ankles—they looked like hard metal but on the inside felt like something soft which molded to the shape of her skin. Then the Tasker's weight was gone and Merin could hear the swish of the rod and Kobi scream again.

Kobi tensed before the next blow, his long hair tangled about his face and getting in his mouth when he screamed. *This is so*

weird, he thought. *I get all ready for her to hit me, and then when she does, it's over with so quickly; then I have to wait for the next one.* Swish, crack, scream. And he was waiting for the next one. *I'm not supposed to like it,* he thought. *I should be acting like I don't like it.* But his throat was moaning the way he did during sex, not like suffering at all, and he wiggled his ass as best he could with his hands bound behind his back. When he squirmed the right way after a blow, his hard cock pressed into the floor. The blows came faster and his moans turned to shrieks of excitement. The pain seemed to go right through him, spreading ripples of sensation throughout his body that aroused him all the more.

And then she stopped. "You'll have to learn better or I'll never get any use out of you. Now, you." She turned to Merin and tapped her lightly along the backs of her thighs with the rod. "Your turn."

The first blow was light, Merin could tell. The rod did not swish as it went though the air and it only stung a little where it caught her: where her thighs and buttocks met. Several more like it followed, evenly spaced in rhythm and in steps up her buttocks and down her thighs. Then another blow right at the base of her buttocks, harder, followed by several of equal strength. And then another one even harder.

Merin began to pant. The blows slowed down as they got harder, giving her more time to process the feeling. She gritted her teeth and held her breath against the blows, and it seemed sometimes she could shut out feeling one. But the next blow always felt twice as worse when she did that. *I wonder when she'll stop?* Merin had no idea how long it had gone on. She started to gasp and cry at each blow.

"You see, this is what happens when you are disobedient. You've both been very bad. I don't even know if we'll be able to use you for anything. But we can't just let you go: you'll make trouble. And if I can't train you, we can't sell you either. Maybe I should just kill you and pretend we never caught you. . . ."

"Oh no, please don't do that." Kobi wormed his way to her feet.

"Do you promise never to assault me or your owners?" She paused the rod in mid-stroke.

"Yes, I promise," Merin said. Kobi nodded.

"I don't believe you." The Tasker swished the rod through the air. "As soon as I stop doing this, you'll convince yourself it wasn't so bad, and you'll disobey."

Merin trembled. "What are you going to do?"

"Make sure that you remember. I'm going to give you each ten strokes with the rod. I want you to count out each one, so you'll remember each. You first," she said to Merin. "Bound the way you are, you cannot move or flee. You are completely at my mercy."

Merin shook in her bonds. It amazed her how helpless they made her feel. It was a thrilling feeling, frightening but strangely comforting. If the Tasker had ordered her to lie still, the way her cybersex lover had, she would not have been able to do it, she thought. She would have tried to get away, even though she wanted to feel the blows. This way, she would feel the blows without the burden of choice. How odd.

The first one struck with a loud crack and she heard herself cry out the way Kobi had. The pain reverberated through her with tingles in her fingertips and fire in her blood.

"That was number one," the Tasker said. "Can you count? Say 'That was one.'"

"That was one." Merin's voice sounded hoarse.

The second blow was much like the first, delivered in exactly the same spot so the pain was magnified. While she screamed, Merin made a note of that fact. The Tasker was hitting her much harder than she had been before, and Merin wondered how much harder she could hit. By the fourth blow she decided she didn't really want to find out. By the sixth blow she was sure she could not take another. But then the sixth one hadn't seemed that much worse than the fifth, and the seventh no worse than the sixth. The pain was awful, but it did not last. It was hard to remember from one blow to the next just what it felt like . . . she anticipated the next one, trying to capture the feeling and dreading it at the same time.

By the time number ten came around, Merin was out of breath but surprised at how quickly it was all over with. "Thank you. . . ." she whispered.

"Thank me? For what?" the Tasker asked.

"For teaching me," Merin said.

She was not sure exactly what it was she had just learned, but it felt wonderful when the Tasker stroked her on the head and said, "You're welcome. You've done well."

Merin was allowed to sit up to watch Kobi take his ten strokes. The Tasker noticed him humping the floor and forced him to stand up. She unlocked his hands and made him put his hands on his knees.

After two blows, Kobi lost count and started to giggle. The Tasker was furious and hit him even harder. Kobi laughed harder: the pain drove swirls around in his mind and he couldn't keep track.

"Why are we doing this?" the Tasker asked him.

"Um, because . . . um . . ."

"To teach you not to disobey your Tasker or you'll be punished."

"Um, right."

And she hit him again, even harder. Merin watched the way the Tasker pulled her arm back and swung it straight at her target. Kobi would jump with the force of each blow, but he didn't act like he wanted it to stop. Remember, Merin told herself, he could always say 'break' and it would. What could he be playing at?

"Tell me why we're doing this."

Kobi struggled to answer. "Because I'm a slave and that's what we do."

"That wasn't the answer I'm looking for." And she hit him again. "How many was that?"

"I don't know."

It went on that way far beyond ten strokes, until the Tasker threw the rod down. "He's addled in the head. No good for anything. I guess I'll have to kill him."

"No, wait!" Merin said, then shrank away as the Tasker

turned her eyes on her. The script was suddenly hers for the writing. "He's not smart but he is useful. Please don't kill him."

"How useful?" The look in the Tasker's eyes told Merin that she'd play it in this direction if that was where the scene went.

"Look at how pretty he is. Surely he'd fetch a high price for his looks." Kobi straightened up and tossed his hair over his shoulder.

"A high price, and for what? He'd ruin Hollen's reputation for poor goods."

"He's slow to learn, but he can be taught. You can't give up on him after just one night!" Merin was surprised at the force of her statements, as if there were really something at stake here, not just an improvisational scene.

The Tasker picked up the rod and tapped it in her palm while she contemplated them. "There's not much you two could do to make it worth my time to spend on you."

"Anything, we'll do anything you ask us to," Merin said, and Kobi nodded.

"Well, you are pretty . . ."

"You said before he might make a good bed slave . . ."

"Bed slaves are a as common as fleas. Hollen can poke his cock into anything he pleases."

"But Tasker," Merin said, her voice lowering, "who pleases you?"

The Tasker looked at the two of them. "You might be salable as a matched set." She narrowed her eyes. "But you'd have to prove it to me."

Kobi dropped to his knees. "Anything, Tasker. We'll show you."

The Tasker unbuttoned her uniform. "Very well, then. Please me and you live."

Merin removed the Tasker's jacket and slid her hands over her white, soft breasts. Kobi loosened her boots and slid them off one at a time, then the Tasker's trousers. The two of them lowered her onto the pallet, her knees hanging over the edge. Merin's tongue snaked over her nipple as she sucked gently on

the ample flesh. The Tasker moaned. "Oh, woman, get that tongue down where you know it'll do the most good."

Merin pushed Kobi aside and knelt between her legs. Kobi climbed on the pallet and took over massaging the Tasker's breasts while Merin breathed onto her sex. She let her tongue search through the folds of labia for the Tasker's clit. The musky woman-scent of her made her mouth water. It had been a long time since Merin had been with a woman and she was eager to make up for lost time. She sucked the clit hood gingerly between her lips and stroked it between her lower lip and her teeth. The Tasker gasped. With one hand she ran her finger around the outside ring of the Tasker's vagina, spreading the fluids there and teasing her. She snagged the clit in her teeth and let her tongue tickle it rapidly while her fingers played just at the edge of the vaginal opening.

After several minutes, the Tasker hissed and grabbed Kobi by the cock. He was hard and the touch of her fingers hardened him even more. She needed to give no order. He replaced Merin between her legs and pressed his cock against her. He rubbed it over her swollen clit and against the tight walls of her vagina. She reached behind him with her feet and pulled him down into her.

"Come over here," she said to Merin while Kobi filled her and pumped her. She positioned Merin on all fours above her with Merin's cunt in her face. "I have to see what you can take as well as what you can give," she said as she pulled off her gloves and began smearing Merin's vaginal juices around.

Merin rested her head on Kobi's shoulder while she felt the Tasker's fingers entering her. One of the tasker's hands was manipulating her clit and labia while the other was working a finger deep into her. Then that finger withdrew and another one burrowed in its place. The Tasker was rough and quick, but Merin was so wet it didn't matter. Two and then three fingers at once filled her. Merin knew the feeling of a woman's hand in her cunt, the tight pyramid shape of it when the thumb tucked in, and she gasped as the Tasker's hand opened like a flower. She felt like her cunt was gasping, too, gaping wide open as the

Tasker stretched her. The Tasker's knuckles crushed against her labia and her other hand continued to saw at her clit.

Kobi knew he wouldn't be able to keep up fucking her much longer. He took one of Merin's hands and put it into the Tasker's crotch. "Help me make her come," he whispered.

Merin let her fingers on the Tasker's clit match the rhythm of the Tasker's fingers on her own. "Pump faster," she whispered to Kobi, nudging him with her head as the Tasker's hand pumped into her.

Kobi gritted his teeth. He would not come before them, he promised himself. He would not. He would not.

The Tasker began a quiet scream which got louder with each successive push. Merin felt her own orgasm blossom and the flush of it creep up her belly, over her nipples, and through her head. Her vagina sucked at the Tasker's hand as she shook with the power of it, and the Tasker's hand shook with the power of her own. The Tasker's scream got still louder as Kobi slammed harder and harder, suddenly free to have his own orgasm and finding himself not quite there yet. He finished with a sudden spasm, burying himself deep with his hands on the Tasker's thighs.

They held their poses for a few moments and then the Tasker disentangled herself from them. "Well, maybe there is some hope for you two after all." She stood up and picked up the pieces of her uniform. "I'll be back for more of the same." And then she exited through the door of the small house.

A few moments later she came back in wearing a bath wrap and grinning. "Lights, normal," she said, and the set was lit with daylight brightness. Now Merin could make out the edges of the door where they had come in and see the view out the window was a flat background. "Wow, you two are really something."

"Thanks," Kobi said and sat down on the pallet. "Ow!" His rump was sore.

The woman's eyebrows knit. "Let me see." He stood up and she ran her soft hand over him, much as she had in the beginning of the scene. "Oh, damn it, there are going to be some marks here." She showed Merin the very tops of Kobi's thighs.

"The first time's always more susceptible to this kind of thing," she explained. "They'll hardly be visible with a little treatment, though."

"Treatment?" Merin imagined the three of them in the med center. *He, uh, fell . . .*

The woman shook her head. "Dramats hurt themselves all the time. Come with me." She led them through the other door into a comfortable backstage area. Couches and tables lined one wall, racks of costumes another. She handed them each a bath wrap from a pile of neatly folded linens and led them into the lavatory area. "Why don't you have a shower while I look for what we need."

Merin and Kobi shared a big shower stall, soaping each other and letting the jets from all sides spray them. "Wouldn't you like a shower this size at home, Merin?"

Merin nodded. "I can think of all sorts of things we could do in it."

When they emerged, the woman showed Kobi a tube of something. "It'll feel a little bit hot, but it'll take the mark away by morning. We use it all the time when people accidentally get bruised in the face." She squeezed some of the white cream onto her hand and rubbed it over the faint bruise marks. "I'm sorry again about that. I don't usually hit first-timers that hard."

"That's okay," Kobi said. "I enjoyed it."

"I thought you did." The woman smiled at the two of them. "I'm pretty busy the next month or so, but if you're interested in getting together again . . . you know my anon ID."

"And you've got mine," Merin said. She wasn't sure how eager she was to feel the Tasker's rod again. She wished there were some way for her to rendezvous with her mysterious cyber partner this way, but he was probably halfway around the world from here. She squeezed Kobi's hand and they went to retrieve their clothes.

Kobi's bruises had faded the next day, but his memories of the rod whistling through the air were as vivid as ever. He

thought the encounter over while working the bar at the Velderet. And it had all been almost legal! If anyone had wondered what they were doing, well, there was no law against auditioning for the part of a Gerrish slave in a drama, and there was no law against having good sex with willing partners. He looked forward to doing it again, but knew they couldn't do it too often or they risked discovery.

He searched the bar for the card Nayda had given him. She'd said to call if there was anything he needed to know. Well, right now he wanted to know if there was a way to create an object for cybersex, something like a window sash opener . . . something new to try on Kobi2, his cyber double. Neither Kobi nor his cyber construct had yet been able to improve his performance at holding off orgasm. But perhaps, Kobi thought, the right persuasive methods hadn't yet been used. He found Nayda's card tucked under a container of winter fruit slices. He'd call her as soon as he got off work. After that there would still be an hour or two to kill in a cyber suite before he had to go home. . . .

His thoughts were interrupted by Mica sliding up to the bar. "The usual," he said, fingers drumming on the top.

Kobi served him up a glass of Bitter Seed with no ice. He always wondered what Mica did for a living. His skin was always a shade dark, like he spent a lot of time in the sun, and he was never the slightest bit overweight. In fact, he always looked a little bit underfed to Kobi. *Well, he's probably not a chef,* Kobi thought to himself. "How have you been?"

"Working hard," Mica said. "A lot of pressure lately." He shrugged to indicate he didn't want to say any more about it. "But I think I found something in my leisure time that might interest you."

Kobi handed Mica a paper throwaway and an inker. Mica scribbled down a few words. Kobi looked at it. "This isn't a net address."

"I know. It's a transmission vector. For picking up offworld dramas."

"Offworld dramas?"

Mica leaned close. "Kylaran dramas."

Kobi hid the throwaway and Nayda's card under the container again. There was so much fun waiting to be had as soon as he got off work!

▶ Chapter Six ▼

KOBI SAT IN FRONT OF THE MEDIA WALL with the control pad in his hand. Merin was usually home from work by now and he was restless waiting for her. He had typed in the code to access the offworld transmission Mica had given him four times, and erased it each time without accessing it. Surely Merin wouldn't be angry if he watched without her, would she? He wasn't sure why he cared. A few months ago he wouldn't have; he would have let her watch it by herself when she had time.

But a few months ago she'd just been a convenient source of sex. Kobi shivered at the thought that now, maybe, they were something more than housemates.

He decided to check his credit while he was waiting, entering his codes and waiting for the connection to the central repository to come up. He hadn't had a chance to cybersex with his virtual self, Kobi2, since that first time. His last night off work had been the night Merin and he had gone to World's Eye Studios for that very special "audition" to be Gerrish slaves. His credit balance showed he could afford a session or two with Kobi2 every month without hardship. *Now,* he thought, *if only I could get Rough and Vigorous night off, maybe I could find someone like Merin's mystery man for myself. . . .*

The entry chime rang and he turned to see Merin come through the door. He was talking before she got her rain cloak off. "I saw Mica again last night and he gave me the most incredible thing: a code for getting offworld transmissions."

Merin looked up at him as she kicked off her shoes. "What kind of transmissions?"

"He says they're Kylaran dramas. I've been waiting for you to get home so I could . . ." He noticed the circles under her eyes as she fell heavily onto the couch next to him. "Where were you, anyway?"

Merin groaned. "I had to be at the legislature extra early today, and then an extended session kept us late." She stretched and put her hands into the small of her back. "Ugh, it's the damn Kylar and their negotiations. Just when it looks like everything is ironed out and we are about to move to approve our application into their federation, they bring up some other point that results in a debate of monstrous proportions. The protesters seem to have calmed down now, but it's all taking so long . . ."

Kobi blinked. "Um, that's too bad. So, do you want to watch this with me?"

She smiled. "Let me fetch myself some dinner and then I'd love to." She stood slowly and stretched her arms toward the ceiling. "You can start without me if you like."

Kobi's fingers were already entering the commands that Mica had given him.

From their tiny kitchen, Merin could hear the beeps and clicks of the signal and connection. She took out a container of self-heating stew. Just the thing for a rainy night, she thought. She discarded the wrapper and set it to steaming. While it came up to temperature, she prepared herself a mug of hot water with sugar and winter fruit syrup. When the stew began to steam she carried it, the mug, and a spoon back to the living room.

An image was just resolving in the center of the screen, not wider than a bed pillow on the large screen of the media wall. Probably for reduced bandwidth, she mused as she sipped her

hot winter fruit drink. The picture came into focus and then began to move.

A young woman, her black hair bound on the top of her head and dressed in a revealing costume of strings of beads and chains, lay in the corner of a dim room, sobbing. In the shadows, a cloaked figure moved and a deep male voice spoke in Kylaran.

"What can he be saying?" Kobi breathed, his eyes glued to the moving images.

"I don't know." The drama seemed to be in the middle. "This is where it started?"

Kobi nodded. The broadcast must already be in progress. Now the woman was speaking, pleading, touching her head to the ground.

The man stepped out of the shadows and threw back his cloak. His cock stood out proudly against a stiff leather half skirt, the garment slit up the front to allow it to protrude. His voice deepened, and his hand made a gesture of beckoning.

The woman's tears stopped then, and the camera closed in on her face. Her eyes narrowed and her lip twitched with anger, but she did not speak.

He beckoned again, with a harsher voice.

On her hands and knees, her elaborate chains and beads clicking, she crawled until she knelt in front of him. Her lips opened slightly and she put her head near his cock, her tongue reaching out as if she was not sure how to get it to her mouth . . .

He spoke another word, short and sharp.

She looked up at him once, and then her mouth closed over his flesh, her lips folding down over his organ.

His eyes closed and he sighed for a moment with pleasure— the camera showed his face filling the screen. And then, abruptly, his eyes opened and he let out a scream. He struck her across the face and stumbled back.

The girl, knocked to the floor, wiped blood from her lips. (His or hers? Merin wondered.) He put both hands over his injured member, his face showing the pain he was in, even as he wanted to stay and beat her, or worse. He left the room then,

and the camera panned back to the girl, whose tears now began to run again. She began a long speech in Kylaran.

"Wah, did you see that? She bit him," Kobi said. "I wonder why."

Merin had not touched her stew. "She must be a captive and he's trying to make her a slave, but she is resisting." She spooned some up and blew on it. Thank god for the self-heating container. "Her long speech here is probably important information we're missing about her background."

"Great." Kobi wondered what Merin would think if he took out his cock and masturbated. *Maybe I should beg for permission?* he thought. *She might like that. Or, she might say no.*

He waited until the next scene began. This was some part of an ancient palace, with vaulting arches of stone. The leather-skirted man of the previous scene sat on a table with his back to the camera while another man bent over him. They were exchanging words, the one man tending to the wound while the other clenched his fists.

Kobi reached under his loose waistband and tugged on his half-turgid cock.

"You know, I think the guy in the leather skirt is a slave, too," Merin was saying. "Look how he bows his head to the older man."

On the screen, the older man's words had turned harsh, castigating. "Maybe he's telling him not to go sticking his thing where it doesn't belong." He began to wind a bandage around the length of the younger man's penis, wrapping all the way down to the base, where he continued around the scrotum, separating his testicles and forcing them to protrude. He pushed the man onto his back, and secured his wrists and ankles to the medical table with leather straps.

Kobi licked his hand and thrust it back into his pants.

The older man now circled the bound, younger man, saying more words they could not understand. Then he stopped between his legs, and swatted him hard on the balls. The bound man screamed. Then he gripped his scrotum in one hand and squeezed. He said harsh words and the bound man replied with

something that sounded like begging. Then he was alone in the room, and the screen faded to black.

"Is that all, I wonder? If this is a real broadcast, then they must send it out at certain times and we got lucky to catch it. . . ." Merin mused. She looked at Kobi. "What are you doing?"

"I'm, um, practicing."

Merin set down her tray of food and slid closer to him. "Oh really? How long do you think you're going to last this time?" She slid his pants down to his knees and raked his testicles with her fingernails.

He shuddered. "Not long if you do that."

Merin untied the sash from her comfortable house robe and wound it around his scrotum as she'd seen them do in the film. Kobi's hand was barely off his cock for a second before he'd put it back to stroke himself more.

"Now, let's see how long you'll last. Keep stroking."

Kobi did, while Merin patted his balls experimentally. The pats turned to light swats as she gradually increased the strength of each one until he cried out in pain. When she grew tired of that, she looked back at her stew. "Let's see if you can last long enough for me to eat this. Take your hand away."

She took some of the steaming food on a spoon and dribbled it onto the head of his cock. Kobi stifled a scream and shook as she dipped her head toward his crotch and licked the hot liquid up. Merin put another dollop on and he closed his eyes as her mouth engulfed his meat and hers. So good, so good! The heat was an intense pain, but he knew it wasn't hot enough to burn him. The self-heater would only go to the point where it would not burn the tongue of the person eating it. *Somehow*, he thought, *I don't think this was the intended use of that feature. . . .*

Merin's mouth dipped again and again and he sank deeper into the sensations of pain and pleasure intermingled. The pain, somehow, took the peak off his arousal, and yet the pleasure was enough to keep him hard and wanting more . . . he squirmed with delight and moaned out loud.

Merin scraped the last of the stew from the bottom of the container and spooned it down his shaft, letting the spoon slide

along the length of it. As she lapped up the last bit, she grasped his balls in one hand and squeezed. Kobi's hips rose off the couch and he moaned deeper.

She licked him again from base to tip and squeezed harder.

"You made it," she said. "I'm so proud."

"Does that mean I can come now?"

"You can come whenever you are able to," she said as she lowered her head to lick him again.

That was all it took; as her tongue slid past his cock's tip, he spurted.

The next day Merin had to be in the legislature early, and again she planned to stay late, trying to put into order the opinions rendered by her group to make some sort of consensus to report to the whole. *What's the point?* she thought as she sat at her desk in frustration. *The Kylar are just going to throw another wrinkle in once this is ironed out.* Why she felt so sure of that she did not know.

Could the rumors be true? That the Kyl would stop at nothing short of total conquest? That every Bellonian would be a Kylaran slave before another turn around the sun? She shivered in the climate-controlled atmosphere of the office. The wild rumors about Kylaran sex and mating practices might also be true, she realized, if that piece of a drama they saw last night was any indication.

Kobi was probably sitting in front of the media wall that very moment trying to tune it in. Or would he be waiting for her again, the way he had the night before? That was odd behavior for him, she decided. He was such an instant gratification kind of person.

She pushed her chair back from her desk and stood up, thinking she didn't want to keep him, or her own gratification, waiting any longer.

Tonight there was no rain, just a warm, wet wind that blew thick strands of cloud across the red moon. Her shoes scuffed rhythmically on the flagstones as she crossed the Plaza of the People outside her legislative office. She was alone in the park; lights burned silently in the wind. She could see the lit windows

of other occupied offices—her group must not be the only one having trouble forging consensus. In the two years since she had taken up her legislative duty, she had never seen it so. But so many people disagreed about the Kylar, about their true intentions, about what would be good or bad about joining the Kyl. *How can we know?* she asked herself. *How can we make the right decision for Bellonia, for our children and theirs?*

Her walk took her past the statues of previous Bellonian notables, all carefully life-sized and never raised by pedestals above those who came to see them. She could see eye to eye with Greizel—who had invented much of the consensus governing structure they now used, Alamm—the military commander from the Gerrish era who had cut off his own hand when he pledged never to strike another human and to serve his fellow men in building a world free of inequality . . .

She turned her head suddenly as one of the figures seemed to move. A shadow. She peered into the rows of figures. Was that the sound of the rustle of cloth in the wind? Or was that just the air in her ears? *My imagination,* she thought. But then, as she walked further, she thought again she saw/heard/felt someone shadowing her in the statues. "Hello?" she called out, expecting a late-night workman or another legislator to step forward. But there was no answer.

Merin walked quickly toward the exit of the plaza and the brightly lit street, unnerved. *This is silly,* she told herself. *There's no one there.* If there was, who could it be? What could they want? It was rare, but it did sometimes happen that mentally unstable individuals wreaked random violence. At the legislative orientation she had been given two years ago, they had mentioned divisive issues that were not resolved quickly resulted in a rise in unstable behavior. But it was rare, wasn't it?

The sound of her own steps seemed to be getting louder as she neared the park exit. Here the hedges grew close to the walkway and she wrapped her arms around herself as if she were cold in the wind. *It's nothing, there's no one,* she told herself again, as she suppressed the urge to look behind her. *I mean, really, why would someone be following you?*

Then she did stop and look behind her. She saw nothing, but her heart began to hammer as two thoughts warred for her attention. One was that He had somehow found her—*O red moon rising, I even told him I was in the capital*—and that He was here. That thought thrilled and frightened her, for much as she wanted to meet Him, and find out what it would be like to kneel at his feet or feel his hands on her hair in real life and not through cybersex, some part of her was also afraid that anyone who played at being a master like he did was—as the psychologists had told them from their earliest schooling—sick, twisted, perverted, in need of rehabilitation. The other thought that gripped her was that somehow someone had found out about the games she played with Kobi, or in cybersex, or that time they had gone to World's Eye Studios so recently, and that someone considered her one of those sick, twisted, perverts and were here to . . .

To what? she thought, shaking herself and forcing herself to walk toward the boulevard again. There was not much need for law enforcement personnel on Bellonia, and the enforcers were mostly psychiatric experts. They didn't stalk you and steal you away to reconditioning. They served a notice to your domicile, first a warning, placing a monitor on certain activities, and sent you to counseling. If that did not do enough to encourage correct behavior after a certain probation period, then there were medications to be tried. If that still did not work, then they took you away—away from familiar people and patterns that needed to be broken.

But that was for regular citizens, she remembered. People doing their legislative duty were watched more closely to be sure power did not go to their heads, and if it looked as if it was, they were sometimes relocated suddenly. But still, she told herself, psych enforcers don't sneak up on you in the middle of the night!

On the boulevard, the cafes were closed up and the storefronts dark. It was even later than she had realized. Here by the buildings, away from the ghosts of Bellonia's past and the wide-open wind, it seemed quieter, she saw no one, and heard no one, but still the feeling that she was not alone did not leave her the entire way home.

When she came in, she found Kobi asleep on the couch, the media wall idled and a strip of cloth hanging loose from his genitals. She turned off the wall and pulled a blanket over him, then went to sleep in her bedroom, her mind still full of questions.

A few days later, Kobi's night off from the Velderet came up and he went across town to the East District looking for the club Nayda had mentioned she frequented. He'd figured 1) it was better to get away from his workplace, especially if he was going to be doing a lot of cybersex that might be noticed by his co-workers, and 2) he might run into Nayda and she was pretty darn cute. The club was called the Setting Sun and had an antique-looking wooden bar and ornate chat cubbies. Kobi liked the plush Velderet's bar better, but their cyber suites were identical, plain gray cubicles with a bed and a terminal. He logged in and brought up Kobi2's menus. Once he had adjusted them to his liking, he lay down and closed his eyes.

When he opened them, Kobi2 was sitting on the bed next to him. "Hi," Kobi2 said.

"Hi." Kobi couldn't help but giggle a little. "Miss me?"

Kobi2 shrugged. Who could say how time passed for a neural model? Maybe it didn't. Maybe it only registered time passing while it was being accessed, while it was accumulating experiences and learning. *Well,* Kobi thought, *it's here to learn, to see if I can learn.*

"Tonight," he began, "we'll try something new."

"Okay," Kobi2 said eagerly, and scratched his naked balls.

Kobi held up his props, computer-generated strips of Ultra-stretch rubber. He still hadn't figured out a way to create something like the rod, but strips of cloth fit within the system's parameters for clothing. With the computer's help, he secured Kobi2 to the cyber bed with the strips, the way the Kylaran guard had been in the video. Last night's episode showed him still tied there after days, in punishment for his treatment of the girl. The older man brought him water and food from time to time, but the man was not released, and occasionally the older man

whipped him across the nipples and the thighs. The guard would thrash and cry for a while, then beg, then eventually go silent and still under the lash, his eyes looking far away or closing. Those scenes had been hard to watch, and yet Kobi's cock came to attention every time.

Merin had worked late every night this week . . . he felt a little pang of guilt that tonight, his night off, he'd come here instead of doing something with her. But she was probably still at her office anyway.

He turned his attention to Kobi2. "Could you make yourself hard?" he suggested. *No wait, that's wrong,* he thought. *I'm supposed to give orders.* "Make yourself hard," he amended, although Kobi2 had already licked his hand wet and was tugging on his cock. To the computer he added, "Neural record Kobi2, full sensation, suitable for full sensory playback."

When it was rigid, he pushed his double's hands away and wrapped a strip of the Ultra-stretch around the base of his balls, then around each testicle in a figure eight, imitating what the man in the drama had done with cloth bandages. He gave the testicles an experimental tap.

"Hey," said Kobi2.

"Hey, what? Don't you like that?"

"Am I supposed to?" Kobi2 asked, his eyebrows knit exactly like Kobi's.

"Yes," said Kobi. "You're supposed to like everything I do to you. You're supposed to like it a lot. But you're supposed to be learning how not to like it *so* much that you come before you're told. Got it?"

"I guess so."

Kobi tapped again, then tried a little harder. Kobi2 grunted, but his cock stayed hard. Kobi put Kobi2's hand on Kobi2's cock and let him stroke as he slapped his balls. Kobi2 grimaced and pulled harder on his cock.

Kobi got tired after a while and slapped the insides of his spread thighs instead. At first he must have been hitting too lightly because Kobi2 looked up at him with a puzzled expression and then said, "Oh, I'm getting really close."

"Don't come," Kobi said, and hit him harder. Kobi2 yelped at the sharpness of the slap and his butt bounced up off the bed.

But in a few moments he was again saying, "I'm going to come!"

"Don't!" Kobi said, and hit him hard on the leg. Kobi2 yelled again, but did not come. How much pain was necessary to distract him? Kobi wondered. It seemed to take more each time as they went on, Kobi2 warning him when he was close, and Kobi slapping him to try to stave it off.

Finally Kobi2 held his hand still and cried, "I can't take it anymore, I'm going to come!"

Kobi grabbed him by the wrist and took up the extra strips of Ultra-stretch in his free hand. He pulled his arm down hard, slapping the strips across Kobi2's chest. Kobi2 screamed. His hips jerked furiously, but he did not come. Kobi hit him again, and Kobi2 again arched up, his cock, as red as the moon, thrust into the air. The skin on his chest colored with red stripes and Kobi looked at them with interest. He let Kobi2's hand go, and it flew to his cock and began jerking quickly. Kobi whipped Kobi2 on the chest, across the thighs, just as he'd seen the old man do in the video drama. He hadn't thought to use the rubber strips this way, but as long as he had them, why not? Thinking about the drama, he eventually bound Kobi2's hand down again and whipped and whipped until his own arm was getting sore. Kobi2 jerked under the lashing, then settled into wincing and grimacing, then eventually seemed to go into a trance.

When he did, Kobi stopped and settled his mouth over Kobi2's cock, and sucked him hard until Kobi2 came alive and came into his mouth with hot spurts. *Is that what my come really tastes like?* Kobi wondered, then decided the computer probably had some generic simulation it used.

Afterward, he stroked the striped flesh of Kobi2's chest. "Did you like it?"

"Yes," Kobi2 answered.

"Okay, well, see you next time. You can go now. Computer, retain connection."

Kobi2 blinked out of existence again and Kobi looked down at

his own hard cock. *Well, Merin,* he thought to himself, *I haven't come yet* . . . "Computer, begin neural playback."

The computer fed the recording of sensation that it had made of Kobi2 into Kobi, and suddenly Kobi felt himself tied down to the bed, looking up at himself as he wrapped his balls in rubber. The tightness made him gasp. It was tighter than Merin had done it. The tap. "Hey," he felt himself say.

He felt his own hand rise and stroke himself while his other self's hand slapped him. He could feel it, and feel the way Kobi2's brain assimilated it as pleasure. *Of course,* he thought, *because I programmed him to like everything I did to him. . . .*

When the first hard slap came on his thigh, Kobi tried to tense for it, but with all Kobi2's nerve responses flowing, he couldn't really. The stinging blow seemed to send electric shocks directly into his genitals, his tightly bound balls, the hot tip of his cock, and he thought he was going to come that second. But he didn't. *Oh wow,* he thought, *maybe it really is working.* Kobi2 was remapping the pain as pleasure, and yet he was able to keep himself from coming. *Oh yeah, oh yeah* . . . Kobi relaxed and let the sensations wash over him, the stimulation, the slaps, the pain . . .

Then came the lash with the rubber; he felt himself howl, the pain/pleasure exploding in his mind and overwhelming him . . . he broke the connection. He found himself sitting up in the cyber suite, panting, his hands covering the smarting flesh on his chest. But of course when he looked there was no tell-tale red, no stripes, because the experience was only happening in his mind, in cybersex.

It was then that he noticed the sticky wetness on his thighs and stomach. Kobi2 had kept from coming, but the real Kobi had not.

Well, Kobi thought, *when I can get through that entire playback without coming myself, then I'll know I'm getting better. And I will.*

What Kobi did not know was that Merin had not stayed late at the legislature that night. Twice that day, once while walking

to the Kylaran embassy to be sure that this time the ambassador actually received the grain samples collected from four continents, and once when coming from having lunch alone on the boulevard, she had again felt that someone was following her. *It's the stress,* she told herself. *You're working too hard and it's making you unstable.* She considered submitting herself for a mental checkup, but then she was afraid, again, that they'd somehow be able to tell how she'd changed since playing power games with Kobi. She wanted too much to see how this whole thing came out with the Kylaran federation, and she had grown too attached to Kobi to accept reassignment or relocation at this moment. No, she would not go to the psychs.

Instead, as soon as the regular hours of the workday ended, she went straight to the Velderet, only remembering that it was Kobi's night off when she didn't see him behind the bar. Just as well, she thought, since she couldn't talk freely to him in a public place about all this. Instead, she went directly to a cyber suite, loaded the preferences that had connected her to Him, and waited.

What were his orders? To lie perfectly still, not move or talk and always pretend that whoever came to her was either Him, or had come of his bidding. She doubted he would be there, on a non-R&V night. She closed her eyes.

"Hello there," said a male voice. It was not Him. She lay still, eyes closed, and reached up. The man settled himself atop her, licking and sucking at her neck, his hands on her breasts. In a few seconds he was thrusting inside her and she moaned underneath him. Whoever he was, his cock was long and slender, and she relished the feeling of it going in and out of her. She imagined that He was watching, that He was there, measuring her performance, evaluating her. She thrust her hips to meet the horn of flesh of the stranger, banging her clit against his pubic bone and trying to come without having to touch herself, or without having to ask him to touch her there.

He gripped her hips then and doubled the speed while he shortened the stroke and came, grunting into her. When he slipped out, he sat back between her legs. "Can I do anything for you, now?" he asked.

She shook her head and soon he was gone. "Computer, retain connection."

"Quota nearing limit," the toneless voice informed her.

"Bill my account," she said. "Maintain connection. I'm not yet satisfied."

She squirmed in place in real life and settled in to wait again. *This is stupid,* she told herself. *He's probably not connected tonight. It's not R&V night. Why would he be?*

Because, she answered herself, *half of me believes he's been following me everywhere, and right now, he might be in the next suite over, trying to connect to me....*

She felt the change that signaled a new connection, someone "entered" the room in cyberspace. She expected another strange voice to say hello, another anonymous fuck that she would, out of obedience to her mystery man, allow to touch her or lick her or fuck her any way he pleased.

But no voice came. Hands touched her thighs and spread them. Fingers splayed her labia wide and she held back a gasp. Warm dry fingers parted the folds of her skin as if looking for something. Then a finger was at the opening of her vagina, pressing, slipping in, all the way up to the knuckle. The finger crooked inside her and she did gasp. No man had ever touched her with such deliberate motions, with such utter surety, just as if he . . . owned . . . her. . . .

She bit her lip as she held back a sob of relief. It was Him. It had to be Him.

And it was. "Damn computer," he said. "No way to tell if you're actually wet or loose or what. Have you been waiting for me long? Have many men been inside you tonight?"

Her heart beat hard at his words. "No, only one," she said, and was going to stop there, but her bottled up emotions gushed forth a little and she went on: "But I did so wish it was you."

"And why is that?" He wiggled his finger inside of her and she felt herself sinking into the darkness behind her eyes. "Tell me."

"Because . . ." She knew what she was supposed to say. She knew what she wanted to say. But her paranoia about psych

enforcers and about whether he might be an unstable element himself choked her. If she knew him in person, she might have a better idea of what he was really like. If she could talk to his friends, his housemate, see if he was sane? But that thought seemed pure blasphemy, seemed to contradict what she felt at that moment. "Because . . ." She forced her common sense to the fore. "I wish I could meet you in person and . . ."

He silenced her with a rough kiss then, his lips pressing hard on hers, his tongue suddenly in her mouth while another finger slid into her and another, and he fucked her with his hand long and hard, until she was coming, light and dark strobing behind her eyelids as she went up in orgasm, her legs shaking as her cunt sucked hard on his fingers, fingers which seemed to know how to draw out the pleasure more and more, so she continued to go higher and higher, her mind seeming to shrink away from her body which expanded and grew as the orgasm grew, as his fingers played her and kept her blossoming again and again, his fingers, her body, until she felt again that her body was not hers to control, but his, entirely his.

And then he was gone, disconnected, and she was left gasping, first in cyberspace, her cunt clutching at the empty air, and then in the cyber suite, where her own hands fled to the empty place in her crotch, as she sobbed and rubbed herself and wondered what had happened and why . . .

When she came back to herself a few moments later, her eyes adjusting to the gray light in the cubicle after being closed so long, she sat up, trembling and tired. She noticed then the blinking of the console. Maybe it was some kind of malfunction? She went to see what the blinking message was.

<div align="center">

Be here again in two days time.
Stay connected until I arrive.
And then we will talk.

</div>

"Yes, Master," she whispered to herself, her breath coming quick as she pondered what this could mean.

► Chapter Seven ▼

KOBI DREAMED A LATE-MORNING DREAM, the kind that was always filled with rolling-around sex, realistic and animalistic at the same time. The kind of dream from which he always woke with his dick hard and hot in his hand. In this dream he was fucking someone; he couldn't see who, but she felt soft beneath him, her cunt slippery wet as he slicked in and out of her, holding himself up by his arms as he dipped into her again and again. A voice came from above him, firm, commanding, and though he could not make out the words exactly, he knew they meant for him to keep doing what he was doing.

Kobi felt his own hair, long and black down his back, begin to snake around him, first growing longer and binding his ankles together, and then his knees, and still he kept up the pumping motion. Then the hair wrapped tightly around his balls and the base of his scrotum, squeezing them so the blood throbbed harder and his cock felt like it wanted to explode. But he could not come yet, the voice had not given permission. The voice continued on, speaking the magic words that would make Kobi's hair tie him tighter, as it wrapped around his arms and slowly pulled them behind his back, and arched his neck and back backwards, until he could do no more than flop like a fish. A sharp command and he knew this was his moment, the moment

when he was allowed to come, but bound as he was he could barely move. He twisted and bucked desperately, trying to fuck hard enough or fast enough to come, his breath getting faster and sweat drenching him, his mouth open and crying out for help or mercy.

He woke alone in his bed, his hand on his hard cock, and he pulled and pulled until he did come. Kobi did not feel much like having breakfast and there were still hours before he had to be at work. He dozed off again, hoping to return to the land of dreams like that one.

Two days time. Merin's eyes swam over the sheafs on her desk: everyone in her group had submitted opinions on the subject of road maintenance along the shoreline and it was Merin's job to forge a consensus out of them. But the only thought in her mind was: *In two days, we'll meet again.* She still could not quite believe that her mystery man, who might be half a world away or right across town, had actually set a date with her. She could not concentrate on her work, thinking about the way his fingers had probed inside her, how his voice spoke with such surety and clarity. She had asked to meet him in person, finally, and he had not refused. They would meet through cybersex and talk about it, he said. Talk about . . . what they did, who they were, what they meant to each other? She didn't know exactly and didn't dare to hope too hard.

Merin pushed the legislative work aside and sketched on her light pad as she tried to imagine the conversation. Would he agree to meet her in the real world? How would she be able to tell if he was mentally unstable or sick? A few years ago, she would have said anyone who could order someone else to have rough sex was sick and in need of counseling. But that was then. She could not imagine how her conversation would go. She realized she had drawn a tall, thin, almost-Kylaran looking man, wrapped tightly in cloth, a cross between him and one of the characters in that Kylaran serial drama Kobi had been watching. A new broadcast came over every night, and Kobi had finally gotten smart and started recording them so

Merin could watch those she didn't catch when she worked late.

She hid the sketch under the latest briefs from work groups in the legislature, a list of new proposals to be considered, and other news. Her eye stopped on one short notice:

Individuals requiring counseling on the rise, up 5% currently. Unprecedented numbers therapeutically relocated in past six months. Indicators: reports of aberrant sexual behaviors. Probable cause? Stress over Kylaran situation, especially considering the sexual symptom. Suggestion: news blackout regarding the Kylar? Suggest solutions to Counseling Working Group.

No, Merin thought, *it can't be because of Rough and Vigorous night.* Kobi had been discreetly spreading the word at the Velderet, and he had other friends, too, plus there was Mica, and people like the actress they had met at World's Eye Studios. She knew people all over the world were doing it. But could some normal people have been caught up in R&V night and complained? But no, everyone connected anonymously, so how could they report it? Unless someone recognized someone . . . maybe ran into them in person at their local sex house and . . .

Her mind was awhirl as she tried to sort out all the terrible implications this could hold. What if it wasn't R&V night at all, but people reacting to the stress of the news about the Kylar themselves? She and Kobi had seen several recent news reports claiming that the Kylar were ruthless, rapacious, unwilling to negotiate for what they could take by force, all claims of which were publicly discounted by the legislature. Yet the negotiations had bogged down repeatedly . . . and what about those Kylaran sex-slave dramas? Could people be seeing them and then acting them out, just as she and Kobi had done? She felt cold, imagining if Kobi changed his mind, decided he didn't like it, and reported her . . .

"Are you well, Merin? You look feverish." Nazir laid a wrinkled hand on Merin's desk next to hers without touching.

Merin sucked in a breath. "I'm fine, maybe a little overtired," she said, but her voice did not sound convincing. "Working so late, you know."

Nazir's wisps of gray hair waved gently as he nodded his head. Before his legislative tenure began, he had been a horticulturist, and his eyes were lined from years of work in the sun. "Ah, I do know," he said with a smile. "Sip a little carnila extract with honey and hot water in the morning. That'll perk you up."

I'm sure it will, Merin thought, forcing a smile. As soon as Nazir was gone, she opened her file of new proposals and began to draft one for reform of the sex-house system, to allow people to connect more easily to the cybersex network from their homes. It would look like a safety measure, as well as an equality issue. But no one would suspect what she was really trying to protect.

Kobi went in to work early—not to do any work, though—to "practice." He settled himself into an empty cyber suite and played back the scene he had done with Kobi2. All the stimuli that Kobi2 had "felt" that night—the rubber strips landing hard against his flesh, the snug curve of his fingers against his penis—Kobi now felt replayed through his nerves. *I will not come, I will not come . . .* he told himself. But, he did come, about five minutes into it. Still, that was longer than yesterday, he told himself, deciding that was progress. A little bit dazed, he cleaned himself up and went to take his place at the bar.

This early in the day it was quiet. The Velderet didn't really come alive until the evening, when the majority of work shifts ended. Kobi busied himself rearranging bottles and dusting behind them. One customer finished a drink and then went into a cyber suite. Kobi climbed up the plush sculpted tiers of conversation nooks to retrieve the glass. As he was returning to the bar, another customer came in. It was Mica.

The thin man hurried down to the bar, his eyes flicking back and forth. Kobi waited until he took a seat before he said, "Hey! Thanks for . . . that address." Kobi half-hoped that Mica would have yet another source of sex-slave media for him this time.

Mica waved a hand and looked over his shoulder. "I came to warn you."

"Me?"

Mica nodded. "Some folks who've seen what you and I have seen . . ." Mica paused to look at his hands, not meeting Kobi's eyes. He flexed his long, thin fingers. "You haven't been trying any of it, have you?"

"Oh, no, 'course not," Kobi said automatically, although his cock tingled where he remembered Merin pouring her hot stew over his flesh, and his balls twitched where she had tied them together.

"Good." Mica stood up. "Don't. People are getting in trouble. Stupid people, trying things they shouldn't. Keep quiet, low profile, don't disturb your neighbors."

"Right, sure, no problem, Mica." Kobi watched as the thin man climbed the curve of stairs to the exit. Mica seemed shrunken down, hunched, as if the trouble had taken some of the substance out of him. Kobi didn't want to think about it. He tuned the bar's media wall to Arts & Music and sang along to popular songs while he waited for his next customer. *Maybe the guy in the cyber suite will come out and have another one,* he thought. His thoughts returned to Mica and he felt lonely. But the man in the cyber suite didn't linger after his session. In fact, he rushed out quickly after his time was up. Probably supposed to be at work instead of yanking his balls, Kobi thought, wishing he could spend more time in the suite himself while there were no customers about, and wondering if he could program a scenario like the dream he'd had. Maybe Nayda could tell him . . .

As if conjured by magic, a little while later Nayda came in. "Just checking some maintenance," she said with a quick smile as she ducked into the service door for the cyber suites. But by the time she emerged, three young women had come in and taken places at the bar and Kobi was mixing up drinks for them and chatting, so he missed when she left.

That night Kobi found out the details of Mica's "trouble" when Merin came in. He was watching the nightly broadcast of the Kylaran drama. In it, the young captive woman was tied, spread-eagled, onto a soft, raised platform, while a man and a

woman alternately gave her pleasure and pain. Sometimes they licked or sucked on her naked nipples, or slapped the insides of her thighs, or plied at her glistening, pink slit with their fingers, but never once did they violate her by penetration. The man was dressed as the others had been, in the short leather kilt slit to expose his erect manhood, but the woman was wrapped in tight silk, long scarves wound around her in elegant curves, leaving her breasts and buttocks bare. Her black hair swung freely down her back, and Kobi guessed she must be of high rank. Her hair swished over her buttocks and Kobi stood up to feel his own hair brush his ass.

The door opened and Kobi turned his head. Merin came in and pushed her curls out of her eyes. When she saw Kobi's nakedness she sighed. "I have bad news."

"Me, too," he said, and punched at the pause control on the media wall controller before he remembered this was being broadcast, not retrieved locally. He muted the sounds of the woman's ecstasy and torment. "Mica came by today and said there'd been some trouble."

Merin kicked off her shoes and sat down on the couch. Kobi sat next to her, his hair folding over his shoulders like a cape. Merin held his hand. "A lot of people are reporting sexual aberrations. Counseling is up five percent, and they say that a lot of people have been relocated for therapeutic reasons."

"Any needing medical reconditioning?"

She shook her head. "The working group didn't release any figures on that yet. But you figure there must be—" *Recon,* she thought. No one ever spoke about it unless they had to. It was a taunt they used on each other as children: "If you don't share with me you'll get sent to *recon.*" And here she was discussing the real possibility of it. "They say it's the stress, the news, the Kylaran influence . . ." She had started to cry without realizing it.

Kobi held her tight. "It's going to be fine," he said, because it seemed like the right thing to say. Kobi didn't worry about the larger implications of her news, he just worried about her for the moment. "Really, really, it's fine."

After a few minutes her breathing slowed and she sat up straighter. "I'm all right. But I'm really worried about what may happen. If you or I were sent for counseling, relocation . . . we might never see each other again." Tears came from her eyes, but her voice remained steady. "I don't want that to happen."

"Me either," Kobi said, holding her hands in his. "But we've been careful, haven't we?"

"We made that trip to World's Eye Studios . . ."

"But someone would have said something by now if we'd been noticed. Besides, we were submissive . . ."

"And we've got recordings of this drama . . ."

"We'll erase them . . ."

"And we've been using this . . ." She held up the rod she'd beat him with.

"It's a window sash opener, Merin; it came with the domicile." Kobi hushed her with a kiss. So maybe there were some indiscreet folks out there, who went too far, weren't careful, he thought. They were nothing to do with them. He told her so when he broke the kiss. "Maybe R&V has encouraged some of those who weren't stable to begin with to finally show their true colors," he added. "Maybe, in a way, we're doing a public service."

"Maybe," she whispered, but she didn't really agree. She pressed her hands to her wet eyes and wondered what had happened to the happiness she had felt the night before, when her master—was he her master?—had told her she would see him again in two days. *Tomorrow,* she thought. *How can I meet him tomorrow?*

Kobi kissed her again, his mouth soft on her wet lips, kissing away the salt taste of her tears. Merin felt the smoothness of his skin, the soft nakedness of him, as he pressed her back into the couch. His lips were warm and his hands deft as he kissed and caressed her, and she let herself sink into the sensation, her jumbled thoughts and emotions floating into the distance as she fell into the familiar touches of Kobi's lovemaking. He did not disrobe her but kept his hands moving under the loose folds of her clothes, his fingers bringing her to climax two times before

he let them slip down inside of her, into the deep places she liked so much. When she began to moan and press back into his hand, he slid her bottoms down and slipped his hips between her legs. When he entered her, she began to cry again, a soft crying with wordless sounds, and he made her come again and again until the crying stopped and she seemed quiet.

After she was asleep with a blanket tucked around her, Kobi noticed two things. The drama on the screen had ended. And he had not come.

The next day Merin introduced the proposal that cybersex, being a safer way of fulfilling sexual satisfaction quotas without the potential danger of meeting one of the admittedly few but seemingly rising number of disturbed individuals, should be subsidized for home use. The connectors were cheap and easy to extend from the main network. No one should have to go all the way to the Velderet or another sex house just to sit in a room alone.

There was nothing she could do for those people who might have blundered in real life, she thought, but at least there was some chance she could help salvage R&V even if people became afraid to go out looking for it.

And tonight she was supposed to meet Him. She wished she could connect from home, her paranoia making her leery of going to the Velderet again so soon after her last visit. She could go somewhere else, but that might seem all the more suspicious. She remembered walking home alone through the park that one night . . . the feeling that someone had been following her fueled her paranoia even more. If only there were some way to send him a message, to tell him to change the day, or talk to him some other way. Surely he'd understand. She was sure he didn't relish the thought of being sent for counseling either—it would be especially bad for him as he was the dominant partner. And yet, thinking about not meeting him as he'd ordered made her feel ill. So ill that she went home in the middle of the day and passed the latest round of consensus forging on to Nazir.

She found the domicile empty, with Kobi at work and

messages waiting for her. She'd listen to them later. She steeped herself some carnila leaves in hot water and sat sipping it on the couch, thinking about Him, thinking about if things would get better or worse. . . . She remembered the Kylaran recordings Kobi had been making. *Better erase them while I'm thinking about it,* she thought. She lit the media wall and called up the retrieval system. Kobi had labeled the files by date. Her fingers tapped on the control pad as she deleted them.

And I never even got to watch them, she thought.

She held the control pad tightly. What would the harm be in watching just one? She could practice what little Kylaran she had learned through the daily updates at the legislature. She called up a recent file and settled down to watch.

The captive woman who seemed to be the main character of the drama was alone in a small room with a stone floor. She was naked now and had only her long hair to cover herself with, which she held around her shoulders. The door opened and a guard in leather kilt and boots stood in the doorway. He laughed and said a few words, and then stepped aside. Other guards held another naked woman by the arms. She pushed against them, trying not to go through the doorway, her feet sliding on the stone. One of the guards reached from behind her and thrust his hand between her legs. From the look on her face Merin guessed he had shoved his fingers up inside her—the camera then showed a close up view of his three middle fingers coned into her cunt, and a quick shot of his other hand wrapped tight around her throat. He lifted her onto the tips of her toes and walked her into the cell. The other guards followed, lifting her on her back, one at each arm and each leg, holding her legs wide so that he could continue to press his fingers into her, his thumb and little finger grinding now, while the woman cried out and squirmed as best she could.

Merin slipped out of her clothes and slid one of her own fingers into her wet hole. She remembered the way He had put his fingers inside her, confident and forceful, the way she would put her own foot into her boot. She had never before considered that her cunt might be like a handle, the instrument

of control, and that what went inside it might be the tool of ownership.

On the screen the men were laughing, lifting the woman up and down while the one guard pumped his hand inside her. Then a sharp voice came through the tiny window in the door and the guards let the woman fall. Their laughter ceased suddenly and out they went in an orderly line.

The two women were left alone. The first one's hair was midnight black, and her skin was dark and brown. The new woman's hair shone with bits of red and her skin was pale under the dirt and grime that told of her struggles. She collapsed into a ball as soon as the guards were gone and began to cry.

The two women exchanged words which Merin could not understand. Once in a while the word for *slave* or *master* would go by, but Merin could not make out more than that. The words she knew—for trade agreement and grain production and livestock and land concession—did not seem to come up.

The red-haired woman seemed to brighten at something the other one said, and the two women huddled together for warmth. Soon the red-haired woman was stroking the black haired woman's breasts with soft fingers, cooing and telling her things that Merin thought must be something like the things Kobi had said to her last night: things will be okay, everything will be all right. Merin let her own fingers play over her breasts as the two women moaned in unison.

The black-haired woman pushed the other woman's hands toward her mound of fur, and soon the red-haired woman parted those dark lips to reveal the redness of a hungry cunt. Her fingers stroked gently and the black-haired woman sighed. After months of captivity and knowing only the pain of the guards and the harsh tortures of her captors, to feel pleasure freely given . . . Merin smeared her juices across the hard nub of her clit as she imagined what it must feel like. The red-haired woman's fingers expertly massaged while her mouth and tongue danced over the other woman's nipples. Merin moaned aloud.

The red-haired woman's hands roamed all over the other woman's body. Her head slid down to between her thighs and

her tongue took up where her fingers left off. Now the camera showed a close angle, the tongue flicking at the clit, and the fingers, circling and circling the edge of the vagina, but not going in. The black-haired woman's moans became louder and Merin pressed two fingers against her clit, moving it side to side, then forward and back. The fingers on the screen continued their dance, up and around the woman's cunt, but never into her, and Merin found herself thinking, *Go on, put your fingers in, ram it up in her like the guards did to you, that's what she wants, she's screaming for it.* Was the woman only teasing her? Or would she not do it because of what the guards had done?

The black-haired woman was clearly begging now, crying and pleading, trying to get her own fingers down into her slit. The other woman caught her hands and twisted them behind her back. At that moment a lone guard entered and chained her hands above her head on a wall. He manacled each foot and attached her legs to rings in the floor that left her wide open and unable to clench her thighs. Merin's fingers moved faster on her own clit. The red-haired woman laughed a cruel laugh and leaned against the guard. The guard smiled at her and pulled her to him. His hard cock protruded from the slit in his leather skirt and he lifted the woman by her hips and impaled her on it. She continued to laugh as she locked her arms around his neck and he pumped her up and down with his large hands locked over her bare ass. The black-haired woman wailed in distress as she realized her betrayal and her unfulfilled state of arousal.

Merin came, her vision darkening as her fingers flew and she struggled to keep watching the screen. But then it went dark, the end of the episode, and she let herself slump, two damp fingers sitting idly inside her cunt as she replayed the images in her mind.

She wished Kobi were home, then, wished for his hard, hot, ready cock. Nothing fit inside her as well as a cock like that, she thought, one of the things she had missed when she had been in a relationship with a woman. But, that was what places like the Velderet were for. Her thoughts drifted to Kobi, pouring drinks at the sex house. If he were her slave in real life, she

mused, she could order him to come home and fill her up right now. She could have his cock—no, *her* cock, she corrected—anytime she pleased. At that moment, it did not seem a dangerous thought. It seemed a happy, all-balanced-in-the-world thought of domestic harmony and bliss. She began moving her fingers inside of her, pretending it was Kobi, then pretending it was Him, pretending the two of them were there, first Kobi thrusting himself inside her, his hot breath on her neck, and then her mystery man, suddenly there, pushing Kobi aside and sliding himself into the wet empty place, his rightful place, his fingers making her come, again and again, fucking her and making her come even after she was exhausted, she came and came, until she had lost count and had no way of making him stop . . .

The door chimed and Merin sat up quickly, wiping her hands on her discarded clothes. She hit the Erase control and switched the media wall off. She hurried to the bedroom to put on a robe and went to the door.

When she opened it a man and a woman greeted her. "Is this a bad time?" the woman asked, eyeing her robe. "We left you several messages . . ."

"Oh . . ." Merin said, thinking of the unretrieved messages she'd ignored when she came home. "Is it urgent?" Some utility problem with the domicile, maybe?

"It's about Kobi," the woman said. "We'd like to talk to you about him, as a part of his evaluation."

"Evaluation?" Merin stammered.

"Yes," the man said, biting his lip impatiently. "We're trying to determine whether he should be counseled." The man did not say, but Merin could hear that he did not mean whether Kobi should be counseled or left alone. It was whether he should only be counseled, or perhaps something worse. "We hope you understand that your complete candor will be necessary."

"I understand," Merin said. She could not say the words that would make them go away and come back later—she could feel the lie sticking in her throat. It would be obvious, and then they would suspect her as well. There was no time to clean up, no

time to put the window sash opener back onto its hook, no time
to pick up her clothes from where they lay in front of the me-
dia wall.

"Please come in," she said, adjusting her robe as she turned.
"I'll steep some more carnila leaves."

By the time they left it was full dark out, and Merin did not
dare go to the Velderet, or anywhere else she might meet or con-
nect with Him. The Evaluators had not recommended that she
herself be counseled at this time, but she knew they would be
watching her. As soon as they were gone, she deleted the rest of
the files and cleaned the domicile. She scrubbed at the syrup
stains by the sink, hydrocleansed the shower, took down the
curtains and washed them. It gave her mind something to do
besides think about Kobi and wonder what he might be going
through, right now.

Kobi lay on his back on a bed in a small, gray room and
thought it ironic how similar the room was to a cyber suite, but
without the neural connectors. Generic institutional small room,
he guessed, probably designed and built by the same govern-
ment team. The Evaluators had been in and out all day, asking
him questions, giving him tests. At first he had been scared, but
now he was mostly bored and hoping he could go home soon.
Thus far no one had come out and said he was under evalua-
tion because of his sexual practices, but he knew that had to be
why he was there. Eventually they would get around to asking
him about that, he supposed, and then maybe it would get
interesting.

In the meantime he wished he could masturbate, but he
didn't dare. His being kept in a room (the door wasn't locked—
he'd tried it) with people going in and out all day reminded him
so much of the Kylaran drama. He wanted to pretend he was a
captive, being broken to be a slave, denied food and water but
trained for sexual duties . . . Thinking about it, his hand strayed
toward his crotch and he quickly rolled over, onto his stomach.
They might be observing him now. He closed his eyes to pretend

to sleep, and again he could see her, bound in chains, covered in beads, suffering . . .

The door opened and he sat up, forgetting about feigning sleep as his need to break the boredom overtook him. "Hi!" he said to the man and woman who entered. They stood in front of him, stiffly, the way most of the Evaluators stood, and the woman repeated several facts about him that identified him: "Kobi, bartender, Velderet. Marianna district resident, schooling level three, employment level three, breeding level zero."

"That's me," he said. They ignored him.

The man continued in the same dispassionate voice. "Your case number is one-one-oh-four-seven. Your final evaluation will take place shortly. In the event that you are relocated, you will be given the opportunity to appoint a representative to put your affairs in order. Do you understand?"

"Yeah, sure," Kobi said and stood up. They escorted him down a long hallway with doors identical to the one on the room he had been in. He could make out the sounds of people coughing, talking in low voices—it sounded like a busy place for so late at night. They brought him past a large empty room full of chairs with an empty podium, and past an area where several people sat around round tables drinking something.

Eventually they passed out of that building entirely and he could see the lights of Marianna City on the horizon. As the two of them were about to take him into another low, generic building, a rumble came from the sky and all three of them looked up.

They could see nothing but the stars being blotted out, one by one.

► Chapter Eight ▼

THEY STOOD LIKE THAT LONG MOMENTS, until the rumble began to fade and the black shape above them began to shrink as it floated toward the city.

"What was that?" the man said, the gruffness of his Evaluator voice gone.

The woman scowled at the shrinking shape in the sky. "Must be a Kylaran. Maybe a trade shipment or something?" But she didn't sound sure.

Kobi didn't say anything. He'd seen ships like it before, on the Kylaran broadcasts. It was a war ship, and he wished, for once, that he had watched the news. He had one last glance at it before they pushed him through the doorway.

They went down a long hallway, turned a corner, and walked some more. There were no doors along the corridor, just one at the end. The woman manipulated a complicated series of locks, and the door swung open with a slight hiss. On the other side was . . . more hallway. Kobi thought of a wisecrack about needing walking shoes, but didn't say anything. The door closed with a quiet clicking, and Kobi knew it had locked behind him. So, now he was locked in. That was new. He could already see the corner up ahead. They turned it, and he saw another door. They

were spiraling in toward something, and each door seemed more complicated and difficult than the last.

Except the last one. That one swung open as they approached it, and the two Evaluators gave him a small shove.

Kobi found himself sliding down the perfectly smooth sides of a huge, black cone. He would have been amused that the place was roughly the size and shape of the lounge at the Velderet if he hadn't been so scared. It was just like the Velderet, if you removed all the seats and cushions and tables, and planed it smooth. He came to a stop at the flat bottom, where the bar would have been, and where currently there was only a strange black box. Kobi would have called it a table, but it had no legs and was solid on all sides, or so it looked. It looked slightly soft, like it was coated in padding, but he did not dare touch it. He sat at the edge of the white circle of floor, his back against the black sides of the cone, and hugged his knees.

They made him wait a long time. He didn't know how long— he only knew his mouth was dry and that he wanted to take a piss very badly. "Hello?" he called, looking around again. Nothing had changed. Far up the sloping walls was the doorway he'd come through, the white ceiling translucent and glowing and no other windows or cameras evident. "Hello? I'm still here."

No reply came. Kobi knew and did not doubt that he was being observed. They said this was his final evaluation and he didn't suppose that pissing on the floor would make a good impression.

Time, as it will do, crawled by. He stood up and walked in a circle, trying to relieve the cramps that he felt in his gut. He approached the black box, looking at it carefully. Maybe there was a drain hole underneath it? He pushed against the box and found that it was soft; he recognized the feel of the covering: Ultra-stretch rubber. He couldn't move it.

He resisted the urge to sit or lie down on it, and went back to sitting in the spot where he had slid to a stop. Some time later, despite the pressure in his bladder, he fell asleep.

As he slept he dreamed of the captive woman in the drama.

In it they were captive together, chained and unable to reach one another, but in the same cell. She was speaking to him.

"They want me to submit, but I will not. I am of noble birth and not meant to be a slave."

"I don't understand," Kobi said. "You submit to them every time they come in here."

"No, it is you who do not understand. Although they may force my flesh, I will not give it willingly. To do so would be to acknowledge that they are my masters. They are not. They are merely my captors."

"How long will you keep it up?" Kobi felt the dryness in his own throat, the chains cutting into his wrists. "What would happen if you gave in?"

"They would bring me up into the palace and make me a prize. I would have silks to wear and a golden bed to lie in while I wait for my master's pleasure."

"That doesn't sound so bad."

"That is because you are slave stock."

"But, if you are forced to . . . do it anyway, why not do it in pleasure and in a golden bed?"

She made a sound of disgust. "Because I am of noble birth. Perhaps if I hold out here long enough, withstand enough of their tortures and degradations, they will realize that they are wrong and that I cannot be broken. Slaves, deep down, have a wish to be broken, you know. Eventually they will be, even if they seem strong at the beginning."

"And if they don't believe you?"

He could see her face, streaked with dirt and tears. "If I decide that there is no other way, I will pretend to give in. I will give them everything they want. They will not know—they are so drunk with their own power that they will believe that they have won. And then, when I am in my master's bed, I will strangle him."

"Oh."

Kobi awoke with a foot on his stomach. "Hey!" He looked up at a figure dressed in bland white togs: another Evaluator, but this one wore a mask over his/her face.

A male voice spoke. "Get up."

Kobi shivered to hear such a commanding voice in real life. To speak like that on the street in Marianna would have caused gasps of shock and surprise. Kobi stammered, "You didn't say please."

The foot bore down harder on Kobi's ready-to-burst bladder and Kobi yelped.

"How can I get up when you're stepping on me?"

"Get up." He spoke no louder this time, but Kobi heard the harshness.

"Please," Kobi said, "don't do this." Kobi did not remember his dream well, but he did remember the decision he had made. He would not fight. That was what they wanted and would send him to recon for sure. He was a model citizen in all respects and planned to show it through his acquiesence.

"Do what," said the voice.

Uh oh, Kobi thought. *I can't very well tell him how I'm planning to dupe him.* "Don't make me piss myself."

"And why not, insect? Why shouldn't I step on you and splatter your juices all over, just like a bug?"

Kobi's mouth gaped. This was a Bellonian saying these things to him. It wasn't possible.

The Evaluator stepped back suddenly and Kobi curled around himself. "You're shocked, I can see it. You don't want to piss yourself. How nice. But you're thinking only of yourself, aren't you, now? And what kind of a way is that for a good citizen to think?"

"That's not what I meant by it and you know it," Kobi said before he could stop himself.

"Oh, Kobi." Kobi shivered to hear the Evaluator speak his name. "That's the problem. You don't know yourself what you mean by it. You don't realize how you've been perverted. You don't realize how you've internalized things you shouldn't have. I'm here to find out exactly what and how"

The Evaluator was wearing gloves, weighted gloves, Kobi realized, as the Evaluator grabbed him by the throat. Kobi tried not to struggle, but it was hard. He closed his eyes and felt

himself pushed and pulled until the backs of his legs hit the black box and he was suddenly lying down on it. He lay perfectly still.

The Evaluator slapped him across the face, not a stinging slap, but a heavy, jaw-jarring blow from the extra weight in the gloves. He kept his eyes closed and watched stars and fires bloom behind his eyes.

"Pervert!" The Evaluator slapped him again. "Look at me!"

Kobi looked. The mask was impassive, form fitted with slits for eyes and mouth, but he could hear the anger in the Evaluator's voice. *He wants me to fight back,* Kobi realized. *He's mad that I'm not.* The Evaluator stepped back then and Kobi saw his mouth moving under the mask, conferring with someone else, subvocally.

The Evaluator spoke to him then. "Take off your clothes."

Kobi stood and did as he was told, holding the clothes in a wad and hoping that the Evaluator would tell him he could piss soon. "Should I fold them?"

"I don't know, should you?"

"I think that I should, but not if you don't want me to."

"Why do you think that you should?" The Evaluator sounded impatient.

"Because these clothes are a resource of the community. It's my duty to preserve them."

"Very good, citizen," the Evaluator snarled. "But how do I know you really believe that?"

Kobi shook his head. "I don't know."

"What if I told you the only place to piss was into those clothes?"

"I'd hope you were lying to me." Kobi put his pants over his shoulder and folded up his shirt while he talked, placing it on the black platform. "I'd hope that this was all some bizarre test that, once it was over, I could go back to being normal . . ."

He stood still for the slap. He saw it coming and he stood for it, and let the pants fall to the floor. He bent to pick them up and the Evaluator shoved his bare shoulder with his boot. Kobi sprawled onto his back.

"I don't believe you," the Evaluator was saying. "Any pervert would say something like that to keep out of recon."

"I don't know what you want!" Kobi cried as the Evaluator came closer to him.

"That's right, you don't. If you did, then this little evaluation wouldn't be valid, now, would it?" The Evaluator straddled Kobi, planted his knees on either side of Kobi's ribs, and slapped him again, making Kobi's ears ring. Kobi could taste blood in his mouth and he began to cry. "I thought you liked this kind of thing." The Evaluator laughed. "I've seen the cyber tapes of you. I'd thought you'd get off and we could have some fun."

Kobi squeezed his eyes shut. So they knew about Kobi2, they really knew.

"No one knows you're here, you know. You belong to us, now. You're not a citizen until we say you are." The blows kept coming. Kobi felt some far away part of himself crying, still. The Evaluator was still talking. "It's really too bad. We don't get to have any fun here."

There was a part of him, under the crying and the pain, that was calm. He realized underneath it all that it was obvious what the Evaluator was doing. Kobi had planned to give in, to do whatever they wanted—but what they wanted was for him to give in, to show how much he liked it, and therefore to betray himself to reconditioning. Somewhere under it all he wanted to laugh. They were so clumsy about it, so obvious. And this Evaluator himself? Well, Kobi could feel the man's erection through the loose togs against his stomach.

"Please stop," he found himself saying. "Please stop."

The Evaluator got up and pulled him back to the platform, put him on it facedown. "What do you want now, Kobi? Do you want me to whip your ass? Or penetrate you, maybe?"

"No, no. Please."

"What do you want?" The Evaluator's voice dropped a notch, a sure sign this was a trick question.

"I just want to go home. That's all." Kobi's face was pressed against the soft rubber sheet, his wet tears making it slick under his cheek.

"You know what the purpose of counseling is, Kobi?"

Kobi supposed he was about the hear the answer anyway, so he said nothing.

"You're supposed to be reminded that your body isn't your own. It's just a cell in the body of society. Isn't that right?"

Kobi nodded, snot mixing with the tears. He felt the gloved hands of the Evaluator on the backs of his legs.

"Sometimes a body gets sick and has to get better. Counseling—you know what it really is? It's like telling your cells not to get sick. Well, you know how well that works, don't you? Not very well at all. Sick cells have to be destroyed. Special killer cells do the work of cleaning up the bad ones. Are you one of the bad ones?"

I suppose you're the killer cell, Kobi thought. The hands went away and then came back, gloveless. For the first time the real possibility that he might die entered Kobi's mind. He had met only one or two people in his lifetime who had gone to recon—he'd supposed at the time that they had been as stupid and brainless before they had gone to recon; in fact, he'd assumed that was why they had been sent there in the first place. But it seemed obvious now that medical reconditioning might entail destroying part of his brain. If he lived through this, would there be any of him left?

"Are you one of the ones we'll have to cull? I don't know, Kobi. We'll decide that later, after we see how you respond to . . . all this."

The black box began to hum, and Kobi felt it rise. He was bent over the edge of it now, and from somewhere the Evaluator pulled straps across his back and thighs. Despite his crying and his fear, Kobi was thinking: stupid idiots. They were going to rape him and see if he liked it. How were they going to tell? Presumably, they knew from the Kobi2 log that he would ejaculate if stimulated enough. But there were two things they didn't know. One, that he really was getting better at resisting, and two, that he could never come when his bladder was full.

That didn't mean, of course, that this was going to be easy. He took deep breaths, but could not stop sobbing as the Evaluator probed at his ass with . . . something. Not his own cock:

some hard, rounded tool. Kobi did not dare look. He knew it would be easier if he relaxed, but he did not want them to think he wanted it. As the Evaluator spread him wide with one hand and pressed the rod with the other, Kobi said, "No!"

The rod was inside him, the pain in his bladder excruciating, Kobi did not have to fake anything. "Leave me alone, please!" he cried. He clenched his fists and teeth.

"You're just a cell, Kobi. Your body is not your own. It belongs to us, to the State. If you can abuse it, why can't we?"

"I didn't . . ."

"Didn't what?"

"I didn't . . ." He cried out as the Evaluator twisted the rod. "Abuse it!"

"Not even at home?"

"Never! It was all . . . all a fantasy! I don't like it to really hurt! That's why I did it through cybersex!" Kobi kept opening his mouth to say, "Stop! Make it stop!" But he was saying these other things instead. "It was just a fantasy!"

"Don't you share a domicile with someone else?"

"Yes."

"What's your roommate's name?"

"Merin!" But they knew that. They knew everything about him. Except what went on in private. Unless Merin had told them . . .

"That poor girl, living with a pervert like you."

Merin would not have told them. He knew it. And yet.

"She must have been so disgusted with you. You made her do these things to you, didn't you?"

"No!" The Evaluator had another tool now, one that made a noise in the air like an electric spark. "No!"

Kobi felt the first bite of fire across his back and screamed.

"This can all stop if you tell us the truth."

"It's true! Merin, never—"

Another line of fire crossed his buttocks.

"Come now, Kobi, I have to be sure."

Kobi could not catch his breath as the pain seemed to intensify on his skin. His chest heaved and he gulped down tears and

mucus. Then he managed to open his mouth and say, "Sss . . . sadist."

"What did you say?" The Evaluator held the rod still and grabbed a handful of Kobi's hair, pulling his head back.

"You . . . you are the evil . . . that brought the Gerrish down." Kobi could see the Evaluator now; with his head twisted back he could see the white mask and the slits of eyes. "There were supposed to be no more like you . . ."

The Evaluator opened his hands and Kobi slumped forward, the rod falling from his ass. "We serve the people. We do what is necessary."

Kobi tried to look at the Evaluator again. "Please. There's nothing I can say or do to convince you, is there? Why don't you just kill me and get it over with? I'm not stupid. There'll be no relocation for me. You can't let me go back out there knowing what I know. So which is it? Are you going to kill me, or just chop out the part of my head that would remember this?"

The Evaluator stared at him for long moments. At last the Evaluator said, for the last time, "What do you want?"

"Mercy," said Kobi. "Mercy."

Merin sat up in bed in the dark, feeling for Kobi and then remembering he was unlikely to be home any time soon. Was it morning yet? Then she heard the noise that had woken her, the emergency signal from the media wall in the living room. She stumbled out into the room and saw that it was strobing red and purple.

Her first thought was that it must be about Kobi. How many hours ago was it that two Evaluators had sat here and questioned her about him? Yes, Merin had said, Kobi was a little more active sexually than her previous roommates, but, no, nothing abnormal. They had pressed her for details of their sexual relationship and she had told them everything right up until that fateful night when they'd confessed to each other. *The easiest lie to give is the truth,* she thought. They then wanted to comb the house records for contraband. Merin had let them search, to prove his innocence. They had found nothing.

She tapped the control pad and a text message came up for her.

Legislative Emergency Session.

That was all it said. No details, nothing else. That was worse, somehow. If it had been a natural disaster or an outbreak of plague or something, the details would have been posted. So it was not about Kobi, at least not directly. Merin knew, somehow, that it was the Kylar. She dressed hurriedly and ran for the door.

The Evaluator was laughing.
"I'll do anything you say," Kobi said. "Just please."
"Piss," the Evaluator said.
Kobi pleaded with his eyes.
"That is my command to you, dirt. Piss."
Kobi laid his head down and felt something inside him come loose. As he started to cry again, and tears sprouted anew on his face, hot urine began to pool under his stomach, still bound tight against the platform, and run down his legs, onto his feet. He could hear it splattering as more and more came, and his abdomen shivered as he released it. He pissed, and the Evaluator laughed and told him he was right, they couldn't let him return to society in such a state. They'd give him mercy, all right, and he'd do anything they said.

They truly thought him beaten. Kobi knew it when the Evaluator carried him out of the room, his boots making soft squeaks against the smooth, steep walls as he climbed to the entrance. The Evaluator brought him, still naked and piss-covered, out to a vehicle and left him there. Kobi guessd that it was probably a short trip to the medical facility where they'd cut out the parts of his brain that made him so sick. The sky was lightening behind him and Kobi guessed that daybreak could not be far off. Kobi heard the Evaluator speaking with other people—a peek out the window revealed two Evaluators, the ones who had brought him to the torture room. They were

nodding to one another. Then one of them gestured skyward and the tenor of the discussion changed. They were upset and distracted about something.

While they argued, Kobi eased himself into the driver's seat. There were no other vehicles in sight—not even the transit van he'd been brought in. He let the lock off the wheels and began to roll silently toward the downhill road. Behind him, he heard a shout. He punched the ignition and left them in the dust.

Kobi's plan was to get down nearer to the city, then ditch the vehicle and hide in someone's yard until he figured out what to do next. But what he found when he got down the mountain was that there was little chance anyone was going to be able to follow or track him. The streets were clogged with people and vehicles, many carrying bags of clothes or their children. Most were trying to leave the city, which seemed understandable given that the ship Kobi had seen last night was now hovering over the city center like the head of a giant axe waiting to fall. It hung black and opaque in the morning light, as the sun was about to rise.

In the back of the vehicle he found white togs like the Evaluators wore and a mask. The mask was surely not a good idea—too conspicuous. But a look into the driver's mirror told him the bruises on his face were conspicuous, too. He put the suit on and pulled one of the loose folds over his head like a hood.

Out on the street, no one was paying any attention to him. If they were distressed by his appearance, it did not show. He could not go home. He knew that would be foolish. Kobi made his way toward the black shape in the sky, and the buildings of the legislature, where he knew Merin could be found.

Merin also fought her way through the streets to get to the legislature. The ship was as huge as a thundercloud—no, larger. She walked under it practically the whole way from her home to the gardens. It stayed twilight underneath the ship, the dawn blocked out as if by the edge of the world.

Her office was deserted. Every legislator was gathered in the

Main Hall. She switched on the screen on her desk to watch the proceedings. Five hundred legislators were talking at once, each one trying to convince his or her neighbors of their opinion of the situation. Briefs scrolled by along the frame:

No word from Kylaran ship since 8:05. Next message expected 12:30. Text of previous announcement follows.

Merin scanned the message. So, it seemed the Kylar had decided that negotiation in good faith was no longer an option. The message declared Bellonia a Kylaran property, the terms of which possession were to be put forth in the later message.

Merin switched off the audio on the Main Hall. What she could make out was of the "I told you so" variety. She put her head in her hands. Two days ago, everything had seemed right. Kobi was not being reconditioned, her master had agreed to meet her, and the Kylar were not the evil conquerors the propaganda made them out to be. Today . . .

"Merin."

She started at the sound of her whispered name. In the doorway, next to Nazir's desk, was a figure in white. "Kobi?"

"Shh." He gestured to her, and she went to him in the shadow of the door.

"Oh my god, Kobi, your face . . ." She went to touch his bruised cheek and then thought better of it. "What happened?"

His jaw worked while he tried to come up with an answer. "Recon," he finally said. "I escaped."

"But your face . . . I thought reconditioning was done with drugs and surgery, and only as a last resort . . . ?"

"Apparently, I am a danger to society," he said with a shrug.

"Well, society is in danger." She pressed her hands to her mouth. "The Kylar are taking over."

He sighed and leaned against the wall. "Why?"

"I don't know." Merin held him to her. "Is there somewhere you can go? Besides our house?"

"I can't go to the Velderet, either." Kobi squeezed his eyes shut. "Maybe . . . Nayda?"

"Who?"

"She's a technician, flirted with me a bunch of times. I memorized her number." He rattled it off to her.

Merin kissed him gently on the mouth. "Well, I doubt she's working today. Go to her, wait for me there."

"What are you going to do?" He held her tight, suddenly afraid that he would never see her again.

"I'm going to find out what I can here."

Kobi didn't know why he began to cry at that exact moment. He sobbed and leaned his head against Merin's shoulder. On his tongue he tasted fear, and the knowledge that nothing would ever be the same, and he kissed her again, harder, not caring about the bruises.

Her hands felt for him under the soft white cloth, and he felt for her, and they sank down in the doorway, rows and rows of desks standing mute guard while they brought their bodies together.

Kobi stood at Nayda's door, waiting for her to open it. It seemed to be taking a long time, and he wondered what he was interrupting. He put his hands over his face so only his eyes showed, his palms on his cheeks, his eyes peering from between his fingers.

"Kobi? What . . . what's wrong?" Nayda opened the door, swallowing nervously.

"Can I come in?"

She stepped back and he entered. The layout of her domicile was identical to his and Merin's, and he wondered if she had a roommate. No one else appeared to be home; he sat down in the living room and let his hands drop.

Nayda gasped in horror and, like Merin, instinctively reached for the bruises before stopping herself. "Who did this to you! Did your roommate . . . ?"

"No." Kobi frowned. "No, Evaluators did this."

"Evaluators!" She burst into tears.

"Have they evaluated you, too?" Kobi asked, perplexed by her reaction.

Nayda shook her head and hid her face in her hands. "Oh, Kobi, I'm so sorry."

He took her hands. "Why?"

"Because . . ." She bit her lip. "Because I'm the one who reported you. I found your program at the Velderet and gave it to them."

Kobi stared into her face.

"I had no idea they'd . . . I mean, I thought they would make you better . . ." She collapsed into his lap, her face hiding under her golden hair.

He stroked her hair. "It's okay, Nayda. It's okay." He waited until she had slowed down her crying some before he went on. "But why, Nayda? Why? I wasn't hurting anyone."

She sat up then and tried to compose herself. "I found it by accident, you know. You'd created a glitch by trying to both read yourself and feel yourself at the same time. I had to disable the feedback loop, and while I was doing it, I looked to see what it was about."

"I'm so sorry—" he said.

"No, no," she said quickly. "It was okay. In fact, I . . . I kind of liked it . . ." She choked a little then. "But it scared me! I thought for sure I'd be the one in counseling if I didn't do something about it. And then with the crackdown, especially, I thought . . . Oh, Kobi, I was just scared and covering my own ass. I mean, what if they found out about it, and then asked me why I hadn't reported it? I had to report it before that happened."

Kobi felt strangely calm. "Or they might have considered you suspect, too," he said.

"Yes. I never knew I'd be . . . excited by that kind of thing. And I thought maybe I was sick or crazy."

"Do you still think so?"

Nayda took a deep breath. "I don't know." She touched a finger lightly to his bruised mouth. "But I know what they did to you is crazy. I'm sorry, Kobi, I wish there was some way I could make it up to you."

"Well," he spoke softly, "a shower and a few hours' sleep would go a long way for me."

"You're not afraid I'm going to report you again?"

"I am. I'm sorry, Nayda, I want to believe everything you say, but it's been a very long night and I don't have much trust left right now." His voice remained calm as he stood up. "You'll just have to come with me."

"Into the shower?" she squeaked.

"It won't hurt. There's plenty of room for two in the cubicle." He shed the white clothes he was wearing. "You can stay dressed if you want, but it's much more pleasant without."

She looked from side to side, as if making sure no one was watching, then slipped out of her clothes, too. "Kobi," she said, in a quiet voice, "no one knows this, everyone thinks because I work in the sex houses I'm really . . . I mean, maybe it's something about being a technical person, but I don't really have a lot of sex. Usually."

He took her by the hand and led her to the shower. "Maybe if you'd been more honest with yourself about what excited you . . . you would," he said. "We don't have to have sex, if you don't want. But I do need you in here with me." He pulled her into the cube and turned on the spray.

"I didn't say . . . I didn't say I didn't want to," she said then, as her skin went slick with soap. She slid her hands up his torso to his nipples. "I . . . I've always thought you were beautiful."

He bent to kiss her then, his wet hair hiding them like a black waterfall. His hands roamed her back, curved over her buttocks, tickling her anus with soapy fingers. She squealed and pressed herself against him, trapping his erection between their slippery bodies. After a while, the soap cycled out, and they were rinsing. Kobi knelt down and searched her clean folds with his tongue, making her squeal more and put one leg over his shoulder. He leaned her into one corner of the cube while he plied her with his tongue and slid a finger into her cunt. His other hand circled a nipple, hard in the wet spray. When the water cycled off, he carried her to her bed and lay her down in a wet pile, and with his hair washed up on her stomach like seaweed, he used his tongue to make her come again and again.

He lay down beside her then, tired and wet, and said "Was that okay?"

She looked up at him. "Are you finished? I mean, I hoped you would . . ." She blushed very dark.

"It's okay Nayda. It's okay to ask for whatever you want."

"I want . . . I want you to do what you did in the tape."

"Which thing?"

"I want you to come in my ass."

"I can do that."

She kissed him. "I've only ever done it in cybersex. I was afraid . . . that it would hurt."

He kissed her back as he rolled on top of her. "There's nothing to fear from pain if it's given with love," he said. "And if I do it right, it shouldn't hurt." He paused then. "Unless you want it to. Do you want it to?"

"I . . . I don't know."

"Let's try it easy first. Got any hand lotion?"

She did, in a container right by the bed. He started with a finger first, to give her the feel of it. His smallest finger, in and out, until she was gasping. Then he put two fingers together and she let out a long, low moan, her legs trembling as her hands clutched at the bedcovers. "Yes, yes," she said, to no question he had asked.

When he slicked himself up, finally, and pressed himself against her, he decided to double check. "You're sure?"

She nodded, and he eased himself into her, bit by bit. "So big," she said, between gasps.

"Breathe," he reminded her. He had had a lover once named Weil, who was much bigger than what he was used to. Freakishly big. He had never let on that it hurt him in the slightest, because he had liked how it hurt. He had liked that big thing ramming him when Weil got close and lost control. Weil had liked Kobi because he had found so few lovers who really enthused over his size, but when he turned breeding age, he'd entered into a family partnership and Kobi never saw him again. "I'm all the way in."

He felt her clench and relax and then wiggle her ass

experimentally. "Oh." She found she could move up and down on him. "Oh, I like that."

"Here, allow me." Kobi pumped himself in and out and saw her head fall back with bliss. "Do you want to come again?" he said, as he got a bit faster.

"Just try and stop me," Nayda said, and a little while later, she did, and he did, too.

They fell asleep in a damp tangle while Kobi wondered to himself about what had just happened. Maybe that hadn't strictly been necessary, but as of now, he had no regrets. He had wanted to spend a night with Nayda ever since they first met, but whoever would have guessed the circumstances that finally made it happen.

The door chime woke them some time later and Nayda panicked. "It's the Evaluators!"

"I hope not," Kobi said sleepily. "I hope it's Merin."

It was Merin, her eyes ringed with fatigue. She took in their disheveled state and smiled. "The Kylar are getting ready to make an announcement. Their Grand Overlord or something is going to make it himself."

"Overlord?" Kobi heard himself say as they all went toward Nayda's media wall.

"Meaning not the ambassador, but the actual governor," Merin said. She sat on the couch and turned the control pad on. It didn't matter which channel they chose. The message would be on all of them. The news reporters had chosen to remain silent and the screen showed just a set of tiny numbers counting toward zero.

And then the image of a man, in a tight Kylaran uniform, black as the ship that hung in the sky and accented with gold, filled the screen. Merin and Kobi gasped simultaneously.

"That's *him*!" said Merin. Her master stood there with a frown on his face.

The camera showed a few members of the Kylaran retinue standing behind him. At his right was the junior ambassador Merin had seen several times in the legislature.

"That's Mica!" said Kobi, pointing. They looked at each other, but there was no time to explain. The Kylar began to speak.

It was clear from his first words that the Overlord was angry. "We Kylar are a people of honor. We keep our promises when they are made with other people of honor. When promises are broken, then we are no better than animals.

"You, Bellonians, we thought you people as well. But you are animals. You allow fear to overcome your rational sense and your sense of honor. We have no choice but to treat you as animals.

"Bellonia is ours; the fate of your world and your resources is not in question. All that remains is the fate of your population. You are not fit to sit at the feet of your masters; even a pet has more loyalty than you have shown. You will be hunted down like prey, like the wild, undisciplined things that you are."

And that was that.

Merin turned to the other two in shock, her lips and throat suddenly dry. "It's me he's talking about. Me."

"What do you mean?" Kobi held her hands.

"I was supposed to meet him last night. I was supposed to be there! But I was talking to the Evaluators instead . . . and then I went to sleep, and woke up, and the warship was here."

Kobi shook his head. "It couldn't be . . ."

"I'm sure of it. It was a test, of whether I would go through with it. He was using the cybersex system to look for people like me and see if our feelings were real!"

"But . . . are your feelings real?" Kobi's voice shrank.

"I think so," Merin said. She had felt so sure, just a few days ago, that she had found something. Exactly what, she wasn't sure, but something important and true. "I've got to talk to him. Convince him that he's wrong."

Nayda frowned. "Wrong about what?"

"We shouldn't be hunted down like animals. We can understand the Kylaran system of honor and should be treated as equals . . ." She clutched Kobi's hand tighter. "I've got to talk to him."

The screen, which had gone black after the message had played out, came to life again, as the news channel resumed broadcasting. "That's the legislature!" Merin said, pointing. The image was of the main plaza, the garden of statues on the right, the Kylaran embassy on the left. It was in flames. "Who could have—?"

Kobi turned her face to him with a gentle finger. "Don't be surprised at anything a Bellonian can do."

"Can I make a suggestion?" Nayda said, sitting on the floor at their feet, her legs crossed. "We can try to send a transmission to him, on his ship."

"How?"

Nayda held up a micro-spanner. "I'm a technical person," she said. "I get things done."

► Chapter Nine ▼

BETWEEN NAYDA'S EXPERTISE, Merin's legislative codes, and the general chaos, it was easy for them to commandeer the ambassadorial comm channel. Then they had to decide what message to send. A text message, they decided, would be seen as a ploy. Instead, Merin stripped naked, knelt in front of Nayda's seeing eye, and they recorded her plea and sent it.

A tense hour went by before the control pad chimed. A live call was coming in. Nayda keyed it to receive, and there was the junior ambassador, the one Kobi had called Mica. The resemblance between the Overlord and him was now obvious, and she wondered if it was merely because they were Kylar, or if they had a closer tie of blood. He spoke.

"The Overlord is very displeased with you."

"I know," Merin replied. "But I thought it honorable to plead my case before him, before I let my people die."

"Your people—"

Merin spat the words out before she could lose her nerve. "Would you slaughter us over a misunderstanding? How can you be so sure of anything? The Overlord and I never even met in the flesh. How can he be so sure of my motive, my honor?"

"He would not defile himself by meeting your flesh with his own."

"Then how can I give myself to him, fully and truly? It is he who breaks the pact, not me."

The ambassador looked perplexed, his eyebrows huddled together on his wan face. "This is his mess. I will leave him to handle it himself. Prepare yourself to come aboard."

"How, ambassador?"

"We know where you are. Wait outside. If you value your dignity with us, what shred you may have left, do not dare to cover yourself. Do not dare to meet the eyes of those who collect you, or speak to them. Be ready."

And the transmission ended.

"Kobi, we don't have much time," Merin said then. "There must be something we can do to convince him that—to convince him that there are other people like me, and that we're not to be slaughtered."

"You want me to go with you?"

"No. But I might need you later. I need you to stay here. You too, Nayda. Do you, by any chance, have a home setup for cybersex?"

Nayda blushed red. "I do. I've got a high-speed connection to the network, even."

"Okay."

"Why?"

"I just have a feeling we might need it, that's all."

Kobi kissed her at the door. "We'll be here."

Merin knelt on the grass outside Nayda's domicile, naked, as ordered. No one was there to see it, the neighbors all having either fled the city or now hiding in their houses. Merin expected soldiers to drop down in a flyer and pick her up. When she felt her body begin to tingle, she thought it was the breeze on her bare skin. Then suddenly she felt the world drop away, gravity disappear, and everything was . . .

She woke in a room she had never seen before, had never even dreamed of before. She was lying on the floor, a padded, supple floor of midnight blue. The walls were black and gleamed with hints of gold seams. The room was not square. It had

seven, eight sides, of irregular size, and one open wall that led
into another room. She did not get to see much beyond that
wall, for in that opening He stood. He took a step forward and
the wall came down into place behind him.

She threw herself down at his feet. "Master, I . . ."

"Hush. Not yet." He pressed something to her forehead with
a gloved hand. He was clad as he had been in the broadcast, in
tight black, with what Merin assumed were marks of his rank in
raised gold on the fabric. "You will tell me everything, later. We
have unfinished business, first."

He held her in place with a hand at the back of her neck and
began to beat her with an open hand on the backs of her thighs,
her buttocks, the rounds of her shoulders. Merin was caught
with the first wave of pain and surprise, as if he'd tossed ice
water onto her. She writhed under the blows but did not
struggle. *This is punishment,* she thought. *This is how he vents
his anger. Once it is vented, then we can talk.* She tried to relax
into the blows. The pain itself was not as hard to take as what
the actress at World's Eye had dished out with her rod, but his
displeasure was. He hit her harder as he went on, and she re-
membered what he had once said about pain. That it wasn't
pain that was to be feared, but the reason for it. *He isn't doing
it just because he's cruel,* she thought, *he feels wronged.* If only
she could have righted all the wrongs in her life by just lying
still and waiting for it to be over! She almost smiled, and the
blows rained down.

"Now," he said, and rolled her over with firm hands. He
spread her legs and then her labia with his gloved fingers.
"Damn these things," he said, indicating the gloves, but he did
not remove them before sliding a finger into her. "I'm not wrong
about you, I know I am not," he said then. "And I know what
I should do next." He pumped his fingers into her slowly.

"Master, may I speak?" she asked, aware that she had to
speak to do so.

"Speak."

"The ambassador said you would not . . . defile your flesh
with mine. Is that true?"

"Yes, that is true. For the moment. So let us talk instead for a time." He withdrew his hand and sat cross-legged across from her. "I need you to look into my eyes for this part."

"Why, Master?" she said, sitting up.

"So I can see if you lie."

She swallowed. "I don't think you know why I did not meet you as we'd planned."

"Indeed. Why? Was my treatment of you imperfect?"

"No, no, nothing like that." Merin dropped her eyes and then forced herself to look into his face. It was a handsome face, a little rugged with age, his eyebrows as dark as the rest of his hair, his eyes glittering like a predator. "The Evaluators came to me."

He barely moved, and yet she sensed his attention had just sharpened another notch.

"They didn't suspect me, they suspected my roommate. I, I'm not sure why . . . they spent the entire evening questioning me." Suddenly she drew her eyebrows together. "Mica. *Mica* gave him those codes. Your junior ambassador." Her voice rose in accusation. She looked away from him now, to stare into the nothing of the walls. "So if I have missed my appointment with you, you have a Kylar to blame." Anger flared in her and she met his eyes again.

He sat back. "I see." He stood up then, his boots making indentations in the soft floor. "Do you know how complicated this makes things?"

"I'm in politics," she said. "I should know."

He laughed. "Yes, my own, I believe you. Let me explain it to you the way I see it. The decree is difficult to take back, at this point. Sander, who you know as Mica, has been eager for a hunt, for a slaughter. I am not sure why. The senior ambassador, Girman, is beneath me in command here, but . . . above me in rank. I . . ." He held out his hand. "Stand. I find I cannot explain all this on an empty stomach, and you may have an ordeal ahead of you. No, do not ask now. All will be explained, if you trust me."

"I trust you," Merin said.

"Then we have no more need of this." He reached toward her forehead and she realized that he was removing something from it: it looked like a little piece of silver foil. He tossed it away. "Come."

Another wall slid back to reveal a parlor and low chairs at a low table, heaped with food. Merin smelled something spicy and sweet. The parlor looked big enough for a party of forty, with cushions and other small tables scattered around the central table, but they were alone. The Overlord took off his gloves and dropped himself into a chair. She settled herself at his feet, feeling the wetness between her legs suddenly as she sat. He shook his head and smiled to himself. "I think you can eat what we have here. Most of it is indigenous, except for some seasonings."

The Kylar, apparently, did not use silverware. He picked at a whole fish with one hand and it came apart into neat segments. He put some on a dish for her, along with some pieces of fruit. He tore free some pieces of the lightest bread Merin had ever seen and added them. "Eat," he said, putting the plate before her and then a piece of bread into his own mouth.

"As I was saying. The situation is complicated. I have allowed my own passions to rule me, though I see not without Sander's help." He paused to peel the rind from a fruit in one swift motion. "To undo the decree will take convincing Girman what I have learned already, which is that Bellonians can be . . . taught. He sees you as weak, people who fear power even as you fear pain. It will be difficult to convince him that you are worth considering further."

"Why? Can you not . . . lend me to him?"

He smiled and she basked in that look. "So sweet. Girman is unusual among us. He takes only male caitan, I'm afraid."

"You said he outranks you?"

"Rank, station, status, you Bellonians do not have as many words as we do to denote these things. Although I am Overlord here, Girman holds a form of . . . seniority over me." He leaned down suddenly and kissed her, his passion stealing her breath. They both ended up atop the cushions, the food forgotten for the moment. "I was Girman's caitan, once."

She jerked in shock. "How?"

"There is much you need to learn about us, and quickly. No one can master without having once been a slave, even briefly. We are expected to serve, and then to . . . move on."

"We?"

"The nobility. There is what we call slave stock, those who will be slaves and only slaves, and there are those born to master, who are nobility. On worlds where we colonize rather than conquer, it is because we found those equivalent to ourselves in place there. On those worlds where we conquer rather than destroy, it is because we found those equivalent to our slave stock. On those worlds where we find neither . . ." He shrugged.

"Why wouldn't Bellonians make good slaves?"

"You have a simplified concept of slave on your world. Your Gerrish, who were all killed—were they fit to serve, or were they merely defeated? We cannot know, but it seems to me they were subjugated without being tested."

"What do you mean?" Merin leaned her head against his shoulder.

"I mean, we only consider those beings with a very highly developed sense of loyalty and honor to be fit for slaves. Were the Gerrish loyal?"

"They fought their subjugation. They would have enslaved us if they had been able."

"As I thought."

He was silent for a few moments, twining his finger in her hair. "Let me tell you something before you ask your next question, because I know you will ask it very soon." He turned his head so she could see his face, and drew back from her a bit on the floor. "The old method of testing a slave, or a master, for that matter, was through observation and intuition. Those who were truly gifted could tell who would betray or who would break, or so they claimed. But our history is littered with stories of our mistakes. The newer method is with technology."

Merin's hand went to her forehead before she realized what she was doing.

"So smart," he said, pleased with her. "Yes, we have ways of

reading your reactions, your inner feelings. I can take the entire population of a planet and scan them, and tell you who is fit to rule, who is fit to serve. But it is costly and time-consuming. And some of our older rulers still do not trust the machines. They trust only their intuition."

"And Girman is one of them."

He nodded. "So I cannot take him the readings of our little encounter earlier as proof. There is another complication, though, too."

"The defilation of flesh business."

"Yes. Girman would not stoop to congress with an animal without first proof that it was not in fact an animal, if you get my meaning."

"Nor would you."

"No. But I gained my proof."

"How?"

"With my intuition." He kissed her again then, and rolled atop her, and Merin felt his erection nosing at her mound. She rolled her knees up then, to accomodate him. "I have waited a long time for this."

"Me, too."

His cock emerged from a slit in his clothes—she felt it hard and silky against the skin of her thigh. He took his time, his control perfect as he entered her, until he had buried himself completely. "So we understand each other."

He did not speak for some time after that, as he let their bodies do what they would, finding a rhythm together, there on the floor among the pillows. Merin felt weightless as he sank and rose, her hands twined behind his neck, their legs an unimportant tangle somewhere below where they joined. Merin felt her orgasm building before she even realized it and was surprised to find him bellowing at the same instant as she came. He rose up then and looked down into her eyes, breathing hard. He seemed about to say something, but maybe his gaze said everything, as he held himself there, until their bodies again became two separate bodies.

When he resumed talking, Merin was shocked by what he

had to say. "I do not have to see your readings to know you are meant to be a master someday."

"Me?" she blurted, having never felt more submissive in her life.

"Yes, you." He kissed her forehead. "I know my days with you as my own are numbered. So tell me, my own, how can we save your people, so that I may keep you for a little while?"

Merin took a deep breath, the solution suddenly obvious. The thought that Kobi would make a better slave than she would had been brewing in the back of her mind ever since the Overlord's announcement. "My roommate. We convince Girman to give him a try, through cybersex, so that he doesn't have to actually touch his flesh."

"You're certain he is up to it?"

"Kobi has dreamed and fantasized all his life of serving the sexual needs of a domineering, alien lord. And he likes pain, when it comes with sex, anyway."

"And what makes you so sure that what Girman requires is sex and pain?"

Merin looked him in the eye. "Intuition."

The Overlord laughed. "Well spoken. You are correct. Sex and pain it is. The choice of personal domination and testing throughout the empire. But there is yet another obstacle to overcome."

"Which is?"

He stood and let his uniform fall, exposing the sculpted planes of his body. He kicked off his boots. "Sander. Your Mica. We must go through him to get to Girman."

Merin stood, too, feeling round and curvaceous compared to his steel-cord thinness. "And what will it take to convince Sander?"

"I am not sure. But a bath could not hurt." He led her to another wall and into steam beyond.

He attired her properly, and at last she wore the black suit of a caitan. She had not been far wrong in her guesses as to its construction and design. He also swept her hair up with a

curving comb of wire, and pinned it atop her head. Some women slaves, or servants, kept trying to do things for him, and he kept shooing them away. Merin wondered what his name was, then, and when she would learn it. In her mind now he was only Master, or the Overlord.

As he dressed her and fixed her hair, he told her what he could of his home planet and his people. They worshipped two gods, one called Zal, who was supreme Master, but also one called Kyl, who was Zal's caitan. Kyl was the god after which they named themselves and their world. Merin found that curious.

But there was no time to learn more than a little manners and custom before they went to Sander.

Junior Ambassador Sander's quarters were on the outer and upper edge of the warship, which meant he had a view of the stars over Bellonia. Merin caught her breath as they stepped through the open wall section and into a room that could have been a lake of black glass, frozen under a cloudless night sky. A sliver of the red moon crested the horizon made by the ship's edge like the eye of a giant mythic beast. Across the dark, smooth expanse the Overlord led her to a more brightly lit area, where Sander sat at a low table like the one in the parlor where they had eaten. No food graced this table, though, and Merin shivered to see tools she did not recognize, but which looked cruel, laid out on it.

The ambassador stood as the Overlord approached, and made an obeisance with his hands and face. He spoke in Kylish, and Merin caught a few of the words—he had received the Overlord's message and was now grateful to receive the Overlord himself.

The Overlord merely nodded and sat down among the cushions that ringed the table. Merin sat behind him and to his right, where he could easily reach her if he wished. Then he spoke in Bellonian, "Sander, you must have guessed by now, I'm having second thoughts about the decree."

"You lead the Hunt," Sander said, seating himself again on the opposite side of the table. "You decide when it begins."

"That is what I mean, Sander. I do not think it should begin at all."

Sander said something harsh in Kylish and sneered.

"Speak her tongue, Sander. She is privy to my secrets now."

"Then I state doubly what I said before. You are twice a fool. I know you, Ahrim, you are easily seduced by the new. You are blinded by a new hole in which to plant your flag of conquest. You forget they are only animals, imitating their betters." Sander's fingers brushed the handle of one of the instruments on the table, then drew back. "Taint your flesh much further and soon even I will be able to have you for my own."

The Overlord—was Ahrim his name?—yawned. "You are always reduced to such dramatic and personal threats, Sander. I think you watch too many dramas." He made a gesture like brushing lint off his shoulder, which Merin took to mean he had rebuffed Sander's advances before. "Must we play this game? I've come here to prove to you that Merin here, at least, is of worthy stock."

Sander pursed his lips as if he tasted something sour.

"Come now, Sander, I know you too well. You, too, enjoy the new. Here is your opportunity."

Sander clenched his fist on the table. "You know me not at all, Ahrim. You know only your own ambitions. Remember what happened on Malakai?"

"That was Bhujan, not me, on Malakai."

Sander looked like he was about to spit. "Maraghi, then."

The Overlord sat back, but Merin could sense his tenseness. "I have admitted to my mistakes on Maraghi. I have paid for them and they are forgotten."

"Girman has not forgotten."

"Nor have you, it would seem." The Overlord gazed into the stars overhead. "Sander, what do you want? Is it my position you seek? Or Girman's favor? Or something else?"

Sander, too, leaned back as if to look at the stars, and Merin was sure that both men were attempting to appear unconcerned. They were both failing, as far as she was concerned. Sander spoke. "So, you have come here knowing you cannot convince

Girman yourself. You have come here for my help in the matter, then. But do you come here in supplication? No. You have come here in challenge, Overlord."

"I have made no challenge, ambassador. I merely came to tell you of my doubts on our course of action." The Overlord's voice was not the slightest bit apologetic. "It is you who began with insults, ambassador. Am I to allow you to speak thus to me? In what manner can you be . . ." He faltered for the Bellonian word and substituted a Kylish one instead, "*Kalillah.*"

Sander laughed. "A language lesson for your animal, then. The word is an expression we have that refers to the state of well-being that comes after sexual release, and translates literally as 'bask in warm light.' I would have to translate it as . . . satisfied? Mollified, perhaps?"

"I was going to ask, merely, what would make you happy?"

Sander laughed again, a short bark. "I am not a happy person, Ahrim. I am not concerned with my own happiness, as you are, but with what is right. It is not right that you should rut with the wild animals and proclaim them people."

"And it is not right that you should proclaim them animals, when you yourself have not—" The Overlord stopped. "Sander, be reasonable. I am not asking you or Girman to take my decadent word. I have brought proof."

Sander steepled his fingers. "Yes, I see you have."

"Then, to return to something I said many minutes ago, here is your opportunity."

Sander stood then, and Merin shivered under his gaze. "No."

The Overlord stood slowly. "You refuse to test her?"

"Here are my terms, Ahrim. Listen carefully." Sander broke into a smile then, and it seemed he had thought of something that would make him happy after all. "I will not touch her. Did you think that I would? No. We'll wire her to one of our own. She'll feel everything and react accordingly. We'll take readings from both her and the other poor bastard for comparison."

The Overlord let out a slow breath. "You are a devious one, Sander. I know already who you'd like to wire her to."

"Do you?"

"Yes. I'm sure you are about to tell me that, given my recent questionable behavior, you've suggested to Girman that I be tested, as well."

Sander's smile did not diminish one bit as he said, "So you do know me, after all. Yes, Ahrim, you will be the mount that she will ride. Do you think she can withstand what you can? Do you think she can perform as well as you?"

"And if she can?"

"Then I will say whatever you wish to Girman on the fate of Bellonia. And whether she can or not, I will be . . . basking in warm light." Sander stroked himself through the thin fabric of his ambassadorial uniform, the same form-fitted colorful outfit Merin had seen him wear in the legislature. "Come to my private chamber this time tomorow. Bring her. Then we shall see what you two are made of."

The Overlord led Merin back the way they had come, his step sure and smooth as they crossed the expanse of black to the doorway. But as soon as the wall had sealed behind them, he began to curse. Merin looked into his face and was shocked to see distress and worry there.

"What's wrong? What is it? I thought you played him very well."

The Overlord took a deep breath and then began to walk briskly. They were passing through a corridor as seemingly featureless and unmarked as any of the walls in the room where she had entered. They went for some distance before he answered. "He is right, I do know him very well, but not well enough to realize he would make this choice."

"Is there more here than what I heard? It doesn't sound like the test will be easy, but—"

"This is more complicated than it needs to be, my own. And I am afraid your society has taboos that will make this seem even worse to you." He made a sharp turn and then a wall section ahead of them slid away. When it had closed behind them, Merin saw they were in someone's sleeping quarters. It was the first room she had seen yet that looked lived in: the bed rumpled, unworn boots stacked in a corner, a table piled with some kind of data folios.

He sat upon the edge of the bed, and at his gesture she helped him out of his boots. The uniform peeled away easily and he was once more naked before her. "Ah, my own, I have so much to tell you, and yet I fear our time together might be short. I do not want to waste any." He hefted his penis in his hands. "Arouse me, but listen well."

Merin dropped to her knees and began to lick all around the shaft.

"Where to begin, my own? Sander has borne a grudge against me his whole life, it seems. He is never happy with his lot, never content. His whole campaign for 'what is right' has been how he came into the Emperor's favor—but it, too, stems from something in our past." He came erect quickly and soon pulled away from her. He lay back on the bed.

"You're talking around in circles," Merin said, as she followed him onto the low platform. "What are you not telling me?"

"I told you I had once been Girman's caitan, yes?" His finger pointed to where Merin's legs met her body and then to his erection, straining up in the open air.

"Yes." Merin tried to imagine her master bound and beaten, and could not quite muster the image. She straddled him, then hesitated. One hand reached between her legs and she was surprised to find how wet she was.

The Overlord's hands fitted against her hips and pressed her down upon him. He felt very big in this position and she grunted as her weight came down.

"Girman was one of the cruelest masters my generation has known," the Overlord was saying. "He would rather break than nurture. He believed, and still believes, that anyone with the true spirit of Kyl can withstand anything. Slaves have been taken from his house with injuries that took months to heal. Some have killed themselves rather than be returned to him."

He thought for a moment, as he considered what to tell her. "Until this mission, I had not seen him for a long time. The rumors are that his methods may have become even more extreme, but I do not know in what way. In his life, he has found very few slaves who could stand up to his scrutiny or treatment."

"But you did," Merin managed to say, as she rose and fell upon him.

"I did. I would be dead now, if I had not." The Overlord closed his eyes. "Sander considered that serving under Girman, and being made a master by him, would have been the highest honor. Indeed, he is right. But this was an honor that went to me, not to him."

"So . . . you and he were rivals, and Girman picked you instead, and Sander has never forgotten it, or forgiven you."

"That is partly it. Did you wonder why I hardly used his title when speaking to him?"

"He called you 'Ahrim.'" Merin said, as his hands went to her nipples. He let his fingers play across them as she continued her up and down motion.

"Do you know what 'Ahrim' means?"

"No," Merin admitted. "They didn't teach us that one."

"It means elder brother. Girman sired us both."

Merin did not know what to say to that. On Bellonia, where children were conceived and raised in sanctioned breeding pairs, close blood relations of the same generation did sometimes consent to have nonprocreative sex with one another. But it was rare, and those from one generation to the next were prohibited because of the clear inequity in power brought on by age. She choked out, "Your father . . ."

"Yes, I served him even as you serve me." He looked from her face to the intersection of their bodies. "After all, who owns one's flesh more than one's parent?"

"And your mother?"

"A slave, of course. Sander's was a different woman. We never knew who in the household had borne us." The Overlord slid his hands down her body to hook his thumbs on either side of her clit.

"Why did he not take Sander for a caitan?" she asked then.

"Clearly I am being too easy on you, if you can still be asking questions," he said. "Give me your other hole."

Merin slid off of him and repositioned herself over him. This was not cybersex, this was real. She pressed her anus down on his slick penis, but it would not give.

He turned her over then, and positioned himself between her legs. "Relax, my own," he said, as he pushed. This time she opened and he slid into her. He began to pump immediately. "What other questions did you have? Ah yes, why Girman did not take Sander as a caitan. I do not know."

Despite the fullness, the intensity of his movement, Merin could still ask questions. "You don't know?"

"Does it surprise you that your master is not all-knowing? I think it was political. He was sent to another house."

"Wait, I don't understand," she said then. "Were you raised to be . . . nobility? Or were you considered slave stock?"

"Ah, my own, you are so very perceptive." He did not answer for long moments while he took his pleasure in her. "Girman does not believe in modern methods, I think I told you that. He broke me by hand, trained me by hand, and eventually realized my potential of his own. I was not the only son he had tried to bring up, after all. But I was the first to succeed."

"And Sander?"

"I will tell you after you come." He raised himself on his knees and held her by one thigh. He continued to fuck her while his free hand sank three fingers into her cunt while his thumb rode up on her clit. *Well,* Merin thought, *I suppose when sex is the national sport, you get pretty athletic at it.* And then she began to come, and thought no more about it.

He continued fucking her with his fingers and in the ass, and when her eyes fluttered open he continued to speak. "Sander was given to another house, one that used modern methods. He has always felt that Girman doubts his nobility as a result. He has always felt it was wrong for Girman not to have taken him personally, and has always been on a campaign of rightness and propriety for that reason. He wants nothing more than to prove himself beyond doubt to Girman."

"And if he proves you unworthy?"

The Overlord shuddered as he came, then continued to slick himself in and out of her. "Then he may prove to Girman once and for all that intuition is not everything." He pulled out of her

then, still hard, and lay down beside her. "The test he has devised . . ." He shook his head.

"You're afraid I can't pass it."

"Remember I, too, must pass it."

"Are you afraid?"

"It has been a very long time since I have been under the whip, my own. And never under the whip of someone who hated me."

Merin dozed in the Overlord's bed while he slept. The more she thought, the more questions came to her. Why, if there was so much tension among them, were Sander and Girman and he all sent to Bellonia together? What would the test be like, and how would it work to have his male body's sensations mapped onto her own? Between coherent thoughts, she would drift into dreams. In one she saw her Overlord lowering himself onto the prick of his father for the first time, as she had once done. In the dream he became Kobi, then, struggling not to come too soon, and she was the one under him, barking orders.

She woke with a start. The bed beside her was empty, and she lay awake in the dim light. The room confused her. Every other place she had seen on the ship was immaculate, the walls smooth, lights, controls, everything hidden from view. But the Overlord's bedroom was . . . cluttered.

Didn't he have slaves to clean things up? Merin sat up and looked around the room. Other than the women who had tried to help her dress that first time, she had seen no one else while on the ship, other than the Overlord and Sander. She vaguely wondered if it was to hide them from her, or to hide her from them.

She lay back in the bed, fingering the edges of the sleek fabric she wore. After a lifetime of blousy Bellonian togs, the caitan's suit left her feeling exposed. *Of course it does,* she thought. *It is the frame, I am the picture.*

He had left her no instructions. There was nothing to do but sleep and hope that Kobi was all right.

► Chapter Ten ▼

KOBI AND NAYDA DID NOT DARE leave the house that day, so they were home and again freshly showered when the message came through.

"It's encrypted," Nayda said, when a screenful of snow covered the media wall. "Let me get to work on it."

Kobi balled himself up on the couch and watched Nayda's face as she worked. The young technician's eyes darted this way and that as she concentrated on the problem, her fingers flying over the control pad. A curl of stray blond hair fell over her eyes and she seemed unaware of it.

After several minutes, she sat back and hit Play again.

This time Merin's face appeared. "Kobi and Nayda, I'm all right. We can't communicate directly right now, and we must keep our transmissions a secret. Kobi, we're trying to convince a high-ranking official here that we're worthy, and we may need your help. My plan is to try to connect you and this official through cybersex, so he can put you to the test, see for himself how well-trained and irresistible you are. I wish I could talk to you. I hope you are safe. Please be there when I contact you again!" And the screen went blank.

Nayda turned to look at him and said, "What's wrong?"

"What do you mean, what's wrong?" The calm that had held Kobi like a blanket since his escape was beginning to fray.

"You look upset. Scared." She moved to sit next to him on the couch.

He felt his own face with his hands. "I guess I am." His heart was beating hard and he felt cold. "Nayda, what am I going to do?"

She put an arm around his shoulders. "I thought you wanted to sleep with a Kylar?"

"But a test . . ." Suddenly, he could feel the metal probe of the Evaluator inside him, the heavy slap against his jaw, and he shivered. "Nayda, I don't think I can!"

"Shh, shh," she said, drawing him into her lap, wincing as she saw the bruises on his face stark against the white of her clothes. "It won't be like that."

"How do we know? We don't. I can't, Nayda. I can't go through with it."

Nayda kissed his lips to quiet him. "Maybe Merin will think of something else. There's nothing we can do now but wait."

When Merin awoke, she knew something was wrong. The light was too bright. She sat up suddenly, and found herself staring into the faces of several Kylar through a clear wall. Not a window—she was encased in a five-sided box, the clear walls running from floor to ceiling. She was at the center of a large room, surrounded by dozens of Kylar, some of them looking at her with interest, others talking among themselves. They were dressed in various colors and cuts of clothing, some women, some men. She was naked in front of them, she realized, not even the suit of a caitan covering her skin. With her fingers she felt around the edges of her face, the back of her neck. Some kind of electrodes were affixed there, similar to the ones she had used for cybersex at the Velderet, only wireless. She was impressed.

A viewscreen came to life at the edge of the room, like a giant window lighting up. She recognized, or thought she recognized, the corridor to her Master's bedroom. And there he was, walking toward the camera, the gold in his uniform glinting.

A moment later and the view switched to a camera inside the room. The door opened and there he stood, a frown on his face. "Merin?"

She suppressed the urge to answer, knowing he could not hear her.

He turned on his heel just as his attackers came out of sidepanels in the hallway. One of them caught him in the stomach with a fist even as he knocked another one down. The struggle was brief, the four attackers subduing his limbs and then one of them reaching for his head, as if to crown him.

An instant later, Merin gasped—she could feel the rough hands gripping him, like iron manacles made flesh. "Master!" she cried out, and several of the Kylar in the room laughed. The connection from his senses to hers was one way—she could not communicate with him. She felt the hard blow of knuckles against her—no, his—chin—the screen showed his head falling back. The attackers laughed, too.

She heard his voice then, harsh words in Kylish, and she realized she could sense his meaning, as well. "Where have you taken her? Let me speak to Sander at once!"

Again they laughed, and kicked him hard in the gut before binding his hands behind his back. Merin couldn't see with what, but it was something unyielding, like a plastic mold that tightened if she—he—struggled. He knew better than to struggle, and they carried him out of the room.

At first Merin thought he was blindfolded also, but she felt no blindfold. No, they carried him through a corridor so dark the cameras showed only a black screen, and for a moment she saw only the room around her. More of the Kylar were looking at her now, their narrow, intense gazes measuring her. She suppressed the urge to beat on the walls at them.

When her master was borne into a bright room once again, it was like a flash behind her eyes, and again she saw what he saw. Sander stood in plain black next to a post almost twice as tall as he was. His arms were folded and he was smiling—a huge grin, a huge, self-satisfied grin. "Greetings, Ahrim."

They undid his hands and reattached them to the pole, high

above his head. Merin felt his feet straining on tiptoe, the slick, smooth pole pressed against one side of his face and the length of his body. "Where is she? What have you done to her?"

"So many questions, brother. But I ask the questions now, and you answer." Sander motioned to the others, who stepped forward and stripped the Overlord's uniform away. One of them brought the gold insignia to him and Sander affixed it to his own shoulder. "Girman was not pleased with your change of heart. It was your own impatience that did you in, brother. If you had only waited before rutting with that beast you brought up from the surface, he might have listened to you. But you could not hold back your own appetite. Weak discipline. Now you are nothing to us, nothing but an example."

His arm lashed out and Merin felt pain blossom like fire across her back. She cried out and the room full of Kylarans laughed.

"We had an agreement," her Master began, but was interrupted by another lash.

"Our agreement was nullified by your Lord and mine. Girman is not interested in testing her, nor you." He drew back his arm again, and Merin huddled on the cold floor of the cell unable to watch the blow come. "The hunt on Bellonia begins tomorrow. The slaughter begins now."

Cheers went up from the assembled crowd as Sander began to whip in earnest. Merin pressed her hands to her face as the pain rained down on her skin. She tried to take deep breaths. *Remember*, she told herself, *this isn't happening to you. You aren't really cut, you aren't really bleeding . . .*

The pain subsided somewhat as Sander paused. She felt a tickle in her throat as her Master tried to speak and failed.

Sander's voice seemed to echo in her ears, coming from both the viewscreen in the room and the link through her master's senses. "You have not screamed yet, brother. Why is that? Wouldn't it make the pain easier to take? Or should you beg for my permission to scream?"

Murmurs of appreciation rose from the crowd, though Merin was not sure why. She closed her eyes, trying to sense his

thoughts, trying to puzzle out the answer. He remained silent, stoic, one cheek pressed against the smooth pole. If the Kylarans laughed at her for crying out, what reaction would they have to him?

She felt the hands on her again, the urge to fight welling up in him as they moved him, and then being beaten down by his desire to prove himself better than Sander. He allowed them to turn him so that his back was to the pole, his hands above his head again.

Sander approached with something glowing in his hand. Again the urge to protest came up, and again he beat it back. Merin could almost hear the unspoken words. *You wouldn't dare mark me . . .* then the battle that raged inside him became clear to her.

He did not know if all was truly lost, if Girman's decision had been made and Bellonia doomed, or if this was all a part of the test. He grasped at the belief that it was all for show, a pack of lies that would be revealed once he had outlasted Sander. But here Sander meant to brand him, maim him, permanently. Would Sander do such a thing if he expected any reprisal? There were rules . . .

The thoughts were obliterated by the searing sensation that started at his breastbone and moved in a straight line down his midsection as Sander pressed the edge of the glowing insignia to his chest and swiped it quickly downward. Merin clutched at herself, the smell of burnt flesh in her nostrils; her lungs constricted suddenly as her Master gasped but did not cry out.

"I have but one thing in mind," Sander said. "And that is to break you."

The next burn came over Merin's nipple and traced a circle around it. She sobbed and wept, her hands rubbing the undamaged flesh. Then the other. Then a tracing of the ribs, three on this side, three on that. Merin could no longer think as she lay on the floor of the cell, her jaw clenched and her fists pounding the hard stone underneath her.

When the fire burned between her legs, she did not move. Neither did her Master. Then suddenly the fire was gone and

there was a hot, wet mouth on her—his—cock. Her master sucked in his breath and she looked up. On the screen it showed Sander with his lips and tongue pressed to his captive's groin. To Merin's surprise, she felt herself becoming wet, her clit engorging even as her Master's erection sprang to life.

"Oh, very good, my brother," said Sander. "How truly you are mine." He stroked the hardness in one hand and Merin felt the ghost cock like an extension of her clit. "Beg my permission to scream."

"No," croaked her Master.

"Beg me to stop, then."

"No."

"So be it." And the brand came down on the tip. Though he did not scream, Merin did, long and loud, as the burn felt like a hot coal wedged between her cuntlips, and as the seconds wore on, the pain worsened. She rolled onto her back and threw her legs open. Kylar pressed close around the cell now, pointing and laughing as she exposed herself, as she licked her hand and rubbed herself to put the fire out.

The burning did not stop, but suddenly she knew how to bear the pain. She continued rubbing, not hard enough to make herself come. The pain leveled off. Sander was standing back from his captive, admiring his handiwork. Merin could not look, but there were gasps from the Kylar in the room.

"Beg me to make you whole again," Sander whispered.

Her master did not reply.

"You belong to me now, you realize that—don't you? I could kill you if I wished."

No one spoke and Sander's whispers came to her from inside her own head. "Come now, brother, you can make it easier on yourself. We have a very long relationship ahead of us. Would you spend it as a cripple?"

Merin cried out as the pain of a blow to her knee doubled her over again.

"Would you spend it as an idiot?"

The next blow of Sander's boot came to her head, and she felt the vertigo in her Master's vision.

"And as a eunuch?" The explosion of pain in her groin was not like anything she had ever felt before.

"Ask for my mercy," Sander whispered.

Her master hung limp, spittle dripping from his lips.

"Ask for my mercy," Sander repeated.

"No," Merin whispered.

Sander gripped her Master's chin and forced him to look up. "Ask for my mercy!"

"No," her Master said, his voice rough but clear. "I want no mercy of yours."

Sander took a barely controlled breath. He stepped back and took another. Then he pulled the insignia from where he had pinned it and threw it to the floor. Without a word, he stalked from the room. With the captor's will no longer in place, the bonds let loose and Merin felt her Master's body slide to the floor. There were hands on him again, this time with hushed voices, calling for help. As one of the servants reached for the link that connected him to her, she heard him whisper the words, "We've won."

Merin waited for hours in the Overlord's chamber. Uniformed servants brought food and then left her. She dawdled in the bath, worrying if he was all right, wondering what she should do other than wait—but there was nothing to do but wait. She could not send another message to Kobi without his help; she could not help him to heal. She consoled herself with the thought that a culture as sufficiently advanced as the Kylar must surely be able to heal flesh and bone quickly.

She nearly drifted to sleep in the heat and steam of the bath, but jerked awake as she dreamed of Sander's eyes staring into her own. Her skin ached in memory of the pain he had inflicted, ghost pains even the warm water could not obliterate.

The servants had left clothes for her, a black-and-gold uniform similar to her Master's. She carried it into the suite where—was it only yesterday?—they had eaten their first meal together. She left the uniform on a pillow and circled the room, letting the air dry her naked skin. She wished the servants would return, even

though she would only be able to have a cursory conversation with them in her rudimentary Kylish.

She wished most of all for him to return.

Merin nestled herself among the pillows and thought over the huge changes the Kylar had brought to her life, and to every Bellonian's. A year ago, she could not have pictured herself beating her housemate with a window rod, or kneeling before an alien lord in sexual service. She shivered.

That first time in cybersex, he had teased her and coaxed her with choices. She remembered the feel of his hands, so light on her nipples, and how he pulled back when she tried to rear up into his touch for firmer contact. How he had made her come while fucking her, and then made her come a second time, never taking his fingers from her too-sensitive clit, torturing her with pain. Her fingers slid between her legs as she lay there, remembering, thinking also of how just a few hours ago she had done this same thing to ease the pain of Sander's attack.

Then she had been surrounded by spectators and she had not come. But now she was alone. She licked two fingers and let her hard clit slide between them. One part of her found it ridiculous that while her life and her planet might still be in some peril, she lay here touching herself. But another part of her felt it was right. These Kylarans had already changed her.

As she moved her fingers in a tighter and tighter circle, she imagined he was with her, urging her on, perhaps stroking himself as he watched her. She imagined him overcome with lust and passion, pushing her legs apart and burying himself in her, even while she continued to rub her clit. With her other hand, she thrust two fingers inside of her, pretending it was his hard cock thrusting in and out. She could not penetrate deeply enough, though, and she let out a little cry.

"Is my caitan in need of something?"

Merin gasped and twisted her head. The Overlord, her Master, stood a few feet away, above and behind her, his insignia back on his uniform where it belonged. She hurried to stand, to rush to kiss him, but before she could get two steps, he said "Kneel."

She dropped to her knees, trembling from desire and ecstasy. He was all right!

He circled her and ran his hands down her hair, then slid to the floor behind her, pulling her to his chest. His fingers circled her nipples and then plunged to the wet seam between her legs. "It would seem, my own, that you are ready for my return."

"Yes, Master." Merin's heart skipped a proverbial beat as she answered.

"Then, let us make me ready for you." He pulled away from her, and as she turned to face him, he shed his uniform.

Merin approached him on her knees and cupped his balls gently in her hand. Part of his pubic hair had been burned away and she handled him with care. He was half hard already, and she could see the shine of new skin along the length of his shaft. She glanced up, and he said, "Come now, let's see if it still works."

She took the tip between her lips and let her tongue graze up and down the slit. She circled the head with her tongue before drawing it deeper into her mouth. He groaned and held still. Soon he was erect and she pushed him deep into the fleshy pocket of her cheek, her hand wrapped around the base.

He pressed her back into the pillows then, and fit his body into hers, his cock piercing her deeply. She clung to him with all fours, gasping.

His voice was in her ear as he settled his weight onto her, as he buried himself as deeply as he could. "Does it feel different?"

"Did you . . . are you bigger?"

"Ah, my own, how well you know me." He began to move in and out of her then. "Do you want more?"

"More, Master?"

"More." He took a deep breath as he filled her, and Merin felt as if he grew again in size.

The truth was she did want more. She didn't know where the desire came from, or why, but she wanted to take everything he could give her. She wanted to feel stretched, filled, overcome with him. She wanted more than she had ever had before, to erase the ghost touches of Sander and to put her once again wholly into her Master's hold. "Oh, yes," she said as she

squeezed her eyes shut, not sure if she could explain her sudden need.

But he seemed to understand. He lifted her into his lap then, and it felt to Merin as if he were expanding inside her to fill her entire body. She no longer felt the pull of the ship's gravity, only the rhythm of his fucking, as he made himself go faster and faster, his hands locked one behind her neck, one under her buttocks. Merin felt she was beyond coming, beyond the lightning flash of orgasm, as she descended into a trance rooted deep in her body, as solid and centered as the planet below. She did not know how long it went on that way. It seemed to be hours. But at last his own orgasm built, and grew, and it seemed to Merin that, as he came, lightning did strike, blinding her with its whiteness, then leaving her in the dark.

When she came to, she was on top of him, and he was still inside her, softening slowly. He opened his eyes and looked at her.

"Can all Kylaran males do that?" Merin asked.

He laughed. "I suppose we should have an anatomy lesson some time."

"I think we just did."

He rolled off of her, and she could see where the other burn scars had been repaired on his chest and ribs. She touched them lightly with her fingers.

He stood and stretched. "Much as I would love to laze here with you endlessly, my own, we have work to do." He extended a hand and pulled her upright. "Sander owes us a good deal more than a favor now. He overplayed his game and will be expecting retribution."

She followed him to the bath. "So what do we do next?"

"We must still convince Girman to call off the hunt."

Merin felt the slight tremor that ran through him as he spoke. "What would have happened if you had given in?"

"Sander would now be Overlord, I would be his slave, and Bellonians would be dying by the thousands."

"Would Girman have stripped you of your title for . . . having me?"

"He still could," her master said, as he stepped into the steaming pool of water. "But I think the odds are now on our side."

She slid into the water next to him, thinking of Kobi, and hoping he was all right.

► Chapter Eleven ▼

MARIANNA WAS ON THE NIGHT SIDE of Bellonia when Merin returned to the surface. Though the streets were lit with their perpetual lamps, the windows of domiciles were dark and no one was on the street. The Kylaran ship still hovered overhead, and if anyone was left in the city, Merin saw no sign of them. Perhaps even the legislators had fled.

She made her way to Nayda's door and waited for the home system to recognize her. The door slid aside and there was Kobi, his eyes still dark, his cheek livid with bruises.

He threw himself into her arms and she stood there for long moments holding him.

"You smell different," he said.

"Kylaran bath soap," she replied. "Oh, Kobi, haven't you been to the med center?"

He shook his head. "We've been afraid to go out." He touched his cheek. "It doesn't hurt anymore," he said, but Merin heard something go soft in his voice.

They went into the living room where Nayda was searching the media bands for news. Someone at World's Eye Studios had left a live feed on, cycling through several cameras placed around the city, one at the plaza of statues in front of the legislature, one on the main thoroughfare out of the city, one

pointed up at the blackness of the Kylaran ship in the sky. It was strangely compelling to sit there for long minutes, watching the breeze flutter the leaves on the plaza trees, the statues like actors waiting for a cue to move, then to stare at the roadway, waiting to see if anyone would come or go . . .

Eventually, Merin spoke. "Well, are you guys still up to trying to save the world?"

They nodded.

"The Overlord"—Merin realized she still did not know his name—"thinks he can rescind the order to destroy us. But he needs the approval of a . . . a higher ranking person. As I said in my message, we think he can be convinced that the Bellonian people are worthy to serve. But we need an example, someone who he can, um, try out." She ran her hands through her dark curls. "After all I've been through, I would do it myself, but—Kobi, he only likes men. And you're the only man we know that . . ."

"I know." Kobi was pale, strands of his long hair hiding his face like a curtain.

"What's wrong?" Merin took his hand in hers. The image on the screen went to the black sky. "I thought you'd jump at the chance."

He drew a shaky breath. "That was before."

"Before . . . ? Oh."

"Before Evaluation," he said, his jaw set. "What will they do to me?" Kobi swallowed.

Merin thought about Sander and could imagine him hunting down Bellonians. "I wish I could tell you it won't be anything like that, but Kobi . . ." Her memory of the brand and the whip was still fresh.

"I'll go through with it," Kobi said. "But I don't know how I'll react. I'm . . ." He hugged himself. "So who is this guy? Do you know what he's like?"

Merin shook her head. "I haven't . . . met him. But he has a reputation for being very cruel."

Kobi began to cry.

Nayda came and sat on his other side. "Didn't you say this would take place through cybersex?"

"Yes. The—" Merin realized that even as she did not know her Master's name, she did not know Girman's title. Maddening Kylaran customs. "His name is Girman. He won't dare defile himself in the flesh, in case we do turn out to be no better than animals."

Nayda squeezed hard on Kobi's hand. "Then maybe Kobi doesn't have to go through with it."

"You mean rig it so he doesn't feel the pain or something?"

"Even better. Let's let Girman have his way with a simulacrum. With Kobi2."

Kobi's head came up suddenly. "I've been training him! He's perfect!"

The screen blinked to an image of the legislature's interior, quiet, empty, and still brightly lit. No one had turned out the lights on the way out. "Who is Kobi2?"

"Merin, he was your idea. Well, sort of. I was trying to train myself to have more stamina, so I would be able to keep from coming. I made a duplicate of my neural map and started training it. I called him Kobi2."

Merin looked at Nayda. "It's possible to fuck yourself in cybersex?"

"Oh, sure," she said, her face a little red, "there's all kinds of things you can do."

"And there's no way someone connecting remotely would be able to tell it wasn't Kobi?"

"Well, I might worry that his vocal responses are somewhat limited. I mean, he has Kobi's personality, but not his memories or experiences." Nayda's gaze drifted into the distance. "But we could wire it for live interaction. It's tricky, but it can be done. Essentially, Kobi, it'll be like you're in a dream state. You won't be in control of what Kobi2's body does or feels, but you'll have subvocal control and the ability to, well, wake up, if you really need to."

Merin reached over and kissed Nayda on the cheek. "Thank you."

"Don't thank me yet. We still have to see if it works." She looked around her apartment. "I don't think we have the processing power to do it here, either."

The media wall blinked again to show the deserted street outside of the Velderet.

The audience with Girman was a formal affair, and her Master agonized over whether she should attend or not. "On the one hand, to bring you is pretty much as good as admitting that I've already had you, my dear. In which case, if your friend fails, and Girman decides against you, I will find myself having to answer for my haste. On the other hand, by bringing you, I show my confidence that I do not expect him to rule against you. This could work in our favor very strongly. But I do not want to make Sander's mistake of putting too much at stake." This he said as he readied himself, neatening his hair and uniform. He had ordered all servants away and paced in the cluttered, homey mess that was his sleeping quarters.

"Sander's mistake was not in putting too much at stake," Merin said from where she sat on the bed, "but in overstepping his ability. His ambition overmatched his competence."

"You think so?" He turned to look at her.

"Were you fooled by his abduction of you? He knew that what it would take to break you was to make you lose hope, to make you think you'd lost already. But the scene he set up—he created it such that your choice was obvious. Even if all was lost and you were made into his slave, the one thing you could hold onto was your pride, your own will. So you did. He never gave you a compelling reason to give that up. His mistake was in thinking that you could merely be forced, overcome. He did not realize that what he had to do was to make you *choose* to give yourself up to him. Then you would have truly been his."

Suddenly her Master was kissing her, mussing both of their hair in the process. When he broke away, he spoke. "You are truly born to be a master. And that is something Sander will never appreciate."

Minutes later they stood outside the blank wall that separated Girman's chambers from the rest of the ship. Four servants in the Overlord's black-and-gold stood behind them. Merin wore the same, dressed not like a caitan but like an attache.

The wall opened to reveal a smaller room than Merin expected after the grandeur of Sander's room and the Overlord's parlor. There were no starscapes in the floor, no curved obsidian walls. The walls were bare, a pale peach color, and lined with shelves—it appeared Girman was some kind of collector. Indirect lights glowed from the white ceiling. The room was dominated by two chairs at the far end, a low table between them.

Girman did not look old enough to be the Overlord's father, Merin thought. But perhaps the Kylar aged at a different speed— or reproduced younger—than Bellonians did. The man was seated in one of the chairs, his back straight and his hands folded in his lap. "Leave them outside," he said.

The Overlord gave a nod to the servants, who took a few steps back, and the wall sealed them on the other side.

As they came closer, Merin could see that the flesh around Girman's eyes was not as taut as it had probably once been after all. He stood, and she noticed he was fairly fleshy in another area as well. Girman wore an open robe, the sleeves long but his chest and flaccid cock exposed.

Her master went to one knee in front of him, and then, eyes closed, cupped Girman's balls in his hand as he leaned in and planted a kiss on the head of Girman's penis. The kiss lingered for just a moment, and then he pulled back. Merin suppressed a shiver. The inequality of the parent/child relationship was unlike any other, and therefore carefully modulated on Bellonia, with groups of parents caring for groups of children to dilute the directness of the effect. Even as she acclimated to the Kylaran ideals of master and slave, her Bellonian brain boggled at the thought of your creator literally owning you, your body truly not your own. She watched the Overlord pay his respects to his origins and shivered.

"Sander tells me you two are in agreement over something," Girman said. He sat down again and folded his robe closed.

The Overlord sat in the other chair. Merin remained standing. Hadn't he said this would be a formal affair? "Yes, hard as that is to believe."

Girman cleared his throat. "I take it you want to rescind the hunt."

"Yes." Her Master interlocked his fingers but did not take his eyes from Girman's.

"You are not a fool, Jurain. Only a fool gives an order and then rescinds it the next day."

"Only a fool lets a mistake go on unchecked."

"Your reputation will be tarnished by the reversal."

"I know, Piri. But I am convinced that I was wrong."

"Sander convinced you?"

"No."

Girman's eyes flicked to Merin, then back to his son. Long moments passed while Merin wondered if they had a subvocal link. Their eyes remained locked, but they did not speak. Then Girman said: "Sander spoke eloquently about why your order should be countermanded. But let me hear the reason from your own lips, Jurain."

"You know Sander and I both made excursions to test the suitability of the stock."

"Yes."

"He made his in person, aside from his ambassadorial duties, spreading—"

"I know all about our media war, Jurain."

The Overlord nodded and went on. "I made mine from here, interfacing our technology with the indigenous systems, so that I could interact with people on a more intimate level."

"And you are telling me you found something worth keeping. I don't believe it, Jurain. The Bellonians have taken all the structure out of sexual relations, separating them from procreative activity and anonymizing them to the ultimate degree. It creates chaos, an utter lack of roles, an utter lack of order. Not only that, their governmental system and even their family structure are antithetical to ours. How can you believe they can understand or grasp our ways?"

"Perhaps you should ask her that." The Overlord's eyes slid to Merin, who felt her face flush. Girman looked also.

Merin took a deep breath before speaking. "Bellonians are not

ignorant of power, or of structure. In fact, we have very high-ordered thinking on these subjects. Where we differ from the Kylar is not in our understanding of power or of relationships between people, but in the choices we make as a result of our understanding. Choice is the key. Animals have no choice—they react on instinct. My people made a choice long ago, to try to minimize the power of each person over another, for the good and survival of our race as a whole. For dozens of generations we have succeeded and prospered, and for dozens of generations we have continued to make the same choice. But it is not the only choice we are each capable of making."

Girman's face was open somehow, as if he were amused, but not smiling. "And you, what is the choice you have made?"

"To serve the Overlord as caitan."

Girman looked back at his son. "So, you have tested her and found her worthy."

The Overlord nodded.

"In all respects."

He nodded again. "By both traditional and modern methods."

Girman seemed to growl in his throat. "But you have still not explained your reversal."

The Overlord's gaze fell to the floor. "My own weakness and misjudgment."

When Girman did not say any more, her Master went on. "I was too hasty in my decision. In the battle between passion and prudence, passion won. I know passion is a necessary trait for a ruler, but prudence is a greater one. It is a lesson I am trying to learn." He dropped to his knees then, and Merin understood this was the true test—would Girman accept his confession?

Girman reached out a hand to stroke his son's hair. Then his fingers sank into a firm grip. "You are lying to me," he whispered, as he bent the Overlord's head back.

"No, Piri, I am speaking the truth."

"You have taught this animal to speak like a person, to justify how you like to rut with her. When she is in heat, you think she is loyal to you. Her will is as weak as your own."

"No, Piri!"

"You know better than to struggle, Jurain. You know what I think of that."

"Yes, Piri." He closed his eyes.

"Tell me again."

"I met her several times through our sense-net. She surprised me again and again. I became more passionate about her, began to make plans for her. But then we had a misunderstanding."

"Because these animals could not keep their promises, you said."

"I was wrong. I was wrong. I did not investigate the reasons fully—"

"You were hurt."

"I was wrong."

"And Sander pushed you to declare a hunt?"

"No, Sander shares no blame in this. I accept the responsibility fully."

Merin took a step forward. "No, we share the blame equally, you and I."

Girman let go and stood, his robe falling open again. "And would you share in the repayment of your Master's debt?"

"Yes." Merin drew herself up as best she could.

Girman gestured toward his son. "Remove his clothing."

Merin did as she was asked, sliding the uniform from her Master's shoulders and down over his hips as he stood.

Girman's eyes roved over the new scars, but he said nothing about them. "Now your own."

Merin took off her own uniform and stood next to her Master. She could feel the heat of him on the backs of her hand and arm where they almost touched. Her nipples stood out, crinkly and hard, in the open air.

Girman sat back down in his chair and said simply, "Show me."

The Overlord moved first. He placed his hands on her shoulders and then held her tight to his chest for a moment. He began to kiss her on the forehead, then all around her face, and down to her neck. Her hands swept across his back, and then their lips met.

She felt him growing hard against her leg. She wanted to ask why this was punishment, or what would happen to make it so, but she did not, afraid that asking would cause them to fail the test somehow. His thumbs found her nipples and she felt ripples of sensation spread throughout her body. Girman was watching closely, but she did not think about him. She thought about her Master, playing her body like a fine artist, and how she could do no less than her best for him.

He pulled her to the floor, pushed her legs apart, and thrust his tongue into her. He tickled her clit with the tip of it, then let the long, wet length of it slide down. He worked at her as her breath grew shorter, and she began to wonder if she would be allowed to come. Somehow, she doubted it. She wished she could ask, but she felt it would be out of place to speak now. He was good with his tongue, and her arousal was nearing its peak.

Just at that point, he pulled himself up and sank his cock into her.

She held her stomach tight while he fucked her, as she struggled not to come. Soon sweat dripped from his face onto hers.

"Faster," said Girman.

Her Master sped up his pumping and gritted his teeth, and Merin became quite sure that not only should she not come, neither should he. He might have been able to fool her, that once, as to whether he had come, but she doubted he could fool his father.

Girman said to her, "Clench tighter." She wasn't sure how he could tell, but afraid that he might, she tightened the walls of her vagina around her Master's cock. He grimaced.

"Turn her over. On your knees. Reach around her, between her legs." Girman's voice continued to give them orders, and they fucked as hard and as fast as he said. "Slow down now, lick her on the back of the neck, rake her with your nails, slowly." Under his father's orders, her Master pinched her clit, engorged himself further inside her, slicked himself in and out.

But neither of them came. Merin wasn't sure how much time

passed, but it was a long time compared to how long she usually spent at love-making. Then finally, after many long minutes of agony trying to keep from coming, Girman simply said, "You may stop."

They held each other tensely for a minute before her Master separated himself from her.

Merin was surprised to see something almost like a smile on Girman's face. "You've been practicing, Jurain."

"I strive to better myself always, as you taught me." The Overlord stood straight in front of his father and Merin stood at his side, a little behind him, but she had a feeling a small smile was on his face as well.

"So you have a specimen for me to test for myelf, is that your plan?"

"Yes. Through the sense-net. You'll never even have to leave the ship."

Girman stood and parted his robe once more, his cock not at all flaccid this time. The Overlord knelt once again, and kissed the hot, hard head of it. Then, still naked, he and Merin left the room.

Once they were in the corridor, he lifted her up in his strong, wiry arms, and carried her back toward his rooms. He seemed unconcerned over their nakedness, so Merin did not worry over it. The air in the ship was warm, and the sound of his bare feet against the floor was pleasant.

He tossed her into the pillows in the parlor and crawled after her.

"Why didn't you tell me he would test us to see if we would come?" Merin said.

"Because I did not know if that would be the test, my own. But I am glad that you discerned that it was."

"So, we're not animals, are we?" Merin said, as he gnawed at the back of her neck. "Because we were able to rule our bodies?"

"That's right," he said. "Although I'm not sure I want to rule mine anymore."

She laughed and wrapped her arms around his neck. "Then rule mine, why don't you."

He laughed, too. She had thought he would plunge right into her, then, but apparently he took the words as a bit of a challenge and instead slid his head between her thighs and began teasing her clit with the lightest of licks. She moaned and tried to press herself up into his motion, but he held her fast and switched to gentle lapping in a circle around her inner labia, never quite touching that hungry spot.

Her body bucked involuntarily, even as she struggled to control herself.

He heaved himself up then, pressed against her side while his hand took his place between her legs. Two fingers held her open while a third continued to tease. "Just because you are not an animal, and just because you help my cause greatly, and just because I feel so strongly toward you, does not mean you are not mine to do with as I wish."

"No, Master."

"I've been very lenient with you, given our situation."

"What do you mean, Master?"

"When I returned from the medical lab, I found you arousing yourself. Would you have come, had I not arrived?"

Merin felt herself blush deeply. "Yes, Master. I probably would have."

"I would have thought you would know that would be a terrible breach of your submission to me."

"I did think about it, but—"

"Shhh." He put his teeth to her neck and bit with just enough pressure to make her gasp in pain. "I will forgive you, since you have not had the formal training you will need to serve me fully. There is no time for that now. But, as you have learned, forgiveness needs punishment as well."

Merin was surprised to find tears welling up in her eyes. "Whatever you wish . . ." she choked out. She was not afraid of what he might do, not at all, but the thought of his displeasure, of disappointing him, was too much.

"You have withstood much, much more pain than most caitan

could," he said, his finger beginning to tap lightly on her clit. "You have shown great restraint as well. That leaves me only pleasure to torture you with."

She thought back, then, to that time at the Velderet, when he had forced her to come, and knew what he would do now.

"I will make you suffer," he whispered into her ear.

"I know," she answered. What she didn't know was how many times. And indeed, it was so many that she was unable to count.

► Chapter Twelve ▼

"OKAY, KOBI, LET'S GIVE THIS A TRY."

Nayda's voice seemed to echo in Kobi's head. He knew he was sitting in her living room, and that she was right next to him, but in his mind's eye he was in the standard cybersex room, alone. The gray bed was to his left, the "door" in front of him. He sat on the bed.

"Now I'm going to superimpose Kobi2. Ready?"

"Yes."

He didn't feel a thing at first. Then the image of Nayda herself coming through the doorway into the cyber setting made Kobi2 turn his head, and Kobi could tell he hadn't done it himself. Weird! The cyber Nayda, naked, was shifting nervously from foot to foot.

Kobi wanted to stand up and hug her. A few moments later, Kobi2 did just that. When Kobi spoke, the words came out of Kobi2's mouth. "So, I can control him, but it takes a little time?"

Nayda was hugging back, hard. She said into the cascade of hair that came down his shoulder, "It's kind of like you can make suggestions. The automated stuff you've programmed him for, he'll do on his own, but you can introduce new suggestions to it as you go along." She looked up into his eyes. "I think . . . I think we should give it a real test run."

Kobi2 didn't hesitate to lean down and kiss her. Kobi settled back for the ride, feeling his hands run down her skin. He could feel it, but it wasn't as direct as if he had been connected himself, touching her. So strange—as if Kobi2 was an extra layer of glass in a window to see through.

Kobi2's tongue searched her mouth hungrily and she whimpered. "It's okay," Kobi said, forcing Kobi2 to break off. "I can be gentle."

She smiled up at him. "I . . . I'm okay. Just a little overwhelmed is all."

"Do you like me?"

"You know I think you're beautiful . . . and here, there are no bruises. . . ." She reached up to touch Kobi2's face, and Kobi felt the suggestion of a caress in his mind.

He kissed her again, deeply, while his hands roamed her back. He helped her lie down on the bed and sucked at her nipples, one and then the other. "Is that good? Do you like that?"

"Oh, yes, that's wonderful!"

He tugged slightly on her nipple with his teeth, while his fingers brushed across the other.

"Oh, yes, yes," she squeaked.

"Has no one ever nibbled your nipples before?" Kobi asked from far away.

"No, I don't think so." Nayda shivered. "I don't think I ever chose that as an option in cybersex before."

She luxuriated under his touch for a few minutes more before saying, "But hey, isn't it *your* sensation centers we're supposed to be testing?"

"Mmm, you're right," he said, rubbing his hardening penis alongside her leg. She wrapped her fingers around it and Kobi2 let out a moan of his own.

She tugged on it a bit, then looked down.

"Is something wrong?" Kobi said, as Kobi2 put his hands between her knees.

"I . . . I'm not ready for you to come inside, yet."

He stroked her hair. "That's perfectly okay, Nayda. You just have to tell me. I'm happy to help you."

Kobi wasn't sure, but he thought he heard a small sob from the woman on the couch next to him in the real world. As Kobi2 stroked her belly and blew gently onto her labia before circling her clit with a finger, Kobi spoke. "Why are you so afraid to ask for what you need?"

"I don't know. I guess I'm always afraid the other person will think I'm demanding too much."

"So you just let them do what they want, even if you don't like it?"

"Well, that's why I usually just have cybersex with automated programs. Because real people . . ."

In the cyber room, Kobi2 was cupping her mound with his hand, rubbing up and down and letting one finger slip into her a bit at a time.

"Nayda, have you let people fuck you when you weren't ready?"

"Y-yes."

"In cybersex or in real sex?"

"Both."

"Does it . . . ?"

"It doesn't hurt as much in cybersex—I mean, I don't get sore or anything, but . . ."

"But it still hurts."

She nodded.

"You have to *tell* people—you know that, don't you?" Kobi2's finger was slipping in and out of her faster and faster.

"But I don't want to push anyone around . . ."

"Nayda, think about it. You're breaking the taboo the *other* way if you let them force themselves on you. Think about how bad people would feel if they knew you'd tricked them into hurting you. They'd be beside themselves."

"I know. That's why I keep it an even bigger secret. I . . . I almost never see someone twice in a row. I never told anyone this before."

Kobi laughed. What she needed was a guy like that one he'd cybersexed with—when was that? The one who kept asking, "Is this all right? Is this okay?"

"Are you ready now?" he asked.

"I think so." Her cyber body looked flushed and relaxed. She felt slick and wet in the simulation.

"I better make sure." He added a second finger, and pumped more slowly in and out of her. As her moans got louder, he added a third finger, and after a few minutes, let them spread like a flower's petals inside her. His thumb rode up her clit and she clutched tight to him and said, "Yes, yes!"

"I guess that means you're ready," he said.

"Yes!"

Kobi stopped speaking and let Kobi2 just do what came naturally to his programming.

When Merin arrived on the surface, she was wearing the black-and-gold of an ambassadorial attache again. Any Bellonian who saw her would have been shocked at the skin-tight uniform, but again, there was no one on the street to see her. It was night on the surface, and most of the city was deserted. Kobi, however, couldn't resist running his hands over the slick material when she came in to the apartment.

"It's a go," Merin said to the two of them, as all three of them sat on the couch, Kobi in the middle. "Girman is ready to give Kobi a test drive. We have about an hour to get ready." She looked at Nayda. "Does it look like it'll work?"

The technician nodded. "We gave it a test run. Everything seems fine."

"And he won't feel a thing?"

"Um, not exactly." They looked at each other.

Kobi spoke up. "I feel everything Kobi2 feels, but somewhat muffled. Filtered. I . . . I think I'll be okay."

Merin wrinkled her brow. "I don't want you . . ." She bit her lip, looking at the bruises on his face. "Are you sure?"

Kobi swallowed. "They're going to kill us all if I don't, isn't that right? I think I can suffer a little bit more." He trembled a little as he said it. "At least this time there'll be a good reason for it."

Merin hugged him. "It's the end of life as we know it," she said then.

Kobi let out a short laugh. "Oh, Merin, life hasn't been the same since that night we got drunk."

"I don't mean for us. I mean for everyone."

Nayda reached a hand toward Kobi's face and winced. "Maybe it's better for everyone, then. If we succeed." Tears welled up in her eyes again. "I'm so sorry, Kobi."

He hugged her. "That's okay. You didn't know what they'd do to me."

"I really thought they'd have you meet with counselors to talk about it, or, or something. Maybe assign you a therapy group . . ." Nayda looked up at Merin. "Does anyone in the legislature know what the Evaluators do?"

Merin shook her head. "I remember a measure last year to increase the number of counselors in training so that more people could be counseled. But Evaluators? That's some other working group entirely. In fact, I think they are independent of the legislature."

Kobi stood up then, his hair falling down his back. "I want you both to stop feeling sorry for me. I beat them. They tried to break me, but they didn't. They thought they did, but all the time I was just waiting for my chance . . ." He turned and looked at Merin. "But I'm still afraid of being tortured."

She said, "Let me tell you what I can about the tests I went through. Maybe it will help."

Kobi sat cross-legged in front of the media wall, while Nayda listened, and Merin told them what she had learned of the Kylar and their ways.

Kobi sat on the edge of the familiar, gray cyber suite bed. If he thought about it hard, he could feel that in the real world he was sitting on the couch, Merin holding one of his hands, Nayda holding the other. Merin had uploaded the caitan's outfit for him again, and his hair was up in a topknot. The transmission from the Kylar had indicated they were adjusting the input at their end and that connection would take place soon.

Soon. "Merin, do you think I should kneel down?"

Her voice was in his left ear. "I don't think it will hurt. Do you remember the position?"

"Yes." He got off the bed and knelt with his knees spread on the floor, his hands behind his back.

"That looks good," Merin said. Nayda had configured the media wall to display the visuals of the system input, and they could see the figure of Kobi—well, Kobi2 actually—take his position on the floor.

They all waited, motionless, until the image of Girman flickered on the screen as the two systems integrated.

Then he was there, in the cyber room. Kobi resisted the urge to look up. He could see the man's bare feet under the edge of his elaborately patterned robe. The robe was drawn closed, Merin noticed. The material swished softly as Girman took a step forward and stopped in front of Kobi. The interface was working perfectly.

Kobi tensed—he wasn't sure what he was expecting, but he steeled himself for it anyway. He shivered even though he knew he wasn't cold. Girman was just staring at him. He tried to relax. If Girman was going to beat him half senseless, then clenching his jaw wasn't going to make it any easier.

The robe whispered again as Girman reached out a hand and stroked Kobi's hair, the long black strands of it pulled up tight into the topknot, and then the soft ends of it falling down from the bun. "Take it down," Girman said.

Kobi's throat twitched as he undid his hair, while he tried to decide if he should apologize for having it up in the first place, or if he should even speak at all. But then he said, "As you wish."

It looked to Merin like Girman's eyes twinkled at that. The Kylaran lord let his fingers slide through Kobi's hair now. He stood close, close enough that Kobi could rest his cheek against the other man's crotch, and ran his hands through the black silk. Kobi's eyes were closed, as he let himself enjoy the sensation. He imagined that Girman enjoyed it, too, for the man kept it up for quite a while before tightening his fingers together behind Kobi's neck and forcing him to look upwards.

"Open your eyes."

Kobi looked up into the face of an older man, a touch of gray in his hair, the skin on his face weathered but smooth. His eyes were bright and penetrating and Kobi felt his mouth fall open, even as his heart started to beat faster. Suddenly he had a crazy wish—he knew it was crazy—he wished they weren't in cyberspace. He wished he could be sure that was Girman's real face, his real eyes. He looked up into them and swallowed hard. He knew that cyberspace was the only thing protecting him from what real damage this man could do, and yet there it was, a wish.

"You may speak, if you have something to say," Girman said. "In fact, I insist."

"I . . . I . . ." Kobi stammered. "I was just wondering if there is anything I can do for you." Talking either eased his fear, or fear made it hard to stop once he had started. "But I figured you'd tell me what you wanted, if I waited long enough."

To his delight, Girman smiled. "Stand up. Let me have a better look at you."

Merin could feel the muscles shift slightly in Kobi's body next to her on the couch as Kobi2 got to his feet. He stood still for a moment, then stretched his arms straight up at the ceiling, tilting his head and arching his back. Then he turned in a full circle. Why did he do that? Merin wondered.

Kobi was wondering almost the same thing. It was as if he couldn't help himself. If he let his fear and apprehension take over, he'd be rooted to the spot—he'd just curl up in a useless ball and wait to die. Some part of him wouldn't let that happen. It was the part of him that had pulled Nayda into the shower before, that had stolen the vehicle. It was the part of him that didn't want to lie back and wait to see what would happen. "I can get rid of this, too," he said, fingering the black stretch of the suit he wore.

Girman nodded, and the garment disappeared. Girman ran the backs of his fingers over Kobi's bare shoulders, brushing his hair back and then sliding his fingertips down Kobi's chest. Kobi trembled, this time not in fear. It was almost like a fantasy he

used to have—what did he used to say in it? "What does my lord require of me now?" His eyes dropped to be subservient, but he found himself looking at Girman's robe where the man's cock was still hidden.

"Look up," Girman said. "I am not your lord, yet." He drew back a hand and a slap caught Kobi on the cheek, loud, but not particularly hard.

Kobi blinked. The blow felt almost playful.

Girman draw back his other hand. Kobi tried not to blink, and a slap came across the other cheek. Kobi stared into Girman's eyes and saw a hint of challenge in them. There was a pause, and then another slap—maybe just a bit harder. Kobi found himself more curious than afraid of the beating now. The blows got gradually stronger, and his cheeks stung, but his brain didn't feel rattled in his skull, he never bit his tongue or felt his neck snap.

What he did feel was his erection rising, which he could not, and did not want to, hide. He had started to train Kobi2 to process pain as pleasure, but he didn't think that was the only reason Girman's treatment was exciting him.

Girman gripped him by the hair again, and tipped him back, and slapped him hard on the nipple. Off balance, Kobi gasped, but felt the tug of desire even stronger in the root of his cock. His cheeks were burning as if he'd drunk a bottle of wine, and he felt as giddy as if he had, too. He found himself on his back then, head cradled under Girman's arm, as the muscular body of the Kylar pressed against him.

"You're enjoying yourself," Girman said.

"Yes."

"Why?"

Kobi felt like he could hardly draw a breath. "Because . . . I like what you are doing to me."

"That is obvious. But why do you like it?"

"I don't know." Kobi thought about it. "I was told all my life that I shouldn't like it. But I dreamed about it anyway."

"About what?" Girman's hand slid over Kobi's chest and stomach.

"About being taken. About being needed and wanted. About being punished if I were not good enough."

"And are you good enough?"

"I don't know." Kobi squeezed his eyes shut, unable to look into Girman's face anymore. "I don't know and I suppose that's the point. Someone else has to—someone else has to decide that."

Girman clamped a hand over Kobi's nose and mouth then, and Kobi couldn't help but struggle instinctively against the loss of air. "It will be my job to decide that, then, won't it?" Girman said. He let Kobi gasp a little air before his hand clamped down again. His other hand went to Kobi's crotch and Kobi moaned under his hand as Girman gripped Kobi's velvet hard erection. Girman stroked him and Kobi wished he could breathe—but found he didn't miss it so much when the pleasure of Girman touching him grew more intense than his need for oxygen.

Then he was breathing again, and Girman was holding both hands in the air. Girman was on his knees beside him now, looking down on Kobi's prone form. They were on the floor of the cyber room, and it didn't matter. Girman's hands resumed their work, taking away Kobi's breath, but giving him indescribable pleasure. Kobi writhed from both sensations, gulping in air when he was allowed, and letting the stimulation run all throughout his body.

Girman stopped again. "Which would you choose? To live, to breathe, or to die in pleasure?"

Kobi coughed a little before he spoke. "That would really depend."

"On what?"

"On what you wanted."

Girman laughed. "I am asking what you want."

Kobi shook his head. "No one wants to die." He shivered then, remembering what was at stake. Perhaps Girman was reminded too, for his face became quite serious. Kobi went on. "Besides, to die would be to give up the chance to experience it again."

"This is true," Girman said, and folded his hand over Kobi's cock again. "And if you were to come now?"

Kobi shook his head again. "I'd be afraid that would end it, too."

Girman smiled, but it was a predatory smile this time. "Very good." He stood up slowly, drawing himself up to his full height. He cast the robe off, and it disappeared from the program. Kobi sat up and looked up at the stiffening rod that was Girman's cock.

"So you know two ways to end it," Girman said, his voice barely above a whisper, a dangerous whisper. But he motioned Kobi up onto the bed and did not say any more.

Instead he laid his body along Kobi's, and licked Kobi's nipples, and rubbed their two cocks together. Kobi was more afraid than he had been since Girman had appeared, and yet that just made him desire the Kylaran lord all the more. He kissed Girman's chest, licked his nipples in return, and found himself wrapping his lips around the engorged head of Girman's cock. To say it was large would be understating the case. As Kobi tongued him, he estimated that he had never had a partner this size, even Weil. With Kobi, this stoked rather than diminished his enthusiasm, and he loosened his jaw as much as he could to allow Girman to pass deeper into him.

He wished again that this were real and not cybersex. He wanted the real taste of Girman's precome burning his throat and he whimpered a bit, even as his eyes began to water, as they usually did when giving a well-endowed partner a vigorous mouth treatment.

One thing flowed into another, then, as he nibbled at Girman's balls and then his tongue found his asshole. One finger worked its way in and he went back to sucking on the Kylar's cock. Girman's hands played with Kobi's hair while he did so. Some time later, Girman pushed him over onto his back and worked a finger into Kobi's ass.

Merin heard a whisper in her ear. "Looks like they're having fun." It was Nayda's voice.

"I think you're right," she answered. The two men looked as

if they could have been any two lovers, gratifying each other's needs. Merin felt almost embarrassed to watch on the screen. Next to her, Kobi's body was hot, and she held tight to his hand, wondering what part of the test this was, and whether Kobi was passing it. Merin was tense, wondering if Girman would turn suddenly cruel. Her Master had said his reputation was to break, not to nurture, but everything she was seeing with her eyes said that cruelty was not Girman's priority.

Kobi cried out when Girman entered him from behind, but it was a cry of triumphant pleasure. Girman began to fuck him hard, pulling his hair with one hand and slapping his buttocks with the other, while he slammed in and out. Somewhere deep in his head, though, Kobi was not completely lost in the sensations. *If I come, or if I die, it ends,* he thought. *Am I afraid to die?*

He decided he wasn't. When he had been with the Evaluator, he was afraid to die. But somehow he couldn't maintain that fear with Girman. It felt almost right to be there with him, and to let Girman determine what would happen next. *This man could kill everyone I know and love,* Kobi thought. *He could kill me.* But the thought had no impact. He felt filled, physically and spiritually, in a way he never had before.

And he started to laugh. He was crying, too, but he was laughing as Girman fucked him with gusto, and slapped him, and held his hair tight. Kobi thought back to the Evaluator and laughed. He'd slapped him in the face and fucked him, too, and hurt him, but it hadn't been like this. This was different. Kobi felt as if all the holes the Evaluator had made in his soul, Girman was filling in. And so he laughed, and cried, and everything all at once.

Girman slowed down, panting. "Turn over, let me see your face."

They disengaged and Girman positioned himself between Kobi's legs, pushing the young man's knees toward his chest as he penetrated him again. Now Kobi could look up into those eyes and see the desire and passion there.

He had been so afraid that Girman would be—what? A

faceless torturer, like the Evaluator. Kobi had feared for his life
when he was with the Evaluator, and the pain had been terrible,
as if it was cutting into more than just his skin.

Now Girman was pinching his nipples hard between his fin-
gernails, and Kobi could only sink deeper into his rapture. Af-
ter a while, Girman stopped fucking him—maybe he was tired—
and turned him over, and began to beat him on the back, on the
meat of his shoulders and on his buttocks, with the flat of his
hand.

Kobi twitched there on the couch, thinking the spanking
would have made him come if it had not been for Kobi2's train-
ing. He was glad he didn't come. He wanted to see where
Girman would take him next.

He found himself lying on his back on the bed, Girman stand-
ing next to him. Kobi got up on his knees, but did not reach for
the man above him, something telling him he should wait to see
what Girman said or did next.

"What are you thinking?" Girman asked.

"I . . ." Kobi hesitated, trying to capture what had been his
last coherent thought.

"That is a command."

"I was thinking that I wished—" Kobi felt himself blush all
over his body. "I wished we were not in cyberspace, but in the
real world."

"Why?"

Kobi shivered. "Because I want to know if it would be the
same."

Girman sat next to him. "Tell me what you mean."

Kobi hesitated a moment, then said, "It might be a kind of
long explanation."

"That is fine." Girman sat like a statue as Kobi began to
speak.

"I was thinking about death, about dying. I . . . I've been
afraid before that someone was going to kill me. But with you,
even though you said . . . well, I just wasn't afraid of that some-
how. Or, I wasn't afraid of dying." Kobi drew a deep breath. "I
don't know if it was because somehow deep down I know I

can't die in cyberspace. Or if it was because of something real I felt."

"What did you feel?"

Kobi had to look away, close his eyes and try to see what was inside of himself. They were still shut when he said, "I felt whole. I felt like I'd been waiting for something . . . I felt like I just wanted you more and more. I wanted you to want me, and I wanted your desire to overwhelm me." He opened his eyes. "Which it did."

Girman met his gaze. "Tell me something." He rubbed his chin as he considered his question. "You said you had been afraid once before that someone was going to kill you. Who was it?"

Kobi swallowed. "Do you know about the Evaluators?"

"Let us say that I do not."

"They . . . they are part of the government here. They are the enforcement part of the government. No one really knows about them, I guess, until they come for you. If you're sick or perverted, they come for you—" Kobi's voice wavered a little "—and they break you before they kill you."

"And did they break you?"

Kobi had to breathe again before he could say, "Yes. Well, they thought they did."

"But they didn't kill you?"

"I didn't give them the chance."

"And did I break you?"

Kobi shook his head. "No. At least, I don't think you did."

"Why aren't you sure?"

Kobi got down on his knees and put his head on Girman's knee. "Because I feel like I'd do anything you said right now."

"Why would you do that?"

"Because . . . because I want to."

Girman cupped Kobi's cheek in his hand. "Then you are not broken." He turned Kobi's face toward his again. "Are you sure it isn't because you're afraid I'll kill your people if you don't?"

Kobi shook his head again. "Maybe I was before, but right now, I just . . . I just want . . ." He gulped, unable to think of the

right words. Maybe Bellonian didn't even have the right words, or if it had once, they had been purged from the language long ago.

"You seem surprised by this."

Kobi nodded. "I didn't think it would be this way."

"But you want it to be real. Not a machine-made fantasy."

Kobi shivered again, remembering what he had told the Evaluator. That it was only a fantasy, that he didn't really want to be hurt. "I didn't know how much I wanted it to be real, until . . . you."

Girman laughed. "We have a saying that translates roughly as: 'We are always undone by our surprising desires.'" He lowered his face to Kobi's and bit him gently on the lip. "That is true for me, as well."

"Are you going to torture me now?" Kobi asked, thinking about what Merin had told him.

"Are you so eager to be a martyr?"

Kobi blushed. "I didn't mean it that way."

Girman snorted. "You see the dilemma, of course. I came here completely sure that you would be willing to suffer indescribable pain, and probably death, to save your planet and your people. Who wouldn't? I was also sure that you would be warned about me." Girman flexed his hands as if thinking about the damage they could inflict. "But I think I already know everything I need to know about how Bellonians can handle pain." He wound his hand into Kobi's hair again. "And now I think I've learned a bit about how you handle pleasure. However, I think I could learn more."

"Oh, yes," Kobi said, betraying his real meaning at last.

Girman slapped him across the face again, and Kobi's nipples and cock sprang up hard. "You'll be disappointed if I don't hurt you," he said into Kobi's ear.

"I . . ."

"Yes? Or no?"

Kobi felt a lump in his throat. "Yes."

"You expected it. You were afraid of it."

"Yes."

"And now it all seems too easy."

"Well . . ."

"You enjoy suffering."

Kobi tried hard to swallow the lump. "I enjoy you making me suffer."

"I am so glad we understand one another." Girman let another hard blow cross Kobi's face, before he wrestled him to the floor surface, facedown. With one hand firm on the back of Kobi's neck, and one leg bent under Kobi's stomach to prop him up, Girman was able to slap Kobi's ass and thighs with his free hand, and land blows on his back. Kobi's knees slid apart and his balls and cock hung down, and Girman took to slapping them as well, in between the other blows.

Merin had spanked him a bunch of times. She had hit him with the window sash opener, and there was the rod that actress had used on them in their "audition." But Girman could hit with more force, the sensation going deep into his muscle, even while it burned the surface, and there was the sudden blossoming of pain whenever his balls took a slap. And Girman did not tire—the blows came down and kept coming.

Kobi wasn't sure how long it had been going on, but he found himself crying out rhythmically with every blow. Tears came. But then they went away. His thoughts drifted, to Merin and Nayda on the couch, to things that had happened before, and then he came back to the moment, shocked all over again at the sensation of the pain. His body began to struggle, but there was no breaking Girman's grip or slowing the blows or getting out from under them, and after long minutes of his muscles tensing and squirming, Kobi suddenly found himself relaxed. It happened in an instant, and it started in his mind an almost unconscious realization that he was literally helpless, that he was completely controlled by this other man. In that moment, he went limp, and his cries turned to moans—and still the blows came, but now, they almost didn't feel like pain. They felt almost . . . familiar, now . . .

And then they stopped.

Girman ran his hands gently over Kobi's reddened and

bruised skin, and Kobi found himself weeping again. The way Girman's leg was wedged under him, Girman's foot was under his chin. He clutched the other man's foot, and through his sobs began to kiss it. The soft and gentle touch just seemed like too much kindness to bear at that moment. No, kindness wasn't the right word. He kissed Girman's feet with a frenzy until he felt the tug on his hair that brought him up to a kneeling position. All the emotions in him seemed to settle as he sat up, as his burning-hot and sore ass came to rest on the flats of his feet. He shivered and was afraid to look up.

Girman stroked his hair and now Kobi was afraid, but not of being hurt. His heart hammered. After kindness came affection, and when you mixed affection with passion you got love. Kobi wasn't sure which he feared more: Girman loving him, or Girman not loving him. He still could not look up. He opened his eyes and was surprised to see his own cock was no longer hard, but soft and quiet.

Girman was standing now, one hand on Kobi's head, his leg so close to Kobi's face that the kneeling man could have leaned against him. Girman spoke. "You wanted to be tested. You wanted to know if you were good enough."

"Yes," Kobi whispered, his hair like a dark curtain around him.

"I want you to tell me what you are feeling right now." Girman's voice seemed to come from somewhere far above him.

"I . . . I want to kiss your feet again."

"Why?"

"I just don't want to be separated from you. I . . . I'm afraid you're going to leave now."

"Are you afraid you failed?"

Kobi felt a little of his daring spirit coming back to him. "I . . . suppose so, in an intellectual way. But I don't really feel it. I mostly just want to hang on to your leg."

Girman chuckled."And what else do you want?"

"Nothing. I want you to stay. I want to please you. I want to do whatever you say to do."

Girman's foot insinuated itself between Kobi's knees and he

lifted Kobi's balls with his toes. "I said there were two ways to end it: to come, or to die. Is that what I said?"

"You did."

"Do you want to come now?"

Kobi's breathing felt deep and calm. "No, I don't."

"Are you surprised?"

"Ah . . . a little."

"Look up."

Kobi looked up into his Master's face—no, Girman's face—and noticed that Girman was flaccid as well.

"There are other things to satisfy oneself with," Girman said. "My slaves do not come in my presence, nor I in theirs."

Kobi's heart skipped a beat.

"I think we must meet in the flesh, the next time."

And then beat even harder.

"And if you will agree, I would like to make you mine, for a time."

Kobi gasped, and then said, "For a time?"

Girman smiled a weary smile. "Do you think this feeling will last forever?"

"I hope it does."

Girman stroked his hair and brushed a strand from Kobi's face. "I do not make promises I cannot keep. But if you would be mine, and train with me in this discipline, I will . . ." He frowned. "You don't have a good word for it. I will keep you. I will protect you."

Kobi looked into Girman's eyes and blinked hard. "You're giving me a choice?"

"If I kidnap you, you'll be nothing more than a pet, a hunted animal."

"And if I agree?"

Girman shrugged. "You'll be my caitan." He held up his hands as if there were not enough words to describe what that meant.

Kobi sat up a little straighter. "And what do I have to do to accept?" He felt both Merin and Nayda's hands in his, squeezing tighter than ever.

Girman smiled again. "Simple. Say yes."

Kobi's heart was beating so loud in his ears, he barely heard the word come out of his mouth. "Yes."

Girman stepped back then, and nodded. "Be ready for me in an hour. Someone will come to pick you up. And now I must go." Desire smoldered in his eyes, then he winked out.

Kobi found himself in the real world being hugged by two screaming women.

"You did it! Oh, my goodness, you did it!" Nayda was saying in one ear.

"Kobi! I can't believe it!" Merin was on the other side.

Both their faces were wet with tears of relief. Kobi found himself kissing Merin and holding her tight. Then he turned to Nayda and hugged her close to him.

After a moment he shook himself and found it hard to stand up. Nayda fetched him a glass of water and he sat drinking it for a long, quiet moment. Then he turned to Merin. "I . . . that didn't go at all the way I thought it would."

She shook her head. "Me either. He . . . really seemed to like you. I thought for a while there all you were going to do was fuck."

Kobi held her hands. "I think that was the test. If I was just some . . . whore, who could do anything, would do anything . . . it wouldn't prove anything. But he saw something that made him think there was more to me than that."

Merin put her forehead against his. "But it looks to me like you just promised yourself to someone who'll never let you come."

"I'm not sure why I feel so sure about this, but I do," Kobi said. "He didn't say 'never'—just never in his presence. And really . . . I felt . . . satisfied at the end. It was better than orgasm, Merin. It was like all the orgasms I've ever had were because I was trying to reach this other, better feeling. And I never quite reached it before . . ." He breathed in and out slowly. "The question is, now what do I do?"

Merin sat back. "I guess you wait until they come to get you."

Nayda flicked the wall back to the news channel, and the vision of the black ship blotting out the sky above the legislature was on. Kobi turned to look at it and saw lights begin to come on, on the surface of the ship, beginning at one edge and then spreading across the sky like a new map of stars. The state of war alert on the ship was being lifted. As the lights brightened, they could see the glow through Nayda's windows, as if a new day were dawning.

► Epilogue ▼

MERIN HURRIED FROM THE LEGISLATURE'S main chambers to her desk, going through the tunnel under the plaza. Above her, thousands of Bellonians were packed into the Plaza of the People, making their way among the statues, showing their support of the new governance, even though they had already cast their ballots through their home links. She wanted to be out there among them, in some way, but it would be impossible to move through the crowd—they would all want to touch her, to talk to her, to tell her their story of their flight from the city, or from the Evaluators, or the fantasies they had kept hidden. The words of her speech were still in her mouth and ringing in her ears.

"We have been half a people, living half our lives, blind to the price we paid for our simple lives."

Girman had given the word that there would be no purge, no hunt, but when she gathered what legislators she could find to meet with the Kylaran leaders, and they began to negotiate the terms of Bellonian self-determination, they found the Kylar questioning their system of government.

"We long ago solved the problems of survival—food, shelter, and perpetuation of our species, caring for our planet and its resources, using our technology and self-restraint to insure that

all were provided for. So that we might never again abuse or exploit one another as the Gerrish were."

The consensus legislative system, in which citizens served three-year terms as lawmakers and regulators, was not the problem. The strict controls on population expansion and allocation of resources were also fine. Even the government's system of assigning people where they would live and work was not inherently offensive to the Kylar.

"It took a strong ideology to change our society into what it is today, and men and women like Greizel, and Alamm, made sacrifices that we do not forget or dishonor when we say that some sacrifices made for idealogy are too high a price to pay."

But the system was corrupt from inside. With the government able to assign people to workshifts and domicile locations, with family structure being an archaic concept, the Evaluators could too easily remove individuals from society. How could it be that so many were sent for distant counseling every year, and so few people ever noticed that they did not return to their homes? Everyone assumed that someone who had gone beyond local group counsel had simply been relocated. But Kobi had told Girman everything he knew. And Girman, who was now his protector, was affronted.

"We have been allowing ourselves to be ruled by secret enforcement, by the very behaviors we had hoped to eradicate from our own conduct, in order to free ourselves from the sins of the past. But as you all now know, we were not free."

For weeks there were inquests, as the legislature resumed operations almost as normal, and Evaluators were questioned, at first by the legislators, and then by the Kylar. The inquests from the legislature were broadcast. Those from the Kylaran ship were not.

"Our founders did what they had thought best, creating a society where most of us could live without harming one another. But the ideal that they wished for, for us to govern our passions with sense and compassion, they would not allow us to attain for ourselves. We are our founders' children, but we were never allowed to leave the creche that they built."

The Kylar, meanwhile, negotiated a tithe of metals and other resources that would not destroy the Bellonian ecology in exchange for Bellonia's entry into the empire and the Kylar's help in building a new goverment on the planet.

"From this day forward, we choose for ourselves. From this day forward we no longer bury our passions. We choose to face them with open eyes, as mature beings. Bellonia will know true freedom at last."

Merin half-ran up the stairs from the tunnel and down the hallway to her desk. The offices were empty and half lit. As she jogged toward her desk, she could see a dark figure seated there.

His back was to her, but he swiveled to face her as she neared. His smile was everything she had hoped to see. "Well done."

She slid to her knees and laid her head on the Overlord's lap. "I thought for sure I would screw it up."

"No, I made you practice it enough times." He buried his fingers in her hair and she sucked in a breath. "Our watchers show that thus far your people are going along with the plan. The vote is overwhelmingly in favor of your election to the leadership position."

"Transitional leadership only," she reminded him. "The consensus will still rule."

"Now you learn what all good rulers know. That they are slaves of their people, not the other way around. And you will have me to keep you humble in their eyes."

"Yes, Master." She kissed his knee.

"In fact, I think that speech may have inflated your ego a bit." He pulled her hair back and crushed his lips to hers. "But we don't have time at the moment to teach you a new lesson in submission. Not when Girman and Kobi are waiting."

Merin got quickly to her feet and shook out her hair, then fell into step behind him as they went toward the back of the building. They were on their way to Kobi's ceremony of initiation up on the ship. Kobi seemed deliriously happy with his new training, and Girman was less frightening to Merin now that she was working with him in the governance council.

The one person she still feared was Sander, but she no longer needed to worry about him. As of tomorrow he would be leaving, and taking a shipload of Bellonians with him. The Evaluators, of course, who couldn't be kept around under the new system. A vote had already condemned them to exile, and Girman seemed to think there was a perfect assignment for them. Girman would not tell her exactly what it was, but she knew that Sander was being punished somehow with the mission. Perhaps she could get the answer out of her Master, if she asked in the right way. . . .

He turned to face her suddenly and she couldn't help but feel he had read her thoughts. His hand reached through the unseen opening in her tight black uniform, down along the seam of her belly, until one finger snaked between her lips and inside her. "I am so glad you are mine, right now," he said. "I know that someday you will be a master yourself, but I am glad that day is not here yet."

His other hand was freeing his hard cock from his own uniform.

She opened her mouth to speak as he lifted her up and impaled her against the wall. He slid easily into her, as if she had been waiting for him to do exactly that ever since she had first caught sight of him, there in the office. Maybe she had. "We shouldn't be late," she said, as she gripped him around the neck and pressed her cheek to his.

"Am I too ruled by my passions?" he whispered, as he lifted her up and down on his shaft.

"Oh, definitely," she teased, between gasps. "Your passions rule us both, remember."

His forehead pressed to hers, his dark eyes stared into hers. "This is not solely my passion, my own."

"I know." She smiled. "But remember, from this day forward we will not bury our passions." She faced him with her eyes open, and had never felt more free.

Afterword

Inspiration is a funny thing. At the time I got the "flash" that resulted in *The Velderet*, several ideas were rattling around in my head. Among the recurring thoughts of those days: how do you write an erotic novel in which the sex stays interesting in every chapter? why is SM fiction always about a perfect encounter, and almost never about a comical or awkward one? and, gee, wouldn't it be fun to write something where the perverts save the world?

I was on the phone to Deena Moore, who was taking over *Taste of Latex* magazine and looking for a regular fiction contribution, when the idea came to me. She said two words, "cybersex" and "serial," and pretty much the whole story came to me at once. Hmm, I thought, by writing it as a serial and not as a novel, I can put my characters through a series of escalating erotic adventures that relate to a larger plot, there will be plenty of sex in each chapter, and I'll have ample opportunity to inject some humor and poke occasional fun at my own SM lifestyle. She wanted something appealing and easy to read, with lots of sex and a futuristic twist. Fetish and high tech together. Hmm, I thought, I can do that . . .

The main challenge, which I hope I have met, was in making each chapter stand alone in the magazine, while still keeping up

an ongoing story. In science fiction, a novel-length story almost always brings the fate of an entire planet or people into question. It's very rarely just about the personal growth of the characters. An erotic short story, however, is typically just the opposite, where the change takes place internal to the characters, and very rarely is there any impact on the world at large or the survival of the human race. It was great fun to blend these two genres from opposite ends of the fiction palette.

For a while, I wasn't sure that the story would ever be completed. I had planned it to run twelve episodes, but the magazine, *Taste of Latex*, ceased publication after only six of them were completed, and the manuscript lay dormant for a while. Masquerade Books then expressed interest in publishing the completed text, but they, too, ceased publishing. In the end, I finished writing the final chapters because I wanted to find out exactly what was going to happen myself! And sometimes doing it yourself is the only way to get something done, hence the Circlet Press edition of the finished book, now in your hands. I hope you found it worth the effort.

I'm sure the Kylar will appear in my fiction again, as they've already figured in many of my short stories. You can keep apprised of their, and my, developments at www.ceciliatan.com. Thanks for taking the ride.

—Cecilia Tan
Cambridge, MA

About the Author

Cecilia Tan is the founder of Circlet Press, publishers of erotica specializing in erotic science fiction. Her own fiction has appeared in numerous anthologies, including *Best American Erotica*, *Best Lesbian Erotica*, *Aqua Erotica*, *Starf*cker*, and in magazines ranging from *Ms. Magazine* to *Penthouse*. Her chapbook collection, *Telepaths Don't Need Safewords*, came out in 1992, and in 1998 HarperCollins published a collection of 23 of her erotic short stories under the title *Black Feathers*. She serves on the board of the New England Leather Alliance as director of Media Relations, and has been a member of the National Leather Association for over a decade. When she's not teaching workshops on sexuality, erotic writing, or tae kwon do classes, she's playing baseball.